ARCHITECTURE

and

NATION BUILDING

ARCHITECTURE

and

NATION BUILDING

Multiculturalism and Democracy

Mohd Tajuddin Mohd Rasdi

PARTRIDGE

A Penguin Random House Company

Library of Congress Control Number: 2015950768
ISBN: Softcover 978-1-4828-3168-9
 eBook 978-1-4828-3169-6

Print information available on the last page.

To order additional copies of this book, contact
Toll Free 800 101 2657 (Singapore)
Toll Free 1 800 81 7340 (Malaysia)
orders.singapore@partridgepublishing.com

www.partridgepublishing.com/singapore

CONTENTS

POLITICS AND NATION BUILDING

RETHINKING THE MOSQUE AND ISLAMIC ARCHITECTURE

VALUES, EDUCATION AND ARCHITECTURE

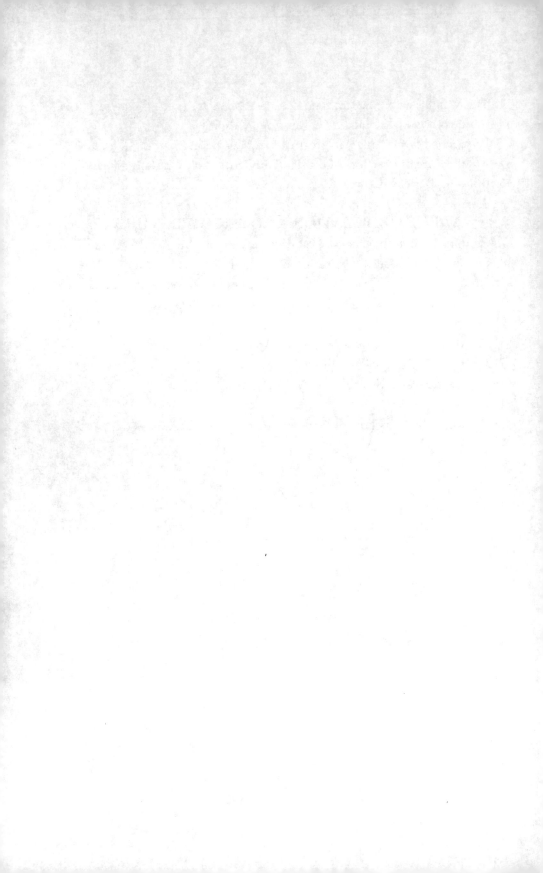

FOREWORD

Architecture of Not One but MANY Malaysia

Whenever the month of August comes around again, the 'hype' about patriotism and 'merdeka' is in the air. The television and radio waves will resound with the chime of One Malaysia and a reminder of how 'lucky' we are to be in a peaceful nation and how important it was to think as One Nation. Well, I will venture an argument that it is better to be a MANY Malaysia and admit to our differences whilst understanding and tolerating them rather than a ONE Malaysia with a single sense of forcing other ethnic values unto one other ethnic group.

At Universiti Teknologi Malaysia main campus in Johor, the architecture speaks of ONE Malaysia 23 years ago when I first step foot as a young and eager lecturer. But the glaring ONE Malaysia might as well be One Melayu Malaysia as the architecture displays neo-Vernacular Malay architecture topped by a monumental statement of Islamcism in the form of a classical middle eastern eclectic assemblage. The original UTM at Jalan Gurney (now Jalan Semarak) was an assemblage of universalist architecture with no trace of any ethnic-centered monumental statements simply because it was built during the pre-Mahathirian era. The UKM campus in Bangi was no different than the UTM city campus as well as UM and UPM. But the International Islamic University Malaysia and the UTM main campus proclaimed a new political ideology of One Malaysia than those propagated by the father of Malaysia, Tunku Abdul Rahman Putra. It was now the era of a dominant single ethnic group using Islam as a main political tool to rally calls of patriotism. The

architectural reading of the two campuses in Johor and Gombak is distinctly clear. The stage for One 'Melayu-Islam' Malaysia was set and it culminated in the 'glorious' idea of Putrajaya.

When I lecture about the idea of a national architecture, I say that it should not exist. This may seem a devastating statement and seemed un-patriotic. The problem here is my critics understand one idea of democracy and the implications of multi-culturalism whilst I understand it wa…yyy differently. I am one who agrees with our tourism slogan which spelled precisely and succinctly who we are as Malaysians…Malaysia Truly Asia. What does the slogan mean? To me it means that we are a nation of many colours, many cultures, many beliefs and many talents. And what does that mean in architectural terms? Many kinds of building languages, not just one. Well, if one was to argue that there must be a common and shared language I would certainly agree. Let that common language be a safe housing planning and design for our children, a crime free planning for the housing estates, a tropical and sustainable energy saving architecture, an expandable building to cope for many growing needs and a way for our old and infirm to use spaces with ease and comfort. Those are the universalist language. We should not have to be forced into an argument whether the Minangkabau roof is the sacrosanct emblem of Malaysianness. It's not even 'Malay' as some would understand it. We should not even be too gung ho with a neo-Malay vernacular simply because over 60% of the country is of that ethnic group. I put forward two kinds of architecture that would answer the idea of an architecture for Malaysia or what politicians like to refer to as a 'National' architecture.

Firstly, take a good look at the buildings in the sixties and seventies. What do we find? The Parliament Building, the National Mosque and Angkasapuri. Where is the neo-Malay vernacular or fanciful middle eastern Islamic garb? Tak ada. As with the UTM city campus, UKM, UPM and UM, the language was universalism. Okay fine they're a bit boring to look at compared to the Crystal Mosque or the splendour of Masjid Wilayah. But this was the time when political leaders know that their responsibility first was to the citizens and not personal wealth and glory. As the architecture shows, to me, leadership then was a responsibility. As again with the present hundreds of millions of Ringgit of public buildings, leadership now is about personal gain and self glory. Call me wrong but architecture…never lies. You just know how to read it.

Now let us walk down memory lane to Malacca, that metropolitan melting pot of the first 'Malaysia'. What do we find at the city center? A glorious cacophony of Malay, Islamic, Chinese, Indian, Portugese, Dutch, English, Baba and so many others that as a non-traveler, I would not even venture to guess. A mosque sits next to a Chinese Temple which is close to other temples and churches with ease and comfort. There was no incident in the whole annals of Malacca of stepping on a cow's head by one religious group expressing patriotic disdain over a temple being built so close to a mosque. Are we not proud of Malacca? Yes! Are we conserving Malacca. Yes...errr...hopefully anyway. Now answer this question. Why in heavens name are we conserving the multiplicity of ethnic architectural language...a 'rojak' of design and cultural statements? For TOURISM! So... when we want to make money Malaysia is MANY Asia but when we are going to govern her, suddenly the Graha Makmur Municipality building is the architecture of ONE Ethnic Malaysia sahaja. When we want to send our children to public universities, there is only One ethnic architecture for Malaysia. Something does not click here. So what are we actually...One or Many? Would we like to be One where every ethnic group has to toe the line of a single group or should we be MANY respecting all ethnic groups and learning seriously to understand and tolerate one another's beliefs? I'd like my children to grow in a MANY Malaysia.

After over a half century of Merdeka, what have we to show today? A Malay NGO shouting about Malay rights, the same ethnic group's claim over an Arabic term for God, the burning of churches by 'mysterious individuals', the stepping and denigrating of Hindus by stepping on a cow's head, the tearing and stepping on pictures of political leaders of a minority ethnic group and many, many more ethnic-related injustices which is beyond this column to reiterate. What is the result? Whenever I give group assignments in class, there would be a polarization of ethnic groups. When I look out my window of my house, there are also polarization of ethnic play groups. In our public schools, there is an all Malay class (so executed because of one extra 'Arabic' subject) and an all non-Malay class (because of solving administration problems of Moral class). I am pretty sure if someone were to observe our children who went through the National Service, the polarization would in all probability exist. If I have to give a grade for our political administration, it would certainly be an F. If there was one thing that I learnt about years of reading and thinking architecture and that is ...a building never lies. I can read the history of

changing or unchanging cultural values and political intentions just by looking at the building's design and planning lay out. And my current reading is that we have fallen from where Tunku Abdul Rahman left. Though we may seem richer in materials and facilities but our spiritual self and muhibbah soul are at it's utmost low.

So what is my architectural merdeka message? For housing and the city, let the glorious cacophony of the Malacca era rise once again. Let us be a 'rojak' and not pretend to like a standardized 'coffe house cake'. Let us be pedas in our rojak but not to the level of causing gastro-intestinal problems! For our universities and administrative buildings, let us embrace again the Parliament house and the spirit of UKM or Jalan Gurney where universalist tropicality rules. Or if there is an urge for symbolism, let Dewan Jubli intan of Johor pave a discourse on Post-Modern mult-cultural eclecticism. Let us do away with the ethnic supremist attitude in our national structures. We are not the One but we are the MANY. In this Merdeka, celebrate our strength in being MANY Malaysia towards a common attitude of harmony and understanding.

Prof. Dr. Mohamad Tajuddin Mohamad Rasdi
UTM, Johor,
Jan 2011

1

Architecture and Racial Harmony

Introduction

The issue of strained race relation in this country has surfaced again. If there is one glaring 'failure' of this coalition government is that this relationship is even worse than before. Yes, we have a peaceful country, but underneath this peace lies a boiling mass of fear and hatred that will hinder the best Malaysians to contribute towards the well being of this country. I personally find that the economic disparity is much closer and its bridging is simply a matter of a few more years and that is a success story for the coalition government. But serious issues of education philosophy in all levels threaten to strike at the very heart of racial harmony. I wish to expound on one aspect which has been hidden all this while and this aspect is also something which I suspect is adding the rift between our races. It is in the way we design our buildings and plan our housing. I maintain that architectural design and housing planning worsen ethnic relation in this country. We must revamp our thinking about design and planning principles if we are to get back on track towards a nation of true peace and harmony.

Design of Terrace Houses

The design and planning issues that disrupts race relation can be divided into three main aspects. The first is the design of the terrace house, the second

is the planning of community facilities and third is the language used in buildings of national significance. Let us first tackle the design of the terrace house. Malaysian terrace house design has seen four decades of changes but yet they still maintain the basic feature that would strain race relation. The most obvious would be the face-to-face windows in the front and back part of the house. The worse situation is in the back alley. Architects have mindlessly design the same windows that permit privacy violations to occur. The back window frames the kitchen and the bedrooms. The aroma of cooking for different cultures may strain healthy social relationships. Because of the packed planning of housing blocks there is hardly any air movement in the back alley that would drive the aroma of cooking away. The use of chimney stacks whether of masonry or metal should be considered by developers as this would dissipate the aroma away.

The bedroom windows should be designed differently to avoid visual violations. As it is now, tenants draw curtains which block views but also badly needed lighting and ventilation. This increases energy usage for cooling and lighting. Window designs should be split into those that provide lighting and ventilation and those that permit view. I recommend that ribbon windows above five feet be designed until the ceiling beam to allow maximum light and ventilation. For restricted views, I recommend slits of window one foot wide be placed at corners rather than at the center of the wall. These slits should be placed in a deep timber or concrete frame of about a foot deep to restrict outside viewing vantage. The Islamic mashrabiya can also be an interesting solution as it permits inside to outside view rather than the other way round. Other ways are to landscape back alleys and street fronts with trees but this would block the sun for drying clothes. Perhaps we could dry clothes on the roof tops rather than at the ground floor.

The other aspect of house design which is of concern is the porch design. I have to be very patient with my Chinese neighbour who burns the joss sticks which lets offensive smoke meander into my living room. I have had to close my glass door which cuts of air circulation. Should we forbid this ritual from being practice? Of course not. A simple solution would be a metal chimney pre-designed into the porch ceiling space. A worse case scenario is the neighbour that keeps the car idle for a while and lets poisonous carbon monoxide into the next house. Nowadays most people extend their porch to cover the whole serambi space. I think more setbacks should be instituted

rather than the twenty foot minimum. In this way a twenty foot serambi that covers completely the car can be a feature but an extra ten foot of roofless and gated space permit the car to idle with less chance of smoke coming into the house.

Planning of Housing Estates

Let us now tackle the housing estate planning rather than just the house design. I had written an article once about how we can simply walk away all or problems related to physical health, social health, economic health, environmental health and personal safety. By walking to shops and the kindergarten, instead of driving, you can have better health. You save money on fuel and pollutes the environment less. At a slower pace of walking you can greet neighbours instead of zooming past them whilst inside your 100% tinted and air-conditioned car. By knowing everyone, you would create a defensible space against strangers planning to commit crime. If the housing estates were filled with people walking back and forth I can almost guarantee that criminal will be put at bay. But how do we encourage the walking culture? Make pedestrianized pavements on the street mandatory. Make the planting of shady trees and obligatory act. Place wakaf huts and simple furniture at the streets for intermittent resting places and which acts as places for mothers and children to wait for their busses. Make kiosks for newspaper and goring pisang stalls easily set up and provide amenities for this small businesses which have the potential of creating a social hub in the community. Place schools, libraries, mosques, temples, community centers and some shops within true walking distance so that there is an encouragement to walk rather han to drive. Promote cycling by proper pathways as well as bicycle parking spaces. It is so simple. By having all these inexpensive features minus the royal palm trees and decorative lamp posts, we would have placed strategic elements that would forge communities and racial interaction.

Design of Community Buildings

Next comes the community buildings. Make sure that there are mosques, temples and churches that act as community nodes for inter racial understanding. Design all these facilities with a friendly façade and landscaped

lawns. Get rid of the parking spaces to permit the open concept of invitation rather than the closed fence and hard tarmac for vehicular parking. Replace the front lawn with playgrounds and coffee stalls with serambi seatings. Let's not be too institutional with Ottoman monster mosques or Chatres Cathedral-like temples or churches. Simple sweeping modernistic lines of humility and tropical porosity should be the order of the day for the architectural vocabulary. Or look back during the days when the Nusantara mosques echoes Chinese pagoda like roof forms to illustrate the tolerance of religions.

Language of Administrative Buildings

Finally, let us look at the design of national monuments, particularly those of the likes of Putrajaya. I have written and spoken about how the Parliament building of Malaysia differ much in design than that of the Prime Minister Department building. One is a socialist manifestation whilst the other is more of a French Palace in all its glory. Please let us remember that we are a democracy and remind the leaders that they are not replacing the Sultans of this country. This country is governed by ordinary people who is supposed to elect ordinary people for a limited number of years. This country is not an autocracy in its lawmaking and Prime Ministers should be careful of family members being very much part of the country's running. We do not want a dynasty in Malaysia. So, for an administrative building, please throw out the feudalistic architectural vocabulary and concentrate more on organic humility such as that proposed by the great architect Frank Lloyd Wright. Secondly, let us not clothe the building with a single ethnic language only. We are a multi racial country. Either design with eclecticism of Malay, Chinese and Indian languages or refrain from referring to any one language. When Architect Raymond Honey was asked to design the Dewan Jubli in Johor Bahru, Sir Gerarld Templer requested that he tried a 'Malayisan' style with an eclectic approach. The Parliament building by Ivor Shipley takes on the non-ethnic approach and merely resorted to tropical architecture with regionalistic overtones. How can the races of this country stand looking at a building that glorifies only and only one race? Even though Malays who are Muslims dominate the country with its 60% presence, there is no need to rub it in.

Thus, as I have frequently said in many lectures and writings, architecture can be the builder of civilizations and also a destroyer of one. One architect

worries me when he asked how architecture can contribute to 'nation building'. Architecture is the house of man. It is the manifestation of man's rituals, behaviors and beliefs. If we can frame our ideal of racial harmony, architecture can set the stage for better race relation. But if we continue to plan and design in the present way without an ounce of thought on privacy violations, communal facilities and a democratic language of architecture, we will definitely carve a certain path towards racial disharmony and the death of this nation.

2

Housing and Children Safety:
Of Death Towers and Dead Zones

Introduction

For this article to have been written, it puts many people in an embarrassing, shameful and even guilty position. I don't know exactly how else to put it to the readers out there, but simplistically…our housing is our children's potential cemetery. I accuse our housing flats as 'Death Towers' for children and I call our zoning cum circulation sense simply as 'Dead Zones' for toddlers and primary school students. I am in complete aghast at the callousness and ignorance of architects, planners, developers and the housing authorities about this issue of children safety in housing that I often wonder if these same players even have children of their own… or if they have ever been aware at all that they have children? For a country with not one but two tallest buildings in the world, I question our competence and even our very sanity at the utter ignorance and worst, of our complete indifference, concerning the stark reality about our children safety in our multi million Ringgit housing property. This article does not contain a statistical information on children who have died or been paralysed through falling or being hit by a vehicle on their way to schools and playgrounds. It is based only on two reported incidents. I have never let statistic govern my concern and my life. To me one dead or paralysed child is simply…one too many.

Death Towers

Let me explain about our 'Death Towers'. The name includes simply all kinds of flats over three storeys in height. It matters not that they are low cost, medium cost, high cost or of a ridiculous cost, they are all the same potential tomb stones for our children. One day, 5 year old Mohd Fakhri stepped onto some flower pots in order to peer at his mother who was francticly looking for him. He fell and died. Open corridors and stairways common in our low rise or high rise flats are deaths personified. Once a Chief Minister's son fell to his death from a balcony in an expensive condominium. Open balconies and windows are invitation to death.

Simple Solutions

Corridors, balconies and windows should be provided with an extended floor slab or a trellised overhang which acts as a sun shading device, protection against rain or even the incorporation of planter boxes. Imagine that, just a mere 2 feet and lives of children can be saved! Should it take a seminar or a government decree for architects to think about using them? Should it take more lives to be lost before developers could put up these buildings and call them 'saleable features'? Architects such as Moshe Safdie, in his famous habitat housing concept created a multi floor building with different floor plans at each level so that what he invented was a vertical village. Architects can design different floor plans that if a child do fall he or she would land on another floor. Its simply a matter of doing. I have often wondered why architects cannot distinguish between the logic of a high rise for housing and an office tower. Office towers are built with vertical walls that are sheer drops on all sides simply because, the focus of work is to the inside. Thus, no one thinks of opening windows for chit chatting with people on the ground. But in a housing architecture, windows must be openable such as air can come through, if not for breathing, its for the washing. I remember sitting along the corridors of the police barracks and looking out at a game of football whilst my mother hailed the man selling bread on his motorcycle. She would lower some money in a basket tied to a rope and ordered verbally from our second floor unit. So architects, repeat after me...the House is not the Office and vice versa! We could have policies against open corridors above the second floor. I

never liked the use of iron grilles but people put them up because the so called professionals, financiers and authority are too lame enough to think of such things as safety design for children.

Some Simple Solutions!

Dead Zone

I will now explain what I mean by the Dead Zone. As I write, a little girl named Siti Suzaini from Merbok lies paralysed. Her mother says she does not have enough money to attempt any medical miracle. I had sent her some money because I could not sleep thinking that I possess the design knowledge to have prevented her daughter from being run over by a car whilst walking home from a Qur'an reading school. And I also could not accept the fact that the country with the two tallest buildings in the world could not help her financially or technologically. I showed her picture to the head of department of planning and I asked a simple question. Why do we design with the grid of roads for vehicular access at the expense of pedestrianized streets? Why do we put pedestrians like children walking to schools and playgrounds as second priority next to vehicles? Excuse me… not second priority…NO priority. I forgot, there does not seem to be any pedestrian pavements in most housing estates. The response from this professional was…children are wild and they do unexpected things. The bottom line is planners are not to be blamed. In other words…it was Siti Suzaini's fault that she was a wild seven year old. I'll let that

sink a while before I lower the boom on these poor excuse for a professional. Or perhaps he presented the 'proper' excuse for a professional in this country?

The solution to planning housing for the safety of children is simply to get rid of the vehicular grid of roads. When I was in Edinburgh, Scotland children can walk to the play ground and to school without crossing a single street. Those living in inner cities simply walk to school with the proper street crossings and traffic lights. There are two reasons why this can happen. Firstly, the schools in UK are smaller compared to our two thousand strong students. One head teacher proudly told me he can identify by name every single primary school child under his care. He has only two hundred students. I think the ministry of education should make policies to create smaller primary schools so that these schools can be located comfortably within walking distance from houses thus eliminating the dangerous school busses thundering to and fro every day. Secondly, planners and developers must think of alternative solutions to housing in relation to the separation of vehicular access and pedestrianized one. I was able to design a 500 unit housing estate where one child can cycle or walk to school, to the playground, to the mosque, to the community center, to the shops without crossing a single street. Now that is what I call 'designing'. What most planners and developers have been doing are merely copying and dressing up buildings and landscapes so as to put such labels as 'environmentally sensitive living'. Lets face simple facts, we'd like our children to be able to survive growing up before they can actually enjoy 'living with nature'.

Conclusion

As I write the final words to this article, I checked my watch and it is time to drive 10 minutes to school and pick up my children. They will come home, take their lunch, do their homework and then play video games or watch the Astro. In the evening we will play badminton or football in the confined house yard which I'm lucky enough to afford. This ritual is a common lifestyle for children as a few feet away, death awaits in the form of cars, trucks and busses. Sometimes I would haul bicycles and drive the children to a manicured playground fifteen minutes from home. My question is simply, is this our idea of progress? It will require another article to explain the sociological, economic, spiritual and intellectual implications of our present housing on the

future of our nation if our children are imprisoned in this manner. My hope is that architects and planners actually approach housing from a humanistic agenda and not from a machine or other agenda. I also dream of the day when developers would think of themselves about building a society first with money as the reward and not money first and yet more money as a short term reward.

3

Towards Good Housing and Community Development: Creating a New Cultural Catalyst

Introduction

As a person trained in architectural design, I have grown to a position that the ills plaguing the problems within the housing estates which I have tried to high light in my many writings are in fact inseparable from the bigger question of the idea of the modern Malaysian 'community'. It is necessary at this point to place the term community in apostrophe since the first question one must ascertain is whether there actually exist a 'community' as we have been brought up to understand. In this short and personal discourse, I shall attempt to portray that we need to redefine our idea of the modern community and that there is a crucial need of a catalyst that would help to contribute to the eradication of many of today's social ills. [1] The catalyst I refer to is the setting up of a new center initially named as Center for Community Development

[1] Much of the ideas developed in this essay come from two of my wrtings; the first is 'Peranan, Kurikulum dan Reka Bentuk Masjid Sebagai Pusat Pembangunan Masyarakat', Penerbit UTM, 1999 and 'Housing Crisis in Malaysia: Back to a Humanistic Agenda', KALAM, UTM, 2003 (the seven articles in this book were published in the Property Times, New Straits Times, from 2003 to 2004). Some of the community programs proposed in this essay came out from my seminar series

and Architecture. The ground result of such a center would see the birth of a new building called a Community Development Center complete with a new line of office bearers that would form part of the leadership in the modern multicultural community in Malaysia.

Problems in the 'New' Malaysian Community

Almost everywhere we drive to in Malaysia presently, one obvious scenery encountered would be the sprawling and ungainly modern housing estates. These housing estates boast of ultra modern facilities and infrastructure such as designer playgrounds, mosques,. *Dewan Serbaguna* or Multi purpose halls, club houses, mosques, shops and many more. The houses range from RM25,000.00 to RM700,000.00 and the affluence of the society can be seen in the variety and large number of cars populating the settlements. The housing estates easily cram in thousands of families in close proximity. Never before has so large a community at one particular place exist in this country in its 46 year old history. But the gnawing question here is what kind of community exist in these locations? Or to be more blunt, is there any kind of 'community' in these massively populated environments? In this section we put forth the argument that communities in Malaysia exist only in numbers and close proximity but in truth we are nothing but a community of strangers just living next door to one another.

A Cultural Dilemma

One stark difference between the traditional and modern communities is that the former consists usually of a single culture where as the latter has more than one race living together in the same housing estate. In Malaysia, a decision was made towards the perceived 'greater good' of a multi-cultural nation, to insist that developers provide a suggested distribution of house owners from different races. And thus, the developers dutifully fulfilled their part of the bargain. And that was it. There was no program for integration and an encouragement to know one another in a more active and controlled

at the Institute from Rural Advancement, Bangi with imams or religious leaders throughout the year 1999 - 2002

manner. I refer this as the '*wawasan* school' syndrome. You kind of hope that close proximity provides opportunities of integration. Well, the theory is sound but it neglects the historical 'hurt' between the races in this country.

In the traditional society with a single cultural entity, the social, moral and religious norms are well understood and entrenched in the fabric of life. The physical environment is the manifestation of these norms as evidenced in the method of privacy controls in building siting, use of landscape elements and compositions of windows and doors. You don't have the problems of back-to-back windows that encroaches serious privacy violations because the Tukang or builder is from that same culture or in fact lives just up north beyond the riverside! The modern version offers faceless architects, developers and municipal authorities. In the traditional community you don't have problems of smoke from the Chinese joss sticks 'aromising' your rooms simply because your neighbour does not perform this ritual. Hence, an extreme suggestion would be to create separate racial enclaves within the housing community but that would put the idea of 'Malaysia' at great risk of being a mere lip service. A better suggestion would be to design a chimney stack. A marvelous one would be to eliminate the terrace house and develop a scheme that would once again allow adequate air movement. A long term strategy would be to develop a community curriculum to teach mutual tolerance. Someone has to teach the different cultures how to live within each other's social norms. Eliminating cultural norms in favour of a 'globalised' or universalized western value system is, I think, not a viable option.

The Socio-Economic Dilemma

In the traditional society, the economic activities of those homogenous cultures living in a village are almost the same or at least directly related to one another. Villages in the coastal areas see fishermen going out to sea whilst those in the interior parts of a country would farm the lands and rear livestock. Thus, it is hardly surprising that a strong communal bonding exist in these traditional societies with close proximity of work places, interdependent activities, the common celebration of successes as well as '*berat sama di pikul*'.

In contrast, the modern society produces the office worker, the retail keepers and others who work in separate geographical and architectural entities. It is not surprising therefore to find next door neighbours who hardly know

one another since two thirds of their waking moments are spent in different places. Coming home from work at the end of the day finds these 'worker bees' confining their activities looking at their children's homework or going out for dinner. Preparing food at home to the middle class families is fast becoming an extinct ritual. The concept of 'week ends' also provide for personalized family activities at shopping complexes or holiday resorts. At least, for Malay Muslim individuals, they would still have to go to the mosque in their community for the maghrib, isya and fajr prayers as well as the weekly *Juma'at* prayers. They would still have to attend other religious activities and celebrations. I am not sure about the Chinese communities as I find them more reserved and pay full attention to their individual family than committing to any communal responsibility, if at all there is any.

Thus, one can see the break down of the Malaysian communities with these isolationist reactions from the modern working ritual. It is very pronounced in the Chinese communities and the Malay-Chinese relationship. I have no experience with Indian communities and thus cannot speak about them but I suspect it would be similar. The Malay middle class still seems to hold a loose sense of community as Islam demands a minimum involvement at the part of congregational prayers and other religious activities. Perhaps if there were enough temples for the Chinese and Indian communities, the break down within those specific races would be less pronounced. As yet, I have lived in and visited many housing estates but found temples wanting in them. On occasion, I would find the shop house churches filled to overflowing with the two races on Sundays.

The Myth of Independence:

The modern society has this simplistic myth of 'independence'. I call it the five 'c's'; careers, condos, cellphones, cars and credit card. Don't leave home without any of them. Interdependence among family members and community members in the traditional societies create a strong bonding and sense of worth. When a family member is sick, the nurse would be none other than one of the family members. The hospital is the house and vice versa. Caring, visiting and funeral services are all within an arm's reach away. Cooking and washing are sanctified duties of the household and teenagers given these tasks know well their roles in the smallest social unit; the family. There are no servants to rely

on. The Indonesian or Filipino maid service is non-existent. In the modern society, our children and teenagers have an identity crisis. Who are they in relation to the family? Forget asking that question in relation to the immediate community. Since all we ask of them is that they study hard for exams, our teenagers look towards the MTV for inspirations of identity in their lots of spare time. Cyber Cafes and Comic book libraries are also favorite escapism with so much time in their hands since '*bibi*' does all the washing, cooking and taking care of baby sisters. Not many knows one fact I have discovered as a parent. Nothing destroys a child more than letting them command a lot of money. I have often wondered what would be the life expectancy of our children after being filled up with Coca-colas, snicker bars and sitting in front of the internet playing 'Red Alert'. I predict that they would live to the ripe old age of twenty eight.

Who are we in relation to the immediate community? Who are we besides teachers in schools, workers in offices, operators in factories and wheelers of business dealings? When we come home, we have no definitive roles in our societies. Is it a wonder that a child can be kidnapped and raped such that we did not know whose child it was? Oops..she's the daughter of the teacher two houses down the street? Who would know or even come to the aid of the family at number 213 when the robbers tied them up and had their way with female members of the family? Now tell me which is the 'stranger', the *Bangla* salesman or the man who owns the BMW three doors away? In architectural parlance, we say that the street and the community ceases to have defensible spaces and marked territoriality simply because no one really knows who the other actually was. In the days of old alienation was a product of different cultures and geographical origins. In the modern context, alienation is the about same culture just two doors away.

The Car Paradox

The car is the symbol of man's progress...and ruin. The progress of the car is that it provides rapid mobility. That is all. Oh...it's also a status symbol. That's it. The car's downside is more than just two. It causes pollution at a grand scale. It wastes time when one gets caught in the traffic jam. It kills people. The car is especially lethal to walkers and cyclist that have no choice in our pavement-less housing estates. Lastly the cars cause social alienation with

its speed and exclusivity behind the tinted glass windows. In the morning, one closes oneself in this mobile home, backs out the front porch and zooms out without so much as a wave or a nod to the neighbours around. So goes the human aquarium. Our housing estates do not provide nice and safe walkways filled with shady trees, paved streets, convenient wakafs and comfort stops. We live in an air-cond house, to an air-cond car taking us to an air-cond office with frequent trips to the air-cond shopping complexes with air-cond play spaces. And this is perceived as progress.

The Community Carrying Capacity

I remember learning about the concept of carrying capacity in a course on Environmental Science at the University of Wisconsin, Green Bay, USA way back in the eighties. It means that in a certain habitat, the food chain can carry so many elephants, tigers, grasshoppers, rabbits and the like. If it gets too crowded, some of the animals must move to new grazing grounds. Victor Papanek, one of the fathers of modern philosophy of design mentions that towns of old seem to have a carrying capacity not exceeding 600 families or so. Villages would have very much less.

The arrogance of modern life places in the hands of the developers the ability to house 1000 families in twenty blocks crammed barely fifty feet away in the low cost housing developments. The designs of such developments remind me of book stacks in libraries. The idea of a carrying capacity to the developers seem to be their bank loans and size of water tanks and electric loading. Human and humane interaction and privacy pale to insignificance. Even mosques have not escaped these techno-related carrying capacity. Whenever I propagate the idea of the mosque should be seen as a community development center and that it should be designed small and numerous there would always be the question of building fewer big mosques simply because it would fit more and also look grand. God should be pleased if we monumentalised His House. Since I cannot vouch for God and His feelings, I would volunteer that big mosques equals long distances and communal alienation since a two hundred capacity *surau* is more intimate than a three thousand strong masjid.

A New Cultural Catalyst: The Community Development Center

It is clear from the discussion above that we need a new cultural catalyst to push and encourage our individual citizens and their ethnic groups into a whole new idea of 'community'. There are three important ingredients in this new catalyst in order to be viable in today's local context. Architecturally, there must be a place for the various ethnic groups to meet and have 'modern rituals' such as 'Hari Keluarga' or Family Day, health check, children playground or music lessons and many more. Secondly, there must be community programs that are 'neutral' culturally but important enough for the security, self advancement and to meet some aspect of national concern. Thirdly, and this is the most important ingredient, there must be a Director with his team to design the community 'curricula' and ensure its running.

The Building

Let us first tackle the architectural problem. The present *Dewan Raya, Dewan Orang Ramai* and *Dewan Serbaguna* are to my mind in truth *Dewan sekali-sekala-Raya, Dewan Orang-tak-Ramai* and *Dewan Serba-tak-Guna*. The idea of an all functioning room dates back a century ago to Mies van der Rohe's 'universal space' idea. The idea is logical, attractive and simple; put up a long span space with no interior columns and make it high enough to suit functions such as sports and community gathering. The problem with this idea is that the room is valid now to be used on two occasions only; a community gathering that occurs once in a blue moon and a weekly badminton game. Try playing chess in the big hall. Try going there for a chit-chat and see if you can pass beyond the closed steel gates. And if you do pass through the gates, pray tell where you are going to sit? The only function that the high ceiling space serves for is simply the badminton game. For other functions, the upper half of the hall's volume is a waste of air conditioning and light energy. It takes a strong light and fan energy to get all of that down the 24 feet or more high ceiling. And, why are we closing the hall from windows that give better lighting and ventilation? It is so that the wind does not interfere with the shuttlecock! Thus, just because of one badminton function, the building fails to attract all other functions and even makes the gathering function difficult. Consider the echo

effect of a closed up and huge volume space when you're trying to announce something on the speaker system. Thus this present typology MUST GO!

First and foremost, a community center building must have a cafeteria or a *warung* type place. The food stall or the cafeteria is one of the most important ice breaking social element. It is a neutral cultural entity since all of us have to eat. Next, a small library space with places for students to study is a big help to our children in the low cost housing flats. Our reading habits is poor not because our children don't like reading but simply because they cannot afford the book prices, there's no library in the housing estate, they are never given a long time in the school library, they don't have time after school because of the '*sekolah agama*' afterwards and finally their parents lack the joy of reading. A nice and safe playground with seating under a clump of shady trees would draw parents and toddlers to it and the socializing would surround the mothers with talks of baby fevers and high cost of schooling. Of course we must have the multi-functional space but to be not two stories high but just a little over twelve feet would do fine. The administration space should include rooms for a director and two assistants with ample storage and workroom in order to organize such activities as exhibitions and family sports day. There should also be one or two smaller rooms for classes and children's tuition activities. The parking lot should be designed to cater to over flow spaces with tents and similar temporary structures. Outside seating are a must to be provided integrated in a landscape that provides both semi private activities and rowdy ones. The architectural language should incorporate ethnic vocabulary with natural materials such as stone, brick and timber with support from the usual reinforced concrete structural frames. Make it a bit resort like and not like a sports center or an abandoned small factory. I see sheets of metal decks being used as walls and curved roofs in today's *dewan* and I guess it is the 'natural' evolutionary type of a badminton hall turning into a small and medium industry workshop! Avoid the urge to make strong 'Putrajaya' symmetry compositions for the building mass but make it asymmetrical with broken up massing to lower the building scale and provide good natural lighting and ventilation. I think with the above mentioned suggestion, we can then live like a community.

The Program

One of the first things that the community officers should do is to get a clear 'social profile' of the families in the housing estate. The professions and expertise of each family members must be documented in a data base. The data base serves two important functions. First it gives an idea of the intellectual and cultural profile that would help the officers design a more conducive curriculum for the social and intellectual programs. Secondly, the data base provides the officers with the important opportunity to create roles for each and every individual in the community. As mentioned earlier, one problem of community breakdown is the alienation and isolation caused by the myth of 'independence' and the diverse career geography of the community members. For instance a math teacher in a community can now be sought by the officers to run a weekly math tuition for the children. The teacher would then feel that she is a strong part of the community. A retired army officer can be given the task of training new community cadets such as the 'police or army cadets' in the school curriculum. In this instance it is recommended that the school closest to the community join forces to have library clubs, *takraw* teams, *nasyid* groups and the like that is shared by both institutions. This is by far the most important element of the community center. It is not just running activities or giving activities to the individuals of a community but in essence, the community center is reinterpreting and redefining the roles to the individuals so that once more he or she will be part of a larger human group entity.

Programs should cater to the retiree, adult, teenager and children groups. The retirees could have more religious, political and less physical programs whilst the adult group should be more for intellectual development for both career and political futures. As the working adults have less time, the elders would be given more roles in community leadership under the supervision of the community director. The program for teenagers would range from better scholastic achievement, art of self-defence, sports and family entertainment projects such as plays and singing groups. Special vocational courses such as auto repair could be offered to post SPM teens and adults.

The Director

In the old traditional society the 'director' of the community would be non other than the *Penghulu* who is the extended arm of the Sultan or the Religious Scholar who is the independent social activist. Nowadays both of these positions are no longer held up in high regard and one even in suspicion. Thus, we need a new 'director'. The community director which I envision is an anthropology graduate who would be more of a facilitator than a political tycoon. He or she would have to be an anthroplogy enthusiast who have had spent participant observation time with all the races. If need be we could design a new degree graduate that would have taken some courses in architecture, sociology, psychology, management, anthropology and political science. He or she would be the social integrator. The community committee would work with the Community Development Director in order to help the efforts of nation building.

Developing the Think Tank for Community Development

When I sent my students to research the areas of children safety in schools and housing, they came back from the Ministry of Housing and the Ministry of Education saying that both ministries think that it is the JKR who should answer those questions. Before that the ministries were unaware that there was even a problem with children safety. The students finally reported that the JKR gave a simple standard answer that the building by-laws are literally 'God's Decree' and thus should cover all aspects of structures. End of discussion. This is the type of malady that we have in this country. We have so many ministries that either duplicate jobs or even have no sense of direction except respond reactively to specific problems or organize sensationalized events to feed the uncritical media and their 'innocent' readership.

I propose that a center called the Center for Community Development and Architecture be set up. The center can draw the resources from the Ministry of Housing, Ministry for Women Affairs, Family and Unity, Ministry of Rural Affairs, Ministry of Education and the Ministry of Public Works. The center is the think tank that can also draw strength from NGO's, academics and professionals.

The center has three major tasks. The first is to run academic programs of post graduate research dealing with the crossing of the two fields of anthropology and architecture with a smattering of other social study areas. It would pool the best minds and social activists to generate the social data base mentioned earlier and also to propose community programs that would create the new modern community culture which has an integrative effect a role playing part. The center can also help a faculty run an undergraduate course of anthropology with a minor in Community Development. Obviously the subjects related to the minor requirements will be offered by the center.

The second task of the center is to test prototype community projects that have been theorized in the academic discourse. The center would choose a community and help the community leadership in *suraus*, temples and community centers run some programs for a year while training the leadership in an on-hands manner. The center would also run programs for developing the community leadership to a more structured and critical understanding of social management. I have had some experience running similar leadership courses for community leaders organized by INFRA or Institute for Rural Advancement in Bangi. Many of INFRA's modules can be upgraded and combined or even restructured to provide the above mentioned short programs for community leaders.

The third task is to be the advisor to government policies directly to the Prime Minister or to the various Ministry. The center would of course entertain any top-down request after a critical academic assessment is made of the request.

Conclusion

When Alvin Toffler wrote his book 'Future Shock' twenty odd years ago, much of what he said about the social stresses of a society having to deal with change from a traditional mindset into another set of cultural norms. In Malaysia, the problem is not only about the future reaching the doors of the traditional society, there is the added burden of a multiracial dimension and an architectural vicious circle. In order to address the perceived social stresses in our Malaysian society, we must pool our resources of academic, professional, organizational and political frameworks. As there is many new social variables introduced in our community contexts, so must we follow suit

with the introduction of a new cultural catalyst. The function of the Center for Community Development and Architecture is to nurture this new catalyst to be released into the host environment whilst at the same time engage in efforts of restructuring the organizational and intellectual mindsets of our present society to accept this new element. Perhaps we would then clear the cobwebs over the half buried notion of a 'bangsa' Malaysia.

Proposal for a community Development Center by Afzan Yas from UTM

4

Crime and Housing in Malaysia: Rethinking the Planning of Community Buildings and Housing for a Changing Society

Introduction

The main purpose of this paper is to present a message that crime and housing are directly related to the changing lifestyles of Malaysians. In this paper I shall show how the present housing estates with respect to its planning of community buildings as well as its definition of those facilities are completely at odds to the real needs of today's society. In the first part of this paper, I will explain how I think Malaysia community has changed drastically from a homogeneous closely knit society to a heterogeneous one with different values and patterns of living. The second part of the paper presents arguments for changes in the definitions of community buildings such as mosques, community halls and playgrounds. I will introduce new building ideas and also innovate existing ones so as to be more in tune with today's lifestyles. In the third and final part of this paper I will present my own planning ideas of these community buildings in relation to the housing components of the estates in order to address the issue of crime. This paper presents my own personal reflections and experience as a family man living for twenty years in several housing estates and my analysis as a concerned Malaysian academic and as a trained architect.

The Issue: Crime and Our Housing Estates

It does not take a genius to understand the criminal mind bent on perpetrating crime in our housing estate. All the criminal need is a house which is isolated and 'lonely'. When a house sits in isolation from its immediate neighbors and prying eyes from the street, it is the perfect target. One would obviously think of a lone solitary bungalow up on a hill amongst a wide landscape of no man's land. But the ironic reality is the same condition can occur in a densely populated suburban terraced house in a housing estate of Malaysia. If one were to go to any middle class terraced house perhaps seven out of ten of them would be uninhabited between 9.00 am to 1 p.m. This is partly because the parents are out working whilst the children would be in schools. The 21st century salesman is unfortunate that if he or she knocks on the gates of the houses, the lady of the house who would answer is the 'amah' or a very fierce dog! The prosperity enjoyed by Malaysian under the Dasar Ekonomi Baru has resulted in more women having outside of the home careers. If one were to find these 'orang rumah' or home based wives and mothers, one must knock n the doors of the low cost housing flats where the traditional family organization of father working whilst mother stays home to cook and care for the children still exists. Though I do not have the statistics to prove it, I hypothesise that there are more break ins in middle class homes than they are in low cost homes. Of course one can argue that there are more jewellery and flat tvs in the middle class homes than in the low cost ones, but the fact remains that the flats and low cost homes have a permanent lived-in look rather than the 'abandoned-building' language of the middle class ones.

To add to this malaise, even if a break in occurs whilst the occupant is in the house, the massive party walls are designed in a manner that acoustically prevent anyone from helping or coming to the victim's aid. If I were a criminal in Malaysia, the housing estates are a heaven sent opportunity to a lifelong career of theft, robbery, rape and murder. I can hit any house I want during the day or at night. I can waylay a lady parking a car at night under her porch or just getting out before the dawn's early light. I can attack any female teenager left alone in the house to do the laundry while she dries ccin the back or front yard. I could even kidnap any child and demand ransom or do worse things simply because the streets are straight and no one neighbor would recognize me as a stranger lurking in their street area. I could also bring a huge lorry and break into a house and leisurely clean up the house as if I am the removal

company. In one strongly worded article to NST, I wrote that it is not a matter of 'if' that a crime will be committed onto you and your family members, it is but a matter of time when your turn will definitely come.

Weakness of Present Discourse on Solutions

The present discourse on solutions have centered primarily on the efficiency of the Police Force, the use of CCTV cameras and gated communities. I will present my personal views concerning these elements that is said to be able to combat crime.

The first concerns the Malaysian Police Force. I am afraid I have nothing commendable to say about our police force. At the time of this writing, there has been four Royal Commission to talk about the various abuses of trust and 'crimes' of the police force. As an intelligent Malaysian who has access to information never before available to the public before the internet age, we Malaysians are in a bad situation concerning our law enforcement agency. I have almost completely lost my faith in our police force. It pains me to say this because my late father was a policeman for forty years and I have lived in police barracks throughout the whole of my childhood. I do not recall or was too young to understand the state of the police force then but I do know that I tell my children never to trust any stranger and even a police officer. It is beyond the scope of this paper for me to fully defend my mistrust of the force but simply to say that I trust the security of my family to a RM30.00 per month security service more than I would those charged by the country to look after our safety. As an academic, I spend most of my time at home writing more than twenty books on architecture. During that time I do not see much efforts by the police force whether in their patrolling, literature production of leaflets or lectures to community to inspire any confidence. Basically, we Malaysians are on our own. I would like to say that I hope the present leadership of this country will perhaps change the police force but I think only a new and fresh government can do so.

With respect to the obvious scientific advantages of the CCTV system, its main drawback lies in a continuous power supply, money and a dedicated response from the police force. As I have a low opinion of the latter I think the point about CCTV is mute. Once I even heard that in Penang the CCTV was a hot item to steal as it has some ringgit value to it. Technology is of course heaven sent but with the proper attitude and will to support it.

Gated community concept is a nice idea to have if you are wealthy and can afford it. Although the drawback seems to be social interaction among people outside the communities will suffer such as during Hari Raya and similar occasions, I think it is a viable answer to the problem of crime. Of course the crimes committed by security officers in many rape cases point to the need of a more reliable personnel than the ones presently available. Thus at the present juncture, a gated community concept with a sophisticated CCTV system and a dedicated and reliable security crew is the best answer to 'imprison' us from the criminals at large. Of course the question here is, who is exactly now in prison?

In the following sections, I will labour to present a 'natural surveillance' system devoid of CCTVs and security guards. It is called 'living in a community'. It sounds sarcastic and it actually is because we Malaysians have forgotten to be a community in the 21st century. I will present both a political and an architectural solutions to the problem of crime and ousing in Malaysia.

The Mosque and Other Religious Buildings

I have built a career out of arguing that the mosque is better designed as a community development center rather than the white elephant that it is at the present. In my books and other writings I argued using religious sources interpreted within aan architectural-behavioral and philosophical framework that Islam defines the idea of a good individual in direct relationship to his community. I have outlined the responsibilities of the individual to the community as well as the community to the individual. The mosque is nothing but a manifestation of this relationship. However, personal agendas and simplistic 'traditionalisation' of the mosque has made it into an isolated building catering to set rituals only and not a viable community center. Once my wife was afraid to pray in a mosque during a journey because it was so desolate in between prayer times. If mosques were to be designed as a viable and lively community center for muslims and for non-mulsims, the idea of bringing together a community can occur and thus set up the concept of natural surveillance. The same can be said of other religious centers such as the Chinese and Indian Temples and the Church. Planning provisions and admissions must facilitate the growth of these centers and not hinder the from the petty perspectives of racism and other private agendas.

The Warungs

The warung or hawker stall is one of the most indispensable facility in the housing estate. With the spouses having careers, there is simply no time to cook meals and the warungs and the hawker stalls are faviurite targets for a quick and informal meal. I have seen municipalities setting up temporary and permanent structures for this function and I think this effort is commendable. However their centralized location should not be an obligatory act but it should be dispersed. A children playground should be incorporated into these stalls such as the ones shown by the Rest Areas by PLUS on the North-south highway. Warung seating should be more diverse and allow for creative landscaping furnitures and elements to present the stall as a meeting place and a leisure area for informal reading as well as conversation.

The Other Buildings

Because of the diverse living patterns of the Malaysian community due to their socio-economic and religious differences, there is a need to upgrade and invent new meeting places where these patterns of lives cross. For instance, the community members cross-patterns and meet at bus stands, LRT terminals and nasi lemak vendors. Where they meet to wait, there should be opportunity for the architect to enhance the meeting space such as interaction can occur while waiting. Thus the present bus stand ought to giveway to the new waiting culture of positive social interaction. The other place where the community members meet is the primary and secondary schools while waiting to pick up their children. I have witnessed many cars waiting by he road side with engine running because there is no parking as well as street furniture for waiting. The proper landscaping and design of lay-bys and front gate-fence of schools can provide quality time for parents to gossip about their children and find things in common. Thus, where the community meet, there is communication and surveillance.

Combating Crime with a New Planning Strategy in Housing

The simple idea of combating crime in our housing estate is to create 'natural surveillance'. This concept is suggested by behavioral scientist in order

to define such design ideas as defensible space and territoriality in architecture. What it essentially means is that a space is designed in a manner that buildings form a wall around it with the front windows facing it. This creates a defined territory which is surveyed by the 'eyes' of the windows. It was shown that strangers feel uneasy coming into such places if they intend any harm because the space is looked as somebody's territory or front yard when in essence it is a public space owned by the local municipality. If we can create a closely knit community with our political programs, and design housing estates to promote natural surveillance, we could look at a safer environment than what we have now. In this section I will outline four strategies of planning and design that would and should promote this idea of natural surveillance.

Decentralizing Community Buildings

In most housing estates in Malaysia, community buildings such as the mosque, the Dewan and the kindergarten is centralized in one location usually close to the big playing field. Developers and planners have understood that they have to 'give up' certain percentage of the land area for such facilities and they too find it convenient to lump it all in one location. Perhaps the original idea for such a design decision was to protect the privacy of the house owners as these were public places and houses are deemed private areas. Thirty or forty years ago, this idea might be valid but it is certainly not so since most of the middle class owners are not at home to watch over their property and children.

I propose that we decentralize such facilities and create more public facilities as I have outlines above. Each community building or structure must be made to be a sentinel to a group of houses. Let us imagine that instead of the present rows of terrace houses, we convert them all into U-shaped organizations with a small padang at the center. On such small padangs would be placed a single community building. Thirteen such community buildings can be community centers, sports hall, hawkers stall, mosque, Chinese Temple, Hindu Temple, church, groups of wakafs, playgrounds, basketball courts, roller blading rink, kindergartens and libraries. We could add schools which should be designed smaller and with shared playing fields. Shop-offices could be clustered into two or three core areas and contain functions of retail, health clinics, post offices and restaurants. We should also add to this list the police hut and Rukun Tetangga offices. With twenty such groups of buildings, it can be a sentinel to over 800 individual houses.

The low-cost flats are also excellent sentinels because the owners still retain a traditional based family unit of father-work and mother-home concept. The low cost flats should be clustered in a few groupings so that it would also stand guard over groups of bungalows, semi-detached units and terraced lots. This would eliminate the 'poor areas' as with the case of many housing estates nowadays.

Walking and Cycling Yourself to Health and Security

It is a common site nowadays to see middle aged and elderly couples walking or jogging at public parks and around the housing estates. No one cycles because there is no safe place to do it. The concern for health is paramount with the present life stresses and environmental pollution. The simplest way I have found to solve much of our physical, social, economic, environmental and spiritual health is through…walking! Just think about it for a minute. Everyone agrees that walking and jogging is a necessity of physical health. And when one jogs or walks the pace of life is slower and one can get to 'smell the roses' as well as greet the neighbours. This creates healthy social cohesion. Thirdly, when one walks to the shops and leave the car behind one is saving money on the high price of petrol as well as save tons of Carbon monoxide to pollute the environment. Spiritual health is about a good dose of community living with a dash of greenery and this can be gotten from a housing estate that plants trees for shading pedestrians. What about crime? If walking creates community interaction and the slow pace of life promotes street surveillance. Try to find walkers on our streets in the housing estates from 10.00 am to 4.00 pm. You may not find any. This is because the housing estates have no pedestrian paving, have no shady trees, no outdoor furniture, no comfort stations and the shops are too far to walk to. We can change all that simply by redistributing shops and community facilities with a linkage of pedestrianized circulation that has strategically placed wakafs, furnitures, and comfort stops. In Toyohashi, Japan, I saw people using a lot of bicycles to go shopping, to work, to schools and to the mall. The Japanese have allowed one third of their roadways for cycling equipped with guard rails. In Malaysia, walking and cycling are activities that invite sudden death by being hit by a car or lorry. If the housing is alive with people walking and cycling back and forth, would crime dare to intrude its ugly head? I think not.

The Back Alley: Use It or Loose It

From my research and observations as an architect living in the housing estate and not some million dollar bungalow up on a lonely hill somewhere, the back alley is a heaven for crime to occur. Recently, the developers or telekom (I'm not sure which) has provided a bonus for the Criminal Institution. This comes in the shape of a nice telephone pole conveniently located (with ladder-like features and everything!) a mere one meter from the rear room windows! The back alley is a great place for criminals because developers like to make the terrace rows long and lonely. Houses in the center of the rows are prime locations for crime because they are farthest from the busy side roads. Solution? Make the rows shorter in such a manner that anyone walking on the side road can actually recognize a person standing in the middle of the back alley at a farthest of about six houses away. Or, just get rid of the back alley. It does not have a shred of use in the present time. Unless, of course, the back alley is nicely landscaped and made into playgrounds for children and with proper seating a place for the remaining womenfolk to chit-chat. I have seen back alleys turned into badminton courts with privately sponsored cement paving. This should be encouraged instead of destroyed by some overzealous municipal officer. Liitle goreng pisang and burger stands ought to be allowed to proliferate as they are some of the best sentinels no money can buy. I feel sad that some municipal zealots forces centralization to what should be a natural and organic growth of commerce and community.

Rethinking the Vehicular Circulation

The bonus to criminals in our housing estates is the efficient vehicular circulation. The housing estates are made for cars and not pedestrian or cyclist friendly. There are grids of straight, smooth and wide roads for gateway cars and vans. In my article about safety in New Straits Times I suggested that this grid iron planning is murderous to children. I explained how in one of my housing projects, I designed a cross-free circulation system for children. The idea of using humps to slow down traffic is certainly inconvenient to drivers and puts a dent in the petrol ringgit and not to mention a few exhaust pipes. Unfortunately, when I put humps on the street in front of my house the municipality came and tore it up as well as the other twenty illegal humps put up by house owners. The reason was because we did not sought permission. Now the traffic in front of my house is as

fast as in the original condition and is a danger to my children as well as a facility for the criminals getting away. We must do away with the grid iron planning, have more humps and also create new ways to slow traffic down. Natural surveillance could not work if criminals find it easy to slip in and out very fast.

Conclusion

Solving the problem of crime in our housing estates need not require years and much money. It is simply a question of intelligence and will power. We have the brilliant designers. We have the researches. We also have the designs. What we lack is political will and intelligence. Our community has changed and we fail to recognize that. Our planning policies are outdated and we have been enforcing the wrong guidelines. The small political will required is simply to admit the changing lifestyles and reprogram the communities. The political will is also needed to shape up the police force as well as write up new planning policies particularly those related to the types of community facilities, planning of these buildings, the back alley and the vehicular circulation. It is either we shape our design to suit our new cultural needs and concerns or we let the design dictate the way we live as reflected in the gated community which to my id is nothing more than a prison for the wrong individual.

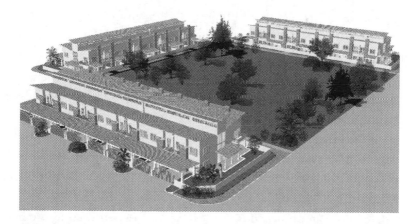

A U-shaped cluster of terrace houses that affords natural surveillance rather than the normal rows of grid. (Design by Nur Liyana, UTM)

5

Crime and Housing: Just Wait for Your Turn.....

Introduction

No statistics is actually required in this matter. Just talk to a few of your neighbours and ask them whose house was broken in quite recently. They would be only too happy to recount about so and so was tied up with his family and robbed so many thousands of Ringgit worth or worse so and so was stabbed in the wee hours of the morning for putting up a fight with criminals who so much as gave a meaningful look towards his daughters. I keep a variety of weapons handy in my bedroom and my daughters's too. I also devised a means of escape or get the hand phones close to me in case of a break in. Heck I even keep a few thousand Ringgit in my bedroom just in case I fail to protect my family and I would have to bargain for my family's life. You see, in an academics' house there are only books and yet more books. We don't have any jewelry worth a respected robbers time of day...or night. I also give strict orders to my teenage daughters to lock and bolt down their doors (with specially devised bolting system). My eldest has this habit of taking a siesta after maghrib prayers and she would many times wake up in the middle of the night for the Isya prayers. I gave her a severe talking to and demonstrated to her what a robber would do to her and the rest of the family when they find her sleeping in an unlocked room. I live in a five bedroom house but my six, nine and eleven year old sleep with my wife and I in our master bedroom. I do not feel safe letting them sleep on their own. So there you have it, dear

readers, we basically live 'under siege' in our own house. In the thousands of housing estates in Malaysia, we are virtually in prisons when witching hours peek into our rooms.

We're on our own...

Forget about the police force in Malaysia, they are of little help in this matter. Instead of publishing the statistics on how and when a break-in occurs in nice little booklets or pamphlets, the police would usually use the ...'oh we are so few in number' excuse (except of course when there's a big wig event or there's an opposition's ceramah going on!). I have also yet to remember a time when I listen to a ceramah whether at a mosque, school or the Community Hall on how we might prevent crime in our neighbourhood by Mr. Policeman himself. I'm still waiting for someone in the police force with a slightly higher IQ to initiate a national research on crime in housing. When I told my Topical Study students to get some information from the police on crime and housing, it was a no show. They practically read the OSA act! It was only when a senior student who had a good friend in the force that we were able to get a peek at some of the reports and thus piece together the criminal mind so that the input would go into the design concept. And what of the mass media? No weekly columns exists as yet on Crime Watch or even a TV series to educate the public that they should not leave their doors unlocked in the day or night time. Robberies and other heinous crimes have been known to occur in the middle of the day as well as at night. Lets face it, in a yuppy world where both husband and wife go to work and leave the house deserted in the day time, it seemed more logical to 'do the house' during that time. No, dear readers, we're in this rocky boat all by ourselves. As the saying goes...rumah kita, tanggungjawab kita!

From my research and observations as a poor architect living in the housing estate and not some million dollar bungalow up on a lonely hill somewhere, the back alley is a heaven for crime to occur. Recently, the developers or Telekom (I'm not sure which) has provided a bonus for the Criminal Institution. This comes in the shape of a nice telephone pole conveniently located (with ladder-like features and everything!) a mere one meter from the rear room windows! How wonderful! An Associate Professor friend of mine went through all the trouble of getting signatures and writing to his Wakil Rakyat to complain

about this situation. I told him that it was a praise worthy thing that he did as the Melayu Baru but unfortunately I don't think he was going to get any respond in the Melayu Lama government....no, not even this close to a national election time! The back alley is a fun place for criminals because developers like to make the terrace rows long and lonely. Houses in the center of the rows are prime locations for crime because they are farthest from the busy side roads. Solution? Make the rows shorter in such a manner that anyone walking on the side road can actually recognize a person standing in the middle of the back alley at a farthest of about six houses away. Or, just get rid of the back alley. It does not have a shred of use in the present time.

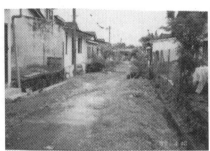

Melayu Lama government....no, not even this close to a national election time! The back alley is a fun place for criminals because developers like to make the terrace rows long and lonely

Some simple suggestions

The roof construction is something of a joke in terms of safety from crime in Malaysian housing scenario. Simply push the roof tiles, karate chop a single timber batten and you're in. Of course you don't need to do and karate chopping if you have an extremely thin accomplice. After that it is simply a simple matter of locating a ceiling trap door or breaking the thin asbestos ceiling piece. It is a sad time for the criminal who finds a roof or ceiling which has been nailed with quarter inch plywood or pieces of metal sheets. I spent RM4,000.00 putting up the plywood ceiling in order to sleep better.

Window openings are also something of an irony in this country. Architects, building authorities and developers know that it is illegal to put up iron

grillwork on openings as they are a fire risk. But tell me which house does not have a window that is not 'grilled'? There is little research encouraged on door and window frames with respect to crime. There is very little point in having an alarm system that activates whilst the criminal was already in the house. The problem here is the common sense of window sizing and placement. Openings for lighting can be made small and numerous so that it is safe from break ins. Openings for viewing purposes should not be placed where there is least eyes on the streets situation. Our opening designs in housing are so standardized that I don't see the point of a six year architecture education at UTM!

The present idea of zoning is also a culprit. Putting the rich with the rich and the poor in another zone by themselves creates a social engineering that puts the rich whose lifestyle see both parents working in the daytime. Of course they can all have security guards patrolling the area. I once paid RM30.00 to a private security company to patrol my house five times each night. Just what I always wanted, a private security guard for my safety.

Conclusion

It is ironic that in the modern age where we can technologically design a housing for great multitudes of people but we manage to be alone under siege in the same development. Crime in housing can be prevented if the houses are designed with it in mind, with the police being actually concerned about helping to educate the public, and some common sense principle that would keep crime at bay. Until then, just wait your turn….

6

Housing and School Design to avoid the Nurin Tragedy

The Nurin Jazlin rape, abduction and murder has shocked and shook a sleepy nation. It shocked even a seasoned father of five and a person who has written about architecture and crime and children safety. However, I have mainly concentrated issues on safety from being run over by vehicles and with respect to crime, I have mentioned strategies on preventing break-ins. In this article I will explain to the Malaysian public how our housing and school design have as much to be blamed for the deaths, kidnapping and mutilation of our precious children. It is up to the relevant ministries to take up my suggestions because developers, professionals and local authorities, I find, are 'a bit slow' in taking action.

Let us take up the subject of planning the housing estates which are safer for our children. The technique or design strategy is actually very simple; provide design with 'eyes on the street' and provide 'defensible space'. To many Malaysians these two phrases are alien and I will walk you through them. The phrase 'eyes on the street' simply refers to the concept of natural surveillance. If the CCTV serves as an 'unnatural surveillance', then in architecture, buildings and spaces are arranged in such a way that there is a constant presence or perception of presence of people along the path taken by our children. For instance, how is the path of our children to the playground, to the schools and to the shops? If these paths are placed in a manner that they are 'lonely' in the sense that there are no community facilities that over look them, then these path are danger zones for kidnappings. Once upon a time, the three

paths would take the children beside rows and rows of terrace houses which would be excellent eyes on the street but today, the terrace houses are totally 'blind' because of the two parents being at work and the houses are sealed for air-conditioning! The solution? Design better ventilated houses (and there are so.. many ways to do it) so that the windows are open to hear screams and even views clearer than the tinted casement glass. I simply do not know where Malaysian architects get their education from when simple rules on properly ventilated houses with properly designed serambi or verandah ought to be a piece of cake to do. I can sketch 3 schemes under five minutes. We should also have pedestrianized paths with intermittent 'bus stop' shelters and street furniture along the way.

Next are the community buildings. At the moment, we have the mosque, the Dewan Serbaguna, the food court and the kindergarten. For the mosque, I would firstly tear down all the masonry fences that keeps the prayer space hidden from the public. I am very sure that if the Prophet Muhammad were alive he would probably ask 'is the mosque only for Muslims?' How on earth is non-Muslim ever going to understand Islam if mosques are kept well hidden from the public's eye. So silly and so selfish. The true mosque should not even have fences. Of course the Malay community will cry 'what about the dogs?' I will then say … so what? The last time I checked the dog was also Allah's creature and kindness to one by a prostitute earned her place in paradise. Check the hadith, please. The point is, the mosque building always have a metal grille door at the serambi and you simply close this without locking it to prevent dogs, pigs, (cats seem to be ok), cows and goats from entering. We should also equip the mosque with a teh tarik stall, a shop and some playground equipments to make it a lively place and not like a tomb during off –prayer times. So the lesson here for designers, please design mosques in a friendlier manner which afford it as one of the 'eyes on the street'.

Then there is the Dewan Serbaguna. I would like to tell the Ministry in charge of this facility to throw this building on the 'over due date' pile. It is a useless piece of architecture because of its design and management aspect. We, the modern Malaysian society' should demand a Community Center with a proper paid management ever present at the center. Is it too much to ask from a country with an oil revenue of 70 billion a year? The community center should be designed without a fence. It should have a bustling cafeteria, a nice reading room or children library. It should have a newspaper rack for the pensioners

to sit in an open serambi while ordering a nice cup of kopi-o. Get the picture? Add a sundry shop and you have a very strong eye on the street!

The planners of housing estate should also disperse all the community facilities and not lump them in one place. Yes, I understand zoning laws and privacy considerations but your laws are outdated, sir. There is virtually no one in the terrace houses between 8 am to 6 pm and therefore there is no privacy to violate. If we can imagine the mosque with a 360 degree 'eye', it can 'jaga' 100 terrace houses on its four sides. The Community Center can take care of another 100 whilst the food court taking up the other 100. The next 100 houses shall be guarded by the playground with the burger stand next to it. This surveillance will not happen if we lump all the facilities in one area. So gentleman of the planning profession, please disperse the community facilities.

Defensible space means that the house owners can territorialise the outside space to be their own. They will then guard it preciously and any stranger would fear stepping into any of these territories. How to do it? Simple. Don't design terrace houses with rows and rows of blocks fronting a vehicular street. A group of 45 terrace houses can be turned nto a 'U-shaped' configuration and made to front the community facilities like the mosque or Community Center. The U-shaped affords a fortress-like environment and will be the 45 strong 'serambi'. Add sittings, play space, paved areas and a concrete slab for aerobic dancing, and you have a perfect 'guarded territory'. Itu macam saja... so easy-lah! But if we keep making rows and rows of houses with the isolated back alleys, we will perpetuate the unsafe practices forever and ever.

Now, we will move on to those housing flats we call home, which I refer to simply as 'pigeon holes'. The University of Wisconsin School of Architecture thought me that, over three stories high, the sense of territoriality among a neighbourhood is lost. This is because at the fourth floor, we can no longer recognize faces and it is too far to shout comfortably a greeting to a friend. We should also try designing flats with intermittent play spaces on every floor so that the toddlers won't have to go down to the ground to play. I mean, which mother has time to go down to the ground floor in the mornings with the house chores on hand?

Let us now tackle the school design. The most important part of design against kidnappings is simply the front area of the school where the children have to wait for their transport. I would design nice waiting spaces, the library and the canteen next to the fence where the children are waiting. While waiting,

the children can do their homework or read at the library while waiting for papa and mama to pick them up. I would also design the headmasters' office and administrative space with large windows directly overlooking the waiting areas. As for standard One pupils, I think the ministry must insist their class teachers to be present while these children are waiting until all of them leave. No excuses! The British can do it and so why can't we?

Lastly, we can now resort to the CCTV cameras planted strategically at our U- shaped neighbourhoods. By using a slowly revolving camera system, you would only need one per 100 resident to sweep the streets as designed in the manner described.

Finally, there is of course no excuse for those parents who simply let their little ones go to school and shops alone. As a father, I cannot understand how can there be such unconcerned parents. Even with the best architectural design, as parents we must be ever vigilant where the safety of our children are concern. For my children's sake I hope that we change out ways of designing and planning houses so that their children would not have to go through the horrors of our kidnapped victims.

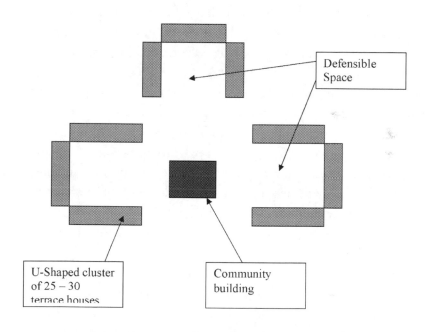

Diagram of a neighbourhood

7

Growing Up and Growing Old with the House

Modern house designs caters to this simplistic scenario; when you are married you would buy a two bedroom house, when you have one or two children you would get a three bedroom house and then when you have more children, you would buy a double storey terrace house with five bedrooms and three bathrooms. And then you would have finally found your paradise. This beautiful scenario takes several simple assumptions. Firstly, it assumes that the housing market is always so good that you could dispose your house with a snap of your fingers. Next it assumes that the couple and the family care not at all about the building of a sedentary community and the importance of good neighborhood rapport. And finally, it assumes that everyone will die at the age of 40 and not grow weak at the old age of 60 or 70. Let us look at a traditional Malay house of old in a culture that is slowly disappearing.

In the traditional culture a married couple would stay with the parents until they get their own house in the form of one unit of the parent's dwelling. This unit is usually the kitchen unit which then goes on to become the new Rumah Ibu. As the couple prosper and have some children, they would add on a new kitchen unit and later on the Anjung which is the equivalent of the living space where the menfolk would gather for khenduris and such. After that more units would be added as the need arises. Thus the cycle of marriage, raising children and growing old with one family of the children taking care of the elders is repeated. The architecture of the house is said to grow organically with the family. The community in the village stays intact and stronger as

newer members are added because there is no immediate need to move to a bigger house. Not so with the modern housing estates. It is designed as a finished product. You either get a two bedroom or a five bedroom house and the municipality would frown upon any renovations that would change the house to a bigger one. So most modern house dwellers defy the by-laws that was made to ensure safety but not drafted within the organic growth of the family.

If I were designing for the organic growth of the modern terrace living unit this is what I would propose. Within the confines of the 20 foot by 65 foot minimum lot I can do many things. There are two ways that growth can occur. The unit can grow horizontally or vertically. For a horizontal growth, I would offer a three bedroom unit designed as thus (and I have already done this on paper). Firstly, I would propose a 20 foot by 25 foot double storey plan that would fit in a living room, kitchen, bathroom, dining space and stairway. The second storey would comprise of three 12 foot by 10 foot rooms with a small toilet in the master bedroom. The roof would have a single inclined elevation with the lower end at the front façade and higher at the other side in order to incorporate clerestory lighting. This lighting is necessary as it would serve as light windows for one of the rooms when extension occurs. The expansion of the house can occur in two stages. For the first stage, a 20 foot by 20 foot unit will be added at the back of the house. In order to make this feasible, as a developer, I would include costing for pilings and footings ready made at the four corners of this proposed extension. When a house owner buys a unit, he or she is told of the four piled footing ready for extension. It is not possible to bring in the huge piling machine once the housing development is completed. The next stage of extension calls for a second storey unit to be built above the added one with a roof inclined to the back and lower than the existing one which then produces the famous jack roof idea that permits lighting at the center of the house.

A second expansion strategy is to build vertically. There are two ways of vertical expansion. The easier one affords only a 50% extension and can add three more rooms. It is to firstly design a core unit of three bedroom with a steep jack-roof with side lit windows. Extension then occurs at the middle portion of the house once the ceiling is peeled away. Light steel trusses and channels or timber floor joists would speed up work immensely but the owner can also opt for reinforced concrete floor. For a reinforced concrete floor, the developer should get the engineer to add a few more tons to the four piled footings of the

central part of the house. The other vertical option for expansion is a 100% built up of the second floor. For this option, all the footings must be designed to carry the added loads and that the roof joist should be of light weight steel that can be dismantled and used again when the second floor is built.

Forty years of housing estates with almost 100% extensions by owners ought to teach the architects, developers and municipalities that one fact remains clear. Families grow. People age and want their children to care for them. If well designed, the expansion of the house can fit in two families even with two separate kitchens so that the children's family can have their privacy while the elderly can still retain their way of life and privacy with the easy thought of their children to help them and that they are just a storey away. The architectural identity of a society can clearly be discerned if houses are designed not with colonial motifs or Minangkabau roofs but with the organic growth needs of the user. Simple, efficient and functionally beautiful. The essence of any architectural masterpieces is simply thus…build according to life and not force life over sheltered boxes. The expansion house concept is a simple reality and can effortlessly be done to save thousands of hacking costs and illegal summons. Let the house grow, and the community will prosper. Any takers?

8

The JKR Police Barracks: Lessons for Regionalism

Introduction

This essay is an appraisal of one of the most successful 'machine a habitae' in the context of Malaysia's own brand of modernistic architecture. In the early days of modernism with Corbusien purism and Miesien structuralism the Wrightian streak of 'organic architecture' took a back seat and only surfaced half a century later when the mantra of 'universalism, globalisation and standardisation' were fated to be viewed as failures against the onslaught of rising nationalistic spirit, religio-cultural revivalism and ecological agenda. The almost forgotten hero returned to the throne and crowned with a new name...regionalism. The JKR Police barrack which I had stayed in for 8 years in my boyhood speaks volumes of lessons on climatic control as well as an architecture well suited for a modern middle class Malaysian. As these words are written, I have just returned from the Police Barracks in Butterworth and Taiping where dozens of these slabs stand idle, derelict and ready to be demolished. I have absolutely no doubt that they will be replaced by the many sorry excuse for housing flats that now litter the country designed by architects who see fit to call themselves 'professionals' but who in reality are no more than illiterate contractors.

The JKR Police barrack

Building Description

My family and I have lived in several types of police quarters and the only one I remember is the four storied walk up flats with two stair cores and single loaded external corridors. The ground floor has no living units but contain an 8 foot by six foot locked storage space for every house unit and interrupted only by openings for parking. The main structural frame is reinforced concrete but the external walls are 70% timber with hollow concrete blocks making up the rest of it. The rectangular floor plan comprises of two bedrooms on one side of the central circulation space with the living room, kitchen and back verandah making up the other side. The bathroom is adjacent to the kitchen whilst the w.c. can be accessed through the back verandah. The internal partitions separating the kitchen and the living room is of concrete block but the wall separating the two adjacent bedrooms are in fact timber closets with an eight inch gap to the top of the r.c. ceiling slab. The front external wall is made of three kinds of timber panels. The first type of wall panel is of fixed translucent glass and a plywood paneling. The second type is the same wood paneling with louvered glass window panes. The third type is a full length timber louvered panel which stops about a foot from the ceiling to allow timber grills running the full length of the external wall stopping only at the concrete block wall. The kitchen is also equipped with a built in chimney flue that traverse through all the units above.

Lessons on Thermal Comfort

I grew up in the police barracks but I have also stayed at our 'wonderful' low cost flats in Subang Jaya when I landed my first job and having to feed a wife and an infant daughter in the '87 recession period. There is a great difference in the two experiences and it is only now that I could reflect on all the architectural theories on thermal comfort that I have understood.

The first rule in thermal comfort design in a terraced unit or a high rise one is simply to let in cross ventilation. The Police barrack is excellent in this regard since it has ventilation fins running at the top of the two external walls. Then there is the advantage of having the full panel louvered wall to allow more body level ventilation especially for a culture that half of the times sits on the floor. The gap between the internal 'wall' and the ceiling in the two bedrooms facilitate the air movement nicely. The chimney flue perhaps added to the lowering of inside air pressure and may function just like an air-well.

The Police barrack is excellent in this regard since it has ventilation fins running at the top of the two external walls.

The other rule about thermal comfort is to reduce as much masonry as possible in order to reduce the storing of heat in the walls which becomes radiators at night due to the phenomena of heat-lag. The use of timber walls and timber closets as spatial dividers contribute to a reduction of almost fifty percent of potential heat storage architectural elements.

Now try to compare these thermal comfort lessons to the present low cost flats and medium cost apartments designed nowadays. There is full masonry usage and nowhere for the air to get in unless one opens the sliding window panes. And even when the air reluctantly enters, where is it going to go if it is stopped dead in the bedroom, living room and kitchen since there is no pressure difference and air way openings. Well, of course, how stupid of me not to know the obvious answer to the contemporary design of flats...just use the air conditioning units! Wonderful. Did it really take six years to train architects to be that ...er...enlightened?

Cultural Lessons

Eight persons living in a small two bedroom apartments in a 'prosperous' and 'peaceful' Malaysia boasting the palatial grandeur of Putrajaya is actually nothing much to be happy about. However, this particular police barrack has one small and simple item that is almost entirely and absolutely 'non-existent' in any of the contemporary apartment design. A ground floor storage room for each unit! Incredible! Fantastic! Extraordinary thinking! Eh? You don't think that is something earth shattering? What degree did you take? Basket Weaving with a minor in architecture? The storage units are for bicycles you fool! Did you know that papa and mama usually have little hobbits called children who usually cries for four or five bicycles per family. And of course there was Papa's Vespa or Honda Cup. Still unconvinced, Mr. Architect? OK, try this on for size. Would Mr. Architect and Madam Designer please carry four bicycles all the way to the fourth floor. Or can you imagine maneuvering up a stair way littered with BMX's chained to the railings amidst the flower pots and rocking chairs?

Our storage room had three important functions as I remember it as a child. It was where I kept the family's one and only bicycle and one and only Vespa. My father could only afford a bicycle when I was thirteen and I was lucky enough to have it since my brothers and sisters never had a chance

(because they were older and grew up when my father drew RM15.00 a month salary. Yes! RM15.00!). The second important function was that the storage area was where my eldest brother slept if he incurred the wrath of my father and an extended period of disappearance was called for. Finally, it was the sleeping place of my first cat, Even, when it became sick and died a few months after seven years of human age.

For the life of me I can never understand how architects and developers fail to understand the needs of their users in relation to storing children bicycles. Bicycles may not seem much in the great scheme of Putrajaya but it is an element that reflects the various rite of passage from children to teenagers. The example of the cat and of my brother presents various other 'rites of passages' that were never sensitively considered in our housing as mere shelter concept.

I wish to add on the presence of the long external corridor in the police barrack. This element is going out of style and is rapidly replaced by living units clustered around a common landing of a stairway. There are several advantages of the external corridor. Firstly, there is greater acoustic privacy since the front wall opens out and not in front of a neighbor's as in the clustered typology. Secondly, there are good lighting and ventilation opportunities in the open corridor concept than the closed landing one. Thirdly, the corridor serves as a good play space for roller skating, and tri-cycling for toddlers. There is hardly any room to play chase or rollerblading in the clustered concept. I remember having picnics, playing police and thieves and the usual toy soldiers and paratroopers. There is certainly much room for improving the JKR concept to include privacy from the small width of the corridor that overlooks into the living rooms of the unit. One simply needs to lower the corridor by half a meter and the problem is solved. There is also the question of children safety with regards to the railings and a simple gutter system, planter box, or cantilevered sun shading grilles could save children from falling to their death.

Conclusion

I have never believed in the conservation of objects, especially architecture. Real acts of conservation must be about the ecology and religious values. If the architecture fits the two agenda, than conservation of objects and buildings, cities and complexes can come within the preview of adaptive reuse or, in the case of the JKR police barrack, a development into improving the idea. But

the sad case of present 'professionalism' and 'education' creates serious doubts about our intellectual heritage in architecture. When such buildings like the National Mosque are ignored for the imperialistic garb of domed mosques, Democratic Parliamentary gestures rejected for petty Chateau Feudalism and a breathing machine of the JKR Police Barrack are left to be replaced with an all masonry and stuffy apartments, I accuse the architects in practice as unprofessional at best and 'prostitutional' at worst. May the next generation be free from their immediate principals of production operators and may God bless them with a new corp of visionary leaders of the built environment

9

Policy Paper on Housing in Malaysia: Creating Safer Designs for Children and Crime, Accommodative Approach for the Old and Infirm and Fostering Intra-Racial Relations

1.0 Introduction

The following essay is a short description of what ails the Malaysian housing estates at the present time. The issues raised have been condensed from my various writing that have been published in The Star newspaper, the Architecture Malaysia magazine, seminar papers and have been compiled into two main books which are 'Housing Crisis in Malaysia: Back to a Humanistic Agenda' (Penerbit UTM, 2007) and 'Malaysian Architecture: Crisis Within' (Utusan Publications and Distributors, 2005). The design strategies in the following essay has been tried out as academic exercises in the author's undergraduate thesis panel as well as the studio design of the third and fourth years at Universiti Teknologi Malaysia. The essay serves as a starting point of a more concerned attitude about developing communities through housing planning and design and not to make housing a mere shelter or just as a commodity investment product.

2.0 Children Safety

There are three dangerous aspects of children safety in our housing development. The first is the death of many children from falling off flats and high rises from corridors and windows. The second death is from being run over by cars and vehicles while walking to school and to the playground. The third is the frightening aspect of children being kidnapped off the streets in broad daylight.

The policies of housing that must be developed are as follows:

All high rise or flats over three stories must indicate safety features to prevent children from falling off in the design of the corridors and windows. Some simple solutions are to provide a minimum of three feet of extended floor slabs or a trellis system that can act as sun shading device and for drying clothes. If these conditions are not met, then designs must exhibit how children can be safe from falling off the windows, balconies and corridors.

To prevent injury and death from car accidents, the planning of housing estates must ensure that children have a cross free pathway to the school and playground. The developers must demonstrate that a child of 12 years and less can walk to school without crossing a single road. Failing to do this design, the developers must demonstrate that there are adequate bridge crossings, traffic lights, humps and other manners in which it will be safe for children to walk.

The housing developer must demonstrate there the paths which children normally takes to walk to school, playground and to the shops are not isolated from street surveillance. This can be done by the proper planning of community facilities, kiosks, and other structures overlooking the streets. There must be a reorganization of house layouts in neighbourhood clusters, resiting community buildings and rescaling of school to fit the minimum 15 minute walking distance. It is also

encouraged that all house types must demonstrate a usable 'serambi' (not a car porch) in front with full visual access to the street.

Death from falling off corridors and windows in flats

A children-traffic-free environment designed by the author

3.0 Old and Infirm

High rises and landed properties in housing estates give very little considerations to the old and infirm. With an increasing ageing population and the rise of such conditions of strokes and knee ailments at an early age, there are many residents who are virtually trapped in their own dwellings. Residents of walk up apartment on upper floors find great difficulty to climb up and down the many stairs. The policies with regards to the old and infirm should be as follows:

Walk-up flats and high rises must be equipped with at least a single lift with a minimum of a two person capacity. This lift is meant only for the old and infirm. The needy occupants will be issued smart cards that would enable the lift or the lift

52 MOHD TAJUDDIN MOHD RASDI

lobby to admit passage. Healthy residents are not allowed to access the lift with the exception of those who are pushing the wheel chairs.

All landed properties with two or three stories terrace houses must include a single bedroom on the ground floor to make the accessibility to the old and infirm possible.

All landed properties of housing should indicate a ready made space for a personal lift to be installed.

4.0 Avoiding Privacy Violations

In a multi-racial country like Malaysia, it is important to understand and respect each other's customs, rituals and belief systems. Unfortunately, the design of flats r high rises as well as terrace housing in Malaysia show total lack of considerations for avoiding privacy violations pertaining to rituals and cultural values. The most obvious violation is the visual violation of the back to back windows in the rear alley. The twenty foot distance in between windows affords privacy violations of sight as well as smell. Muslims who must observe the 'aurat rule' find much difficulty in this case. The smell of cooking would permeate through he opposite or adjacent house thus causing racial tensions. Privacy of sight also occurs during the clothes drying ritual in the early morning or afternoon. The placement of blocks of flats adjacent to each other with a mere 50 feet separating them is also something of a violations in relation to sight. The violation of smell comes from the burning of incense by the Indians or joss sticks by the Chinese would allow smoke to permeate to the next door neighbour. The idling of cars also contributes toxic fumes to the adjacent house which has the porch are covered. The policies which must be institute with regards to these kinds of violations are:

Terrace housing layout can be replaced by cluster type housing to avoid any presence of back alleys.

If back alleys are unavoidable, then the design of windows and fenestrations must be so that there is no visual intrusion but adequate lighting.

The use of 'chimney stacks' to draw off smoke from cooking and ritual burning of incense or joss sticks should be incorporated into ceiling designs.

For flats and high rises, the use of cluster apartments over a stair core should be replaced with an external corridor with access directly from the stair core. No occupant should be made to pass by another apartment in order to get to their own.

5.0 Basic Rituals and Needs

There are a few basic needs that are still not met by apartments in Malaysia.

Gender Space

The design of two bedroom apartments for family members must be done away with and replaced with a minimum of three bedroom. This is to cater to the gender need of female and male children in the family so as not to disrupt the cultural values of our people.

Drying

There is inadequate dying space given to the apartments nowadays. A back *serambi* of 30 square feet should be considered. Front corridors can also be made into drying areas with the proper balustrade designs and extended floor slabs to capture the water drips. The use of the *kolong* or open ground floor is possible for the first and second floor occupants. The use of the roof as an extra drying space for the third and fourth floor could also be possible.

No drying space and serambi for flowers

Storage

There is inadequate storage space in our apartment save the JKR police barrack. In the excellently designed police barracks of old, each apartment unit comes with a 6 foot by eight foot storage space on the ground floor in an open ground plan. This storage facility is excellent for motorcycles, children bicycles and other things. Storage facility should be a must for walk up high rise design.

Thermal Comfort

There is poor thermal comfort in present flat design with all masonry walls with little fenestrations. The design of the JKR police barrack must be emulated with its use of timber walls over reinforced concrete structural frame, generous fenestration in its louvered wall and ribbon fins as well as gaps in walls of rooms to let air flow possible.

6.0 Growth and Expansion

Family growth is a normal part of the idea in nurturing a community. In the traditional times, the architecture of the house caters to this growth with endless expansions and enlargements of houses. This leads to a more stable community in any settlement. However, modern houses in the housing estate are designed as 'finished' products and hence growth as never considered. The capitalistic idea was that if your family outgrows the house, you would have to vacate the premise and buy a bigger house. Although this generate income to developers, it spells disaster to community brotherhood. Modern societies tend to be housed by isolated families devoid of the spirit of the 'kampung' community. The State policy on housing should encourage the idea of living in a particular community for a long period of time.

> Allow designs that would easily accommodate a 100 percent expansion. That means if the current house is 500 sq. meter then it should be allowed time enough mature into a 1000 sq. meter., then it should not be allowed to expand another 500 square meters.

> The municipality should allow the view that there are taller and fatter houses than the ones he is looking to exhibit.

> Column calculations should include a second floor expansion.

> The roof should be allowed to be used in order to control the height of the building.

7.0 Racial Harmony and Interaction

Building Racial Harmony and Community Interaction through Planning and Design is important for any country so as to have racial harmony through interaction of the various members of the community. By having community interaction mutual understanding and tolerance of rituals and belief system will materialize. The problem with Malaysian housing is that firstly, there is limited outside spaces to linger and sit and secondly, the community buildings

display a lack of sensitivity to public and people orinted architecture. From the planning perspective, there are very few public furniture like benches to wait for school busses, park furniture, pavilions, *wakaf* huts and shady trees to encourage people to leave their houses and come out into the open air. There is hardly a sidewalk and places to stop and snack or rest. The community buildings such as the mosque and Dewan Serbaguna are fenced up in an unfriendly manner. There are hardly any other community related facilities.

Provide public seatings for 10 percent of the population at the side walks, parks, playgrounds and open air cafes.

Provide safe vehicular free environment for walking, jogging and aerobic dancing.

Encourage the setting of many kiosks or mini architecture for people to congregate around.

Provide various community buildings like temples, churches and mosques and design these buildings so that other people can access them.

Design Community Halls or Branch Libraries and Market Places in an open and friendly manner whilst encouraging other facilities to be set up like club houses, Rukun Tetangga offices, family restaurants and many others.

Plan houses in horse-shoe or U-shaped configuration with no more than 30 units per cluster of neighbourhood.

Create terrace clusters of Muslim and non-Muslim entities in blocks of ten units in order to avoid privacy violations and encourage interaction with common rituals and values.

Create public spaces in Shopping Malls for people to linger and sit. Provide 20% gross area for public spaces.

Unfriendly Community Hall with gates and industrial like architecture

A generous bicycle path provided by the Toyohashi Municipality

8.0 Crime in Housing

Crime basically occurs in housing estates which have the following features:

- A centralized community area
- Isolated streets with terrace housing of middle income to high income grouping

- A smooth escape route of grid –iron streets
- Existence of the isolated back alleys
- Commercial and residential areas that are isolated from one another
- Few community or public amenities and furniture
- A non-pedestrianized street
- A fenced up community building design

All of the above features makes community presence during the day and night to be completely scarce. The simple objective of planning for safety is to put lots of 'eyes on the street' or street surveillance. By creating houses that have 'eyes on the street' and by creating facilities that would encourage people to come out of their houses and mix and mingle with others, there would be less crime perpetrated. Thus the policies with respect to crime should be as follows:

> Houses should be designed with a front 'serambi' or verandah for people to view the streets in front.

> Fences should not be too visually closed up on all houses and community or public facilities

> Streets should be paved and pedestrianized with many public furniture for seating.

> Terrace houses should be designed in U-shaped planning format with no more than 30 houses per cluster.

> There should be many community buildings such as mosques, hawker stalls, kindergartens, branch libraries, badminton courts, basket ball courts, kiosks, newsstands pavilions and others spread out and not centralized in an area.

> All community buildings should be designed with their fences that affords seating and not be visually unobtrusive but porous on to the streets.

House owners should be given permission to open small shops in their premises such as barber shop, food stall, tuition classes, sundry shop, Laundromat and similar commercial activities that do not intrude too much on the acoustic and visual privacy of other residents.

9.0 Conclusion

It is hoped that the following brief description of policies may provide a starting idea to make Malaysian mass housing be more humane and culturally responsive in our socio-political contexts. There are of course many more policies that might touch on energy saving measures and such issues but the above policies, if implemented' would provide the basis for a sustainable community in Malaysia. All the policies mentioned above are completely 'do-able' and requires a concerned p arty to see them through. The developers must target safety and social health as their main selling points whilst the authorities must spear head visionary decisions that would help communities come together for our greater good.

10

The Vertical Kampung

OVER the past year, I have pointed out the problems besetting typical housing designs in Malaysia, and how bad design is destroying social harmony in residential developments.

In this final column for 2008, I wish to present an architectural solution to some of those problems.

In this semester's Year Three work at Universiti Teknologi Malaysia, I challenged students to re-engineer the designs of our terrace typology, housing estate typology, and walk-up apartment typology. Due to space constraints, I will concentrate on the last typology only, using one of my students' designs to introduce the vertical kampung concept.

This concept will, hopefully, change mindsets that think it's impossible to build comfortable, low density, medium-rise housing that is affordable.

The traditional way

Consider the social and architectural scenario in a kampung.

Before you see Pak Mat and his family in his traditional timber house, you would have to walk across the *laman* or front yard. You would then stand at the bottom of the steps, the *rumah tangga*, leading up to his house and pronounce your greeting.

Pak Mat would greet you from his *serambi* or verandah, and invite you to sit there. If you are a male relative travelling with womenfolk, they will seek

alternate entry at the *kelek anak* or *rumah dapur* (literally, kitchen house, a separate but connected structure).

You would sit chatting with Pak Mat on the serambi if you have a serious matter to discuss, such as a marriage proposal from another family for one of his daughters. As a male, you would not be allowed into the *rumah ibu* (literally, mother house), the main part of the house, as that is specifically meant for the womenfolk, and many ceremonial functions involving women.

If Pak Mat and his family were to visit a neighbouring house they would walk over, perhaps stopping to chat with Uncle Lim sitting at a *wakaf* or small hut stationed beside the kampung's "streets".

This is how the traditional spaces of laman, rumah tangga, serambi, kelek anak, rumah dapur, and rumah ibu function within Malay society.

The problems

Now, let's have a look at modern walk-up apartments (that can cost up to RM200,000).

To get to a friend's apartment, you would have to traverse between four and eight flights of stairs, being careful to avoid bumping into bicycles, clothes lines and *pasu bunga* (flower pots) that litter the stairs and landings.

Upon arrival, you would be facing a blank door – no gradual introduction through a laman. When your friend opens the door, you might glimpse the home's womenfolk without their *hijab* (head covering), and when you are invited into the living room, the children would have to scurry in and out of their rooms to get to the toilet, kitchen or outside in plain view – no serambi to keep the main part of the home private.

If a kenduri (ceremonial feast) is being held in the living room and you and your family are late, there is no alternative route to the kitchen, so the womenfolk would have stand around awkwardly until the ceremony ends – no rumah dapur with separate entry.

If the occupants of the house want to visit another family living in the same development, they would walk through small corridors or traverse a constricted landing – no laman, no room for a wakaf, no space to mingle with neighbours.

Possible answers

One of the students, Nur Hafilah Hashim, presents a solution that would allow social etiquette and traditions to be maintained.

In her design for walk-up apartments, the visitor would still have to climb the stairs – though there would be space elsewhere in the development for the bicycles and pasu bunga so the stairs would remain clear and safe – but would end up on a generous landing that serves as a laman for four units in a cluster.

The laman functions also as overflow space during kenduris, and as a place for toddlers and young children to play safely without having to use the stairs.

Each of the four units facing the laman has a small serambi to place shoes and potted plants in.

Hafilah also integrates a "back door" for each apartment as an alternate entry for women.

The whole serambi cluster is adequately ventilated through a central airwell and also side fenestration, which allows smoke from joss sticks burnt by Chinese neighbours to escape without intruding on the other units in the cluster.

Another unique feature of this design are corridors that are wider than the usual cramped ones we see in typical apartment blocks that serve merely as bridges between apartments. The bigger corridors function as social streets because of their "friendliness" – intermittent alcoves with outdoor furniture allow people to sit and chat. Such corridors are "social joiners" and not social inhibitors.

The great visionary architect of the 1920s, Le Corbusier, had introduced the concept of "streets in the sky" in his post-WWII Unité d'Habitation in Marseilles, France. He, too recognised that the corridor is not simply an abstract connector between boxes of living units.

In the Hafilah scheme, one could also sell goreng pisang or kuih for afternoon snacks along broad, well-ventilated corridors, thus creating a social hub within a cluster of units.

Hafilah has also provided each apartment with a storage unit on the ground floor for motorcycles and bicycles. The *kolong* (space under the raised building) is equipped with public furniture so people can relax and interact.

The grounds in which the apartment blocks stand are grassed with pavilions and fountains and landscaped so that they are free from traffic, thus allowing little children to play safely under the watchful eyes of their guardians.

This is how architecture should be.

Fostering good design

A Malaysian architectural identity will make itself known if architects would only ask how architecture can answer the needs of cultural rituals and etiquette.

How can we realise such people-friendly designs? All it takes is a responsible government and municipal and city councils, a listening client, and an architect sensitive enough to actually consider the user's actual needs and dispatch a design team educationally qualified enough to do the job well.

It would also help if schools of architecture train students to design public projects rather than elite luxury condos. Most importantly, students have to be taught to look at problems from a human and humane perspective rather than from a perspective that emphasises styles and technology for their own sakes.

11

Housing and Thermal Comfort: Of Human Ovens and Complacent Attitudes

Introduction

A distinguished scholar and practitioner, Professor Alvin Boyarsky from the AA school of architecture mentioned that when he first arrived in Malaysia, what he expected of tropical architecture with sun shades, generous ventilation openings, some timber usage and verandahs, he was aghast to find the contrary in building designs with masonry and reinforced concrete air conditioned boxes galore. That was in 1983 during a discourse on Malaysian architectural identity. Quite recently, the Managing Director of a Housing Development company told me after my presentation that the only space not air conditioned in his house is the toilet. He also told me that he tries very hard to walk and sweat at least one hour a day. How ironic life is. Here we are with all the advanced technology to keep us 'comfortable' but we have to sacrifice an hour of our valuable time simply to sweat. Developers nowadays seem to take the use of air conditioned as a matter of course with the ignorant public playing into their hands quite nicely. I do not have the medical data to back my claims but I think creating an air-conditioned culture from house, car to office and vice versa is going to take a toll not only on health but also on money and an a damaged environment. Dr. Haji Tetsu, a post doctoral candidate stationed at the Faculty of Built Environment in Universiti Teknologi Malaysia specializes

in Environmental Engineering of urban development and he claims that the over emphasis of air-conditioning in Japan is creating havoc with temperatures and climate in the cities.

The Simple Formula

As an average architectural graduate I know a few things about thermal comfort in the tropics and can suggest simple solutions to this problem. The first problem to tackle is to decide if anyone out there, whether architect, developer, building authorities and the house owner do actually believe that there IS actually a problem! Does it take another SARS-like epidemic to wake people up to the simple idea that the moving air is the best solution in any urban environment? Several hundred years ago, the renowned Muslim scholar mentioned in his magnum opus 'Muqadimah' that the most important aspect of city planning is the presence of moving air. He would rate a city very poor if the air is stale and trapped in between the buildings. I mentioned this statement to my late supervisor, Professor C.B. Wilson as a justification that Islamic City planning does not require one to have arched bridges over man made lakes or even 'floating mosques'. Thus, on the subject of creating a housing that uses passive solutions in thermal comfort, there are simply five design considerations.

Firstly, as Ibnu Khaldun mentions, let there be maximum air movement. How is this done? I propose that before the approval of any planning submission, the developers must submit a report prepared by a local academic acting as a consultant on air flow tests on the proposed layout. We cannot keep allowing rows and rows of terrace houses on grid formats at the whims of the land surveyor or simple minded planners. The air flow tests is cheap and simple. There should be one done on the planning layout as well as the cross sectional massing of the area to ensure that all house units are not cheated from the wind. In temperate regions where the hot or frigidly cold wind is something undesirable, then their planning layout and cross sectional massing would be different.

Secondly, the opening design and placement of the individual unit must be such that there is adequate cross ventilation. Most of our house units has windows on one side of the wall. When the door is closed there is no cross

ventilation occurring. Louvered doors and internal wall partitions should be used so that air is free to move when privacy is required by the room occupant.

Thirdly, the proportions of the room especially the height must be at least ten feet to allow comfortable air circulation and also the all important ceiling fans. Nowadays, developers simply put up a nine foot ceiling that can hardly incorporate the fan. The colonial buildings of the past understood the importance of height as a function of thermal comfort. The use of clerestory windows in the upper part of the walls of the house reduces the stack effect of trapped warm air.

Fourthly, there must be a means in which the hot air which naturally rises to be able to escape via the ceiling and into the roof attic. The gable ends of the roofs should incorporate louvered walls so that the warm air is not trapped in the attic space.

Another important strategy is the consideration of building materials. In our modern housing design we use reinforced concrete structural frames and masonry infill walls. Masonry has a heat retention and radiating property. In the day time, the masonry soak up the heat and radiates it back at night and in the evenings. I propose that we use the reinforced concrete for the structural frames, party walls and floors but timber as the internal wall partitions. For the outer walls we could use the aluminum louvered walls and louvered glass windows. In this manner there is a minimum amount of masonry to soak in the heat. There is something funny going on in a country of abundant timber when it is more expensive than masonry. There is perhaps a need of governmental intervention in order to kick start the timber usage in this country. Mr. Jimmy Lim, a noted architect who specializes in timber wondered aloud why we have a national car and not a national house. With the national house that combines timber and reinforced concrete construction, much of the problems of thermal comfort can be eliminated.

I grew up in the four storey walk up police barracks in Butterworth and Taiping. The flat has a reinforced concrete structure and floor slabs but masonry party walls. The unique aspect of this flat is that its outer walls are all of timber with louvers and timber fins at the top of the wall. My family has never complained of being stuffy or hot because the flat 'breathes' naturally. The last time I visited the barracks, it was ready to be pulled down. It is a great pity that no one has recognizes the potential solution that this design offers us. There are many other early type of high ceiling house designs that

is waiting to be rediscovered. Let us not bind ourselves with the unnatural way of air conditioned living anymore than we have to. It is not a matter of availability of materials or technical know how that is pulling us back. It is simply an attitude of complacency and indifference. We simply have to make up our minds and change the housing designs for the better for the sake of our children's generation. Let us get rid of the human ovens once and for all.

12

Housing, Health and Social Interaction: Follow the Yellow Brick Road...

Introduction

One of the ironies of the modern man is that he spends much of his thoughts and energy inventing and thinking of new and better ways to save energy in transportation so that he could save time in getting from one place to another. And what does he do with all the spare time that he has? He goes jogging. He does that because the doctor tells him that God had created his body in a certain biological balance of muscle strain, sweat and so many heart beats per minute. This balance is needed to stay healthy. And where is that reflected in the housing estates? I notice that a few years ago you'd have to get in your car and drive forty minutes so that you could arrive somewhere safe and inspiring at a natural park with jogging tracks. Nowadays I see developers putting the paved tracks on the playing fields. This seems to be a step in a progressive direction with one small 'insignificant' problem. Our modern man still takes his car and drive five minutes to the grocery shops. Why on earth couldn't he just walk the ten minutes and get the groceries in a cart? Simply because, there is no pedestrian pavement to get him safely there. If he wants he could have just walked on the tarmac and take his chances being hit by another relative of his car, probably the bus.

A Simple Formula and the Scottish Connection

Why am I delving in such a seemingly 'worthless' problem? Well, I happen to think that designing a housing estate with an attitude of promoting people to walk would solve much of our health problem, reduce fossil fuel usage and pollution by about half and increase community interaction tremendously in a manner that our housing estate shall no more resemble a parking lot for families. Throw in the Singapore style landscaping and you would add a spiritual dimension that no mosque or temple could rival for as Frank Lloyd Wright says ; 'Nature is the only body of God you would ever see'. This idea came to me on three separate occasions. The first was in 1993 when I was in Tollcross, Edinburgh. Since I was busy studying I was worried that I did not get much exercise and I went to seek advice from a local doctor. This was how the conversation went,

"Doctor, I am worried that I do not get much exercise for my health."

"Do you walk to the University of Edinburgh or drive there?"

"I walk the ten blocks to the university"

"Do you walk fast or slow?"

"Well, I would probably freeze to death if I had walked slowly!"

"Do you carry your books when you walk?"

"All ten pounds worth!"

"Then you're doing well and you don't need any exercise!"

That was it? Just walking everyday was the formula to good health? How simple! Now the second occasion was when I reached 38 years old just shy of the turn of the millennium I was feeling extremely tired for no apparent reason. Needless to say, the doctor diagnosed that I was stressed and leading towards hypertension. I was so busy writing and doing public lectures that I neglected my health. I hated jogging or even walking because I thought it took valuable time away from reading and writing. It took me about a year to change my lifestyle from writing after morning prayers till mid morning to washing my car and taking a 45 minute walk around the housing estate. When I started walking, I began to make new friends because I now pass them by at the human speed and not that of the car's. I have to always praise the neighbour's cat, flowers or simply the new curtains on the windows. I began to notice things and ultimately to 'smell the roses' as they say. What an astounding political revolution! I actually have two legged humans for neighbours! And

they talk too! Well, so much for social theories and perhaps I think you ought to close down the Ministry of Social Unity. Just get Dr. Mahathir to prescribe to the nation that people should now walk and thus put the Ministry in charge of environment out of business.

The Japanese Way

The third occasion was when I first traveled to Toyohashi, Japan. As my colleagues were busy taking photographs of buildings and yet more buildings, I was taking shots at only one phenomenon; the use of bicycles! I was amazed at the many bicycles parked outside of malls, video arcades and comic book shops.

Many bicycles parked outside of malls, video arcades and comic book shops

I was curious to see that the bicycles used by students and elderly alike were almost of the same kind! Hey, we're talking Japan here! The country that dumps cars all over the world and makes novelty a global religion to put the United States to shame is using bicycles like China and has a standardized product? Wake me up, please! I saw the roadways being divided into two thirds for cars and another third for pedestrians and bicycles. There are six inch curbs to separare the two paths and at many places even a low metal fence. It was only when I was driving home to my housing estate and observing the lack

of a pedestrian pavement along our streets and the extinction of bicycles in our lives that it dawned upon me. The Toyohashi municipality had probably provided the school children with a typical bicycle and made all the efforts to encourage people to walk and cycle perhaps to control pollution, reduce traffic jams, create safety for children and ultimately produce an all around healthy community. I did not see a single school bus when I was there.

A 'monumental' lesson

The lesson here is very simple. We can walk our social problems, environmental concerns and health issues away by making housing friendly to walkers and not just to cars. We could provide pavement where people walk for once, plant shady trees, built little wakafs for short rest stops, kiosks for information or the newspaper and perhaps even well designed toilets along the way. Now tell me what is the great difficulty in doing that? It is pointless to have not one but two tallest buildings in the world as beacons of our intellectual prowess and not be able to recognize this simple solution to our housing problem. It is also frustrating to see so much money spent on a shiny 'jewelled' city complete with man made lakes (as an excuse to build an 'Islamic bridge' perhaps!) and gives the impression that we do not have enough money for pavement. I would like everyone to drive to Skudai town and see the luscious landscaping with decorative lamp posts that would put even Putrajaya to shame in the middle of the highway. As for the pedestrian pavement, well... lets just not speak about it.

Conclusion

Thus while we wait for our leadership to change their attitudes (or change in government) towards a better idea of city planning and housing, I have the perfect idea for an assignment for my architectural design students. I would make them walk two kilometers for three days in the housing estate from one point to another. Perhaps the searing heat, the pelting rain and the dangerous driving of Malaysians can work miracles that books and lectures have failed to perform. As in 'The Wizard of Oz' the four friends had walked all their problems away by simply following the yellow brick road.

13

A Building without a Floor

Today's column is about the need for Community Centers in Malaysian housing estates in order to solve our racial tolerance problems and forge national unity. I know I have written several articles about this but those people at the Ministry for Unity might have been too busy to read the previous one. And also I though I would pay 'tribute' to our new Prime Minister!

It is good that the new Prime Minister of Malaysia is talking about One Malaysia. It is strange also to STILL be talking about unity issues in a country that has celebrated more than half a century of independence. That some political party made a boo-boo at our harmonious living objective does not seem to be an important concern. I predict come 3030, if the present attitude of not admitting mistakes persist we will still be talking about unity and racial tolerance. I am actually very careful at marking something as a 'mistake' To me a 'mistake' is an action done after considering honestly several courses of actions. In this racial unity jazz, I truly suspect one of two things, but definitely NOT a 'mistake'. It was either our intelligentsia and leaders honestly failed to understand the approach and mechanism to achieve racial unity (how can one make a 'mistrake' if one does not know anything) OR…they never wanted it in the first place (and THAT is not a 'mistake'). My money is on the latter. Sorry for being blunt but I have eyes and ears and see and hear many things of which my over active imagination likes to piece together to form hyphotheses. Why do I say so? Well I can give you loads of social, historical, religious and

political 'facts' but this column, unfortunately, is about architecture only and so I will limit my answers to architecture and planning.

First glaring answer (which is phrased as a question); where are the temples and churches in the housing estates? Believe me when I tell you that I spend more time in the housing estates than on aeroplanes traveling overseas or in the country. I am a truly domesticated 'animal' and a true-blue husband-of-the-house. I have ten housing estates in Johor that I am very well acquainted with. So where are they? I don't remember seeing any Chinese temple. I have seen one church which was a single shopping lot in a 30 year old housing estate, and I stumbled upon four Indian temples; one was a terrace house with the front serambi as it's holy space, another which is a true-blue Indian temple smack dab in the middle of a new town, one next to the Telekom in Skudai town center and another 'hidden' Indian temple on a hill in the back of my own housing estate. Strange that I can find four temples, one shop lot Church and zero Chinese temple. One would surmise that the Chinese have lost their religion and perhaps have gone into Christianity and that the religiosity of Indians have increased as much as Muslims with their many monumental mosques. How can there be racial unity and tolerance if one ethnic group is side lined in a housing development. If it was ever proven that authorities purposely make it difficult for other religious minority to build temples and churches, there you have the big answer. As a Muslim I do not condone this and I will tell you the Prophet Muhammad would agree with me (well, actually, I learnt about religious tolerance from him)

Secondly, I have talked about the concept of 'privacy violations' in many articles where the housing policies have not been developed to take care of this. The joss stick issue, the dog issue, the ritual burning of offerings are all sensitive issues which have many architectural and planning solutions if one were to give due respect to all these issues. But because the administrators of this country are predominantly of one racial group the sentiment seems to be 'why should I help this immigrant groups' or 'my religion forbid me to help these people spread their religion'. Again as a Muslim, both these attitudes are furthest away from the true teachings of the Prophet Muhammad that I have come to understand.

Finally, the most important answer to the twenty sen question of racial unity and one Malaysia is…tan tan tara; the Community Center! We do not have one. Putrajaya has them in the housing precincts. Sure their curriculum

could do with an overhaul but they started the ball rolling. Singapore has many community centers and a fair (not good but 'boleh lah') curriculum to forge racial unity. We' are still stuck with the Dewan Serbaguna and the Dewan Orang Ramai or the Balai Raya. All are single function spaces that have no personnel at the facilities and no activity except the occasional ones. This will never do. We have to be serious and hire a Director, and two helpers to run the community programs so that all races would come and share in the activities. Not once every independence day or just before a national or a by-election. And also we need a new idea of a Community Center.

There was actually one other reason why I decided to write about this issue in today's column. One day, while on one of my jogging-strolling walks I saw some construction workers getting ready to construct a structure on a piece of land meant for a 'Balai Raya'. I asked our unofficial 'penghulu', Encik Aziz, and he told me that the UMNO YB of Skudai area had asked the District and Land Office to allocate RM20,000 to produce a 24' X 36ft. shelter that would have only a roof and a floor slab. No walls. No toilets. No rooms. Encik Aziz told me that if we do not collect donations, he would have passed into the Next World before we see any wall, toilet or rooms. I was aghast. No Balai Raya, I can understand. But no walls? Today, the project is 'completed'. There is a metal roof that would probably not survive a single monsoon season. There are ten of the thinnest columns I have ever seen which would probably not survive two years of soil settlement. And, ladies and gentleman, there is NO FLOOR! I kid you not. The government has just graciously given a wall-less structure without a floor slab! And this is the New Balai Raya for the community to come and gather. Well, guys, somebody is not serious about One Malaysia. I know there are ignorant, inept and racist administrators out there in Malaysia but even I would never have predicted that this would result with a building without walls and worse without a floor slab!! I take my hat off to our new low. A building without a floor is the perfect symbol to a statement without any depth or worse, any intention. Congratulations, One Malaysia!

14

An Ecumenical Center for Malaysian Universities

In this chapter, I would like my fellow Malaysians to indulge me in a proposal that would see the making of the future citizenry of Malaysia. The birth place of this new citizenry is the public universities and the issue is; a place of worship for non-Muslim students and staff. In other words, I wish to suggest that all public universities be equipped with a Malaysian idea of an ecumenical center. In line with the first statement of the Rukun Negara, 'Kepercayaan kepada Tuhan', all races in this country have a complete right to be part of any religion of their choosing. Since the university is the microcosm of the small state and city, it too must not ignore this important tenet. The more so for such illustrious university as UTM whose motto is, 'Untuk Tuhan dan Manusia'. The motto aptly implies that however technologically competent humans are, technology must be governed with a humane heart brought about only by humbling it to the majesty of God. Only religion teaches man the morality to be humans. Science can put food on the table and shelter him from the elements but that which makes man differs from animals and insect is what governs his heart and his love for all man and respect for the environment. The founding fathers of UTM understood this philosophy well that man indeed does not exist by bread alone.

Simply understood, an ecumenical center is a 'universal space' created for the worship of all religions. This is a nice idea but to my mind it is wholly impractical in Malaysia. When I studied for my first and second degrees at the University of Wisconsin, Green Bay, I remember praying the Jumaat

prayers at the ecumenical center. I also remember hosting a Malaysian Islamic Study Group seminar and chairing a session for the famous orator Dato' Dr. Hassan Ali, who was then completing his Ph.D at the university of Wisconsin, Madison. The architecture of the ecumenical center was akin to that of the church interior, dimly lit, cool and filled with furniture. The idea of the center is that each student group of differing faiths can take turns worshipping at this place. The Buddhists, Muslims, Hindus, Christians and others were expected to use this. In Green Bay, where there was no mosque then, the Muslim students used to perform the Friday Prayers at my apartment. We would take turns at becoming the Imam and I had to give a sermon or khutba once or twice. Who I am at this present time was made mostly by my six years in two American universities, the other being the University of Wisconsin, Milwaukee. Much of my discovery of Islam and Malaysian politics was there at the incubating place called 'a university'. Unfortunately, and sadly, looking at our public universities, I cannot say they are the incubator of a good Malaysian citizenry. I do not see much of students' political and religious awareness in my twenty three years as an educator at one particular university. Perhaps it is different at other universities but I seriously doubt it.

Well, let us not dwell in the past. Let us venture forth into a new future. What awaits the new batch of students in Malaysia's future? I hope that they all can become individually a human first, a Malaysian citizen second, a responsible family and community member third and perhaps a good engineer, doctor or architect last. Most universities nowadays are similar to the secondary and primary schools in their craving for A's in academic and is interested in the soft skills only so much as these students can become good managers. If this be the case, I predict a difficult and rocky road ahead for this country in the next 50 years. I see the future of Malaysia quite well simply by observing my students in class and chatting with them in my office. The results does not bode well until universities of Malaysia come to grips that we are breeding the next generation of leadership and if there is to be racial respect and harmony (and not simply mere tolerance), it would have to occur now and here in these universities. The private universities will not make this an important item yet as they are mostly in this 'business' as nothing more than just that… another business with a monetary balance sheet. Forget about them at this moment. In 20 years they will perhaps change. But we have great big universities with a matured academic staff of the first and second generation and a young

vibrant core of scholars that can see to a great new future…if only we can realize the true objective of education and not spend time calculating GPA's and university rankings. Our children are here, the Malays, the Chinese, the Indians and other races that make up the colourful landscape of our society. Their differences in culture and religions are our strength… or can potentially be our strength. It is the celebration of these differences that the ecumenical complex must exist.

There are three models of an ecumenical center that may be possible to be built and organized for Malaysian universities. The first model is a single building with a large hall and spaces for administration. This is the one that UWGB has. I do not think this is adequate. In Malaysia, some rituals require the burning of incense and the presence of a representation of a deity and certain liturgical furnishing. I believe that houses of worship must have a 'home' where' the sense of smell as well as the visual plethora of ornaments, sculptures and colours permeate the psyche. I would propose two kinds of complexes. The first is three different buildings to house Buddhists, Hindus and Christian worship. They can be located on three or four acres of land that has three volumes of buildings as homes for the faiths as well as a community place where Muslims and other non-Muslims can interact. The specific homes of the faiths should comprise a worship hall, administrative offices, meeting room and also I recommend a hostel for the priest or religious scholar invited to perform the prayers or deliver lectures. The complex would also house a gallery where all the faiths can put up their explanation of beliefs and rituals and also a bazaar-cafeteria space for other students to linger and interact with one another.

Another idea is a complex with a single moderately sized space that can be shared by all the faiths. But this complex would contain small offices for the different religions that is roughly 100 square meters to house a small club administration and meditation space where the representation of the deity or special liturgical furniture be kept. The single universal space of the ecumenical center must be designed in a way that is convenient for the different faiths to use. It could be equipped with an exhaust fan that pulls out any smoke in incense burning prior to use by other faiths and a revolving wall that would have the symbols of worship built-in for different turns of use. I imagine one or two acres would be adequate for this complex. The exhibition gallery,

bazaar and cafeteria can be in the ground floor of the office row over looking a student plaza.

As with the medieval universities of the west where the university architecture is dominated by the presence of the huge and impending edifice of the church, Malaysian universities are anchored by the imposing presence of the mosque. We are at a time when the West was several hundred years ago. We begin to realize that knowledge alone without morality will get us no where but our mutual destruction as Robert Oppenheimer once observed. The West has since then shed off their moralistic obligation with Christianity as their anchor but Muslim countries now arise with a new sense of morality for knowledge acquisition. In Malaysia, it requires a visionary leader to take just a small step to complete this moralistic stand and present the non-muslim with the generosity of Islamic conscience of accommodating them with a home of their own to complete the mind and soul of the 'humane' being. In my studio at UTM, we have already begun the thinking process towards the realization of Malaysia's future…

15

Big Plus for PLUS Architecture

As with a few million other Malaysians, I too frequently use the North-South PLUS Highway. Twice a month on the average. And with a few million other Malaysians I also gripe at the rising Tol cost and also ponder on the billion Ringgit question; when the heck do we stop paying the tol? I have personally heard of many allegations from the opposition parties as to the unjustifiable claims for tol increase and extension of time that sometimes leave me quite angry and frustrated. In an untransparent country like Malaysia that can perhaps even declare the laundry ticket of a Minister OSA (Official Secrets Act), we will only know the accounting of PLUS when the opposition comes to power...or will we? Hmm...Well, anyways, that is not the subject of my column. My subject is how I feel much impressed with the way PLUS spends their money making the travelers feel rested and comforted at the R & R areas. I would give much of their architecture an A+ although I might have some suggestions of small improvements (Sorry but I had to start this essay on the negative note lest readers think I have switched political camps or views!!).

First of all, I would like to comment on the places for food and public furniture. Well as far as the food is concerned, there is the cooking space, the eating space and the waiting space. Since I do not work in the kitchens of the stalls and have not spent weeks looking at how the garbage is handled in the back alleys I would reserve my comments. But judging by the very few presence of flies and no time that I have seen a cockroach or rat scurrying about I'd say everything is pretty nifty...but don't take my word for it. As far as the seating

spaces go, there is enough variety and numbers to cater to the normal travelling day of the highway. This is of course thrown off balance during the festive season where you may find the food but not the space to sit and eat. PLUS should tell their architects that the space must be made to expand for instance, certain ponds or fountains can be covered and extra furniture added or certain landscaping elements like potted plants can be moved to make way for extra seatings or better yet the palnter boxes can be made to be sits in their own right. The Jejantas or Restaurant bridge, I think fail miserably in this department as there are miles of passageway with no benches or any seating furniture to comfort the travelers. Finally, I have often wondered how come there are no Chinese food stalls to cater to the great number of Chinese users? The answer is quite obvious in that PLUS is a Malay dominated company closely associated with a certain political party who thinks that making things difficult for non-muslims is an essential requirement of being a Malay and a Muslim. As a Muslim myself, I believe that separate stall areas can be constructed (they've got the land for it and certainly the money!) to separate the two types of food and eating habits. If we are to practice seriously to be Malaysian, we should look at this problem not as a small matter but as an important opportunity.

Next comes the toilet; an indispensable place more important then the food stalls! I think the architects have surpassed themselves in relation to public toilet architecture. I seriously think that all municipalities of Malaysia must take their cue from PLUS and produce toilets that are not only clean but presents a comforting environment of cool landscapes, airy atmosphere and a regionalistic aura of timber structures and clay tiles. Bravo guys (architects and clients of course)!! Once in a jury discussion, a famous Malaysian architect and I wanted to award the PLUS toilet first prize over a 200 million Putrajaya project but our suggestion was stalemated by two other juries who did not want PAM to look stupid!! A toilet for a PAM award? An Second prize goes to… RM200 million putrajaya Project! Now how would that look? The battle was heated as my friend Architect J was adamant. When it was certain that the two sides would not shift their views, Architect J suggested that no first prize should be awarded but two second prizes. A few days later I got a call by the committee to persuade me to give up on the toilet battle and when Architect J heard of the request, he gave the organizers a piece of his mind that made up their minds to not make up his! I find absolutely no problem with the toilet

facilities and I see that contingency plans have recently been made for the festive season needs with extra parking and toilet units.

Next comes the Surau or the place of prayers for Muslims. Again top marks overall. The municipalities must again take their cue from the people at PLUS and start producing suraus with such a regionalistic ambience that one feels closer to one's Maker with stone pavings, clay roof tiles, varnished timber trusses and decks and generously placed 'pelantar' for prayers and green plants adorning the waiting or seating spaces. Wonderful!! The architecture language of gable roof with courtyards letting rain pelting in is a sheer interpretation of tropical paradise in a budgeted entry. I prefer to stay at this Surau for meditation and contemplation than the big Putra mosque or Wilayah Mosque. The humility that one feels upon entry into the Surau is overpowering and that speaks volume about a true idea of Islamic Architecture. Now comes a criticism. I have often wondered why PLUS did not ask the architect to make a special space for a non-Muslim meditation center? True enough that Christians and Buddhists or Taoists or Hindus do not pray as regimentally as Muslims but the Surau serves both as a place to sleep and meditate. So I think, non-Muslims should also have a place for men and a separate one for women to perhaps rest and take a short nap. Yes there are pavilions called 'wakafs' but this hardly speaks of modesty when one wants to sprawl down and take a 20 minute nap. The wakafs are not ideal spaces for this purpose. The wakafs should be designed to be a bit more private and allow women of all religions to lie modestly and safely to take a short nap from the tiredness of travel.

As for the public spaces and seatings, nothing tops the Tapah Southbound rest area. Here one discovers a delightful forest of brick columns and many pockets of fountains with green plants ooling the seating area. If I were a child this place is a great one to play hide and seek after being cooped up by mum and dad for two hours listening to the golden years of Uji Rashid! I have not enough praise s for his rest area for providing a multitude of different pocket spaces and courtyards that is a delight to the eyes and body. The other rest areas also have adequate public spaces but not as exciting.

Finally, what of the architectural language? Again I would have to tip my hat off to some of the architects designing the new Northbound Macjap R&R, the Jejantas and of course the Tapah Southbound. These three buildings merits awards that could give architects of administrative centers universities and other institutions what a regionalistic Malaysian architecture should be!

Truly the new Machap architecture is a symphony of clashing the modern and the traditional with such superb taste and handling that the spaces as well as the architecture comes in a symbiosis that speaks excellence not only of public architecture but of any architecture in general. If I were the PAM Jury, this would top my list of excellence in public architecture. Period. The Jejantas, when it was conceived two decades ago, speaks of a modernistic structuralist approach that can power its own vocabulary of Malaysian architecture of aluminium and steel. As opposed to the easy approach of using clay tiles and timber the Jejantas took a bold approach of modernism and the unique form will last for centuries to come as a classic typology of sleek public Malaysian architecture. If I had a wishing wand, I would like to put the architecture firms that designed the Machap R&R, Jejantas and Tapah R&R and put them to designing a truly democratic architecture in Putrajaya instead of the monstrosities (The PM Office, The PM Residence and the Putra Mosque) that we have right now.

So all in all, PLUS have made sound investment in public architecture that borders on absolute excellence. Though I have very few nice things to say to Malaysian architects, my hat off to the R&R designers that I have mentioned above. Nice going guys!

16

The Development of the Wilayah Pembangunan Iskandar: Harmony, Sustainability and Survivability of Building Design and City Planning

The Problem of the Modern City and Living

The modern cities of recent Asia and of the old Western world have been designed without much thought to the idea of community living between humans. Because of the possibilities of technology and the uncapped greed of capitalism, the city is strained with vehicles and movement of products with people making up the formula of service providers and machine attendants. The Industrial and the Communist Revolutions both provided visions of cities as huge factories with human workers happily trudging their way to stoke the engines of progress. The cost of such vision was a disharmony between man and his self, his ecological environment and his God or spiritual self. A new politics about harmonious living must ensue before a new idea of the city and modern living can be put on the drawing board. The development of the WPI affords an opportunity not to make the same vision of the Industrial and Communist cities that has been the foundation stone whether consciously or unconsciously of many human settlements. This essay outlines three main concerns of building and city designs. The first is the basic need of human beings to grow physically and spiritually, to play innovatively, to interact and foster brotherhood, to become old and infirm gracefully and finally to die

and honorable death. The second concern is that of political system and the environment with objects and concepts to remind and phrase who we are as a nation. Finally, the third part outlines the basic idea of survival in the long term and also in a pre-emptive stance against the advent of holocaust situations

The Family, the House and Immediate Neighborhood

Before the city, comes the grouping of villages, fortresses and encampments. In modern day parlance, it is housing, administrative centers, commercial and industrial areas. Before all this comes the neighbourhood and finally to the nucleus of it all: the house. The WPI development should ensure all the mistakes of the modern house design not be repeated or enhanced. Firstly, the house must be designed to grow with the family. The house must be flexible in interior partitioning and growth from a three bedroom to a six bedroom one and back to a three bedroom house may be possible to cater to the growing needs of the family. With present technology, this can be done easily with hindsight and fore sight. Secondly, the house must have a social serambi for community and neighborhood interaction. The family is nothing without the peace and harmony beween families in the immediate neighborhood. The third priority is respect of privacy whether visual, olfactory or auditory. Windows and fenestrations must be designed with care so as not to intrude visually and from the perspective of smell. Building materials for party walls must be carefully chosen for auditory concerns. Fourth is safety from crime and the neighbourhood should have its own territorial courtyard. Lonely back alleys must be fully utillised or totally eliminated. Fifth is thermal comfort and houses should be cool without the use of air-conditioning. The use of timber or other less heat absorbent materials should be used for internal works. Proper air movement from one end to the other end should be uninterrupted. Sixth is the house inhabitants and neighbourhood can perform small religious rituals such as the celebration of birth, circumcision and death. Seventh is the ability for small children to play without fear of vehicular accidents or criminal offence.

The Malaysian Community, the Temple, The Mosque, the Dewan and Micro-architecture

What makes a family are parents and children. What makes a nation are its various races and communities. What makes a *successful* nation is the close interaction between the races and communities. The first priority is the micro-architecture of wakafs and public furniture laid out over shady trees and paved walkways. People must be encouraged to come out and walk to places or just for exercise. Interaction occurs with these facilities which are freed from cross circulation with vehicles. Secondly, the community facilities must be of interests and of various kinds to get people to visit. Mosques, churches and temples should be designed to invite not just one group but of many to understand and tolerate each other's beliefs. There are ways to landscape the outdoors of these facilities and provide 'serambi' spaces for multi functional uses. Thirdly, the Dewan Raya should be replaced with a full fledge Community Center with librariy facilities, cafeterias, meeting rooms and small classes. It should look like a club house with swimming pools and games or sports room with regular activities. Fourthly, is the setting up of many kinds of kiosks and extended wakafs with food courts or gerais scattered around to enliven dead spaces and serve as community nodes.

The Children, the School and the 'Play Facilities'

The future of the nation is her children. From 3 to 18 years of age, children spend 15 years in the housing estates, schools and condominiums. What facilities do we provide to nurture their growth? First is safety against vehicular accidents. Routes to school, play grounds, community facilities and other families must be safe for cycling and walking without crossing any roads at all. Play grounds should emulate adventure play parks. There must be enough 'forest area to remind the children of the importance of trees and plants with small bodies of water. What kind of individual would it be if children do not appreciate 'Nature'? The school architecture must be designed no longer as a standard factory architecture. Do we want shoes or innovative individuals as products? School architecture must be totally revamped and no amount of standard space should appear anywhere. It should provide Nature with trees, rocks and water bodies with windows and openings receiving cool breezes from

the landscaped area. Special children safety features in windows, balconies and corridors of schools and high rise must be taken into consideration in the design of dwelling units as well as public or commercial ones.

The Elderly and the Handicap

The present design of Malaysian cities seem to assume that we do not become old or that we do not become handicap through accidents, disease or our birth condition or even to the point of we becoming pregnant. For instance, walk-up schools of three or four stories should have an elevator with a restricted access. All the buildings must be accessible from the single elevator. Even the design of terrace houses should consider the small elevator shaft for Malaysians above forty years of age have problems climbing stairs which would render the upper levels of the house virtually useless. Traversing through the streets, a person on wheel chair should be able to continue an active life through shopping, going to work and to school. The provision of special toilet facilities must come about without extra costs. Handicaps of sights or those who are blind must be provided with the proper hand rails or voice operated and auditory sensitive markers to make way finding less of a challenge.

Honoring the Dead

The mark of a truly civilized nation can be measured by how the society treats their Dead. Death is the only reminder of man's mortality and it curbs his arrogance and greed. Death is also an act of faith to many where it is but a transitory phase to a different life for the soul. It is one of the Great Mysteries that hold man in awe and thus its architecture should come about with a meditative and contemplative atmosphere. Cemeteries should be designed with proper vehicular access and public furniture for visits as well as on site facilities for preparing the funerary rituals. Each culture in Malaysia has its own ways and these should be carefully understood and all efforts must be made to provide for them. Issues of limited spaces for land must be dealt with in creative but acceptable ways which religions permit. Siting of cemeteries should be carefully considered so as to remind the city inhabitants about the truth of their frail existence. It is hoped with such reminders that the inhabitants will be more time conscious and care more for others as well as those less fortunate.

People's Democracy

The administrative architecture of the new WPI should reflect full democracy. As it is Malaysia seems to turn itself into little kingdoms with palatial like office complexes with setbacks and expenditure unbefitting of a country claimed to be the conscience of the people. The administrative centers should be more modest in expression and provide full access for the people to meet their elected representatives as well as civil servants. The architecture of public access and transparency must be paramount with proper assembly spaces, waiting areas and meeting spaces so that people can be more active participants in developing this country. As of now, most facilities are geared solely for the elected representatives, officials and support staff. This must change to a more public friendly architecture since the public is the 'boss' in the true legal sense. An architecture of democracy is also visible through the presence of public friendly street furniture and micro-architecture with accessibility and affordability of people to earn an honest living through trade and other skills. The business centers should cater both to the less fortunate as well as the high powered economic giants by the provision of affordable market places, street architecture and open air trading spaces.

Energy Conservation

Energy conservation needs in the 21st century is not a style or a fad. It is a stark necessity. The depletion of fossil fuel reserves and the pollution of the environment make it paramount that buildings and cities or townships be designed with energy conservation in mind. A simple terrace house in Malaysia consumes so much energy that it is a simple thing to put dormers for natural lighting and through ventilation with the proper proportions of timber and masonry to light and cool the house using 70% less energy. Add to this the standard features of solar power cells, and mini wind mills one can almost make the terrace house free from electric bills forever. The commercial high rises should capitalize on smart control of air-conditioning and lighting with cladding that can supply part of the electrical energy. Lifestyle should also be encouraged to change to suit the new walking and cycling townships with efficient mass transit systems. The days of the cars and traffic jams and massive roadway systems should be phased down. Instead, nowadays, Malaysia is enlarging her roadways which indicate a reactive posture and not a pre-emptive vision.

Holocaust Architecture

About 70,000 years ago, a mega volcano erupted in Indonesia which formed what is now Lake Toba. The eruption was so massive that scientists believed that it changed the climate and turn the world into an Ice Age. The human population was believed to have almost been wiped out from 60 million to a few surviving thousand. Death came from suffocation of the poisonous dust particles and the blocking of the sun for a few years. In the previous century alone Mount Pinatubo in the Phillipines erupted with an explosion that dwarfed all of man's super weapons and arsenals spewing couds of dust even to the very shores of Malaysia. The Boxing Day Tsunami which killed a total of half a million people around the world was the result of the normal activity of the earth in its shakes and quakes. Scientists have also found evidences of meteorite or comet impact that have shifted the global climate patterns as recent as the Siberian Thundra impact 100 years ago. The London skies darkened for weeks with the dust particles strewn into the atmosphere. As if holocaust such as these were not enough, man has always shown that he is a species that can guarantee his own destruction through numerous wars and global conflicts caused by greed and petty intolerance. Devastation through conventional and nuclear wars is staring man in the face with a question not of 'if' but of 'when'. What of the modern city? What of new developments such as the WPI. Are these facts science fiction or should we not be prepared to survive such calamities? Can buildings designed nowadays provide basic survival elements such as the collection of rain water and it filtration as well as converting the sun and wind energy into minimal power to run refrigeration units as well as some lighting. Will there be radiation shelters deep underground which doubles as subterranean subway stations? How do we design for earthquake construction and survive a Tsunami flood?

Conclusion

Greed and novelty have always been partners of the destruction of the built environment and making the human habitation interesting but hellish in the long run. The WPI should be a democratic development that shares out facilities for all and sundry and also make sure that future generation should enjoy the same resources. It is a simple thing to make up ones mind and

decide on the important agendas of harmonious living, sustainable existence and survivable environment. We possess the intelligence and technology to forge the WPI n whatever manner we please. Just so that Greed and novelty be not the masters the WPI will be set to be the shining example of what true Malaysian identity truly is in lifestyle and physical built environment.

17

The Discontinued Traditions of Malay Wood Carvings in Malaysia: A Failure to Develop the Discourse on Ornamentation in Architectural Works of Modern and Post-Modern Architecture

1.1 Introduction

The main intention of this paper is to contribute some thoughts on why the tradition of wood carvings in traditional Malay architecture was discontinued at the rise of modern and post-modern architectural works in Malaysia. Although the tradition of wood carvings more or less came to a stop in public architectural works with the development of colonial architecture, this paper seeks to clarify the modernistic and post-modern arguments on the problem or issues of ornamentation. I propose that the main reason why traditional wood carvings never became part of mainstream modern and post-modern architecture and is relegated to the elitist works of palaces and hotels or resorts is because architects, artists and intellectuals in Malaysia failed to develop a working discourse on ornamentation in architecture. Although modernism mainly or seemingly rejected the use of ornaments, there was still a strong strand of its development in the architecture of Frank Lloyd Wright. The western post-modernist architects such as Michael Graves and Charles

Jencks went on to develop a discourse on ornamentation under the area of architectural meaning and linguistics.

The paper is divided into three main parts. The first part presents a brief evolution of thoughts concerning the relationship between ornament and architecture as I have understood them in the western context. I hope to show that the idea of ornament went through important changes in form, motif, materials and philosophy. The second part of this paper presents a look at some of the approaches of architecture towards defining a Malaysian identity. I hope to show the lack of ornament and if there was any done, it was at a superficial level. The final part of this paper presents my own personal thoughts as to my position on ornament and how it might be reinterpreted into the modern context. The 'semangat kayu' of wood carvings comes directly under the general considerations of ornament in architecture. It is hoped that this paper can spark an attempt to put back the question of architectural ornamentation as a valid and professional discourse so that we could create a more meaningful architecture for our society in this part of the world.

2.1 The Issue of Ornamentation in Western Architecture

I would like to begin the discussion on ornamentation in architecture by expounding what I know of the western architectural context. There are three reasons why I have chosen this beginning. Firstly, my architectural training is from the West and so is most of the architectural fraternity in the education or practice line in this country. Secondly, there is quite an abundance of literature on this subject matter as oppose to those found in our part of the world. Thirdly, the issue of ornament in architecture is directly related to the idea of political governance in a western conception of democracy and constitution. I will suggest how much of the discourse in architecture and ornament directly relates to the ideas of political governance.

2.1.1 The Western Vernacular Tradition of Ornament and Architecture

I suspect strongly that there was no strong issue of ornamentation in most traditional societies for various reasons. Homogenous societies that believe in a theo-centric conception of community have well understood rituals, and codes of behaviors with the corresponding symbols in its physical manifestation. Thus

statues, figures, carvings of floral, cosmic or animal motifs are part and parcel
of a coded language well understood by all. It was accepted that the temple
or the palace or the residence of the tribal leaders would show much carvings
and ornamentation for they project a special social and spiritual message.
The existence of ornament as part and parcel of a complete architecture was
accepted without much moralistic argument. There was no question of whether
ornament is a non-structural element and therefore no concern of its moral
existence. The Greeks, Romans and Gothic architects conceived ornaments
for reasons of sending spiritual and ritualistic messages in its many forms. In
the architectural treatises of Vitruvius, there were descriptions of ornaments
in a-matter-of-fact tone as in his description of the structural proportions of
columns and arches. The feudalistic and hierarchic nature of life which revolves
around the kings, aristocrats and priests may have aided in the total acceptance
of ornament as part of a religious and stately symbolic message. Thus in the
vernacular tradition of the early Western architects there was simply no issue
of ornamentation as it is part and parcel of architecture and life.

2.1.2 The Issue of Ornament and Architecture in the Age of the Renaissance

The Renaissance began a systematic imitation and adoption of Classical
Greco-Roman architecture. The period saw the birth of a new patron of the
arts aside the royals, aristocrats and clerics. The rich merchant and middle
class began to crave for symbols of status and ornament in architectural work
found new meanings as status symbols other than the religious or the official
creed. The 18th century ushered in the new super powers of the French, British
and Spanish which began its conquest and influence of the known world. The
Battle of Styles erupted in Britain, France, Germany and later on in the new
world of the Americas. The middle class sought many books on the proper
architectural languages of Greek and Roman architectural vocabulary. Andrea
Palladio's book on the four Books of architecture inspired many architects such
as Christopher Wren and Inigo Jones to experiment with the various eclectic
mixtures of Roman, Greek and sometimes even Egyptian architecture. The
concern then was whichever architect adopted the truest forms and proportions
of the ancient classical architecture, his work would be considered the best.
Thus began much works of measuring and drawing of the ancient ruins of
Western Europe. The political hierarchy was still feudalistic with an addition

of a new aristocracy, that is, the rich merchant class. At this time the moral question of ornament is about which carvings was most appropriate in the sense of its authentic origins.

2.1.3 The Issue of Ornament and Architecture in the Age of Enlightenment

The 19th century was a period of great questioning of politics, religion and the arts. This new debate was fueled by the birth of rationalism and scientific thoughts. Centuries of religious dogma was replaced by strict Christian doctrines administered by the all powerful clergy that stifled philosophical musings as well as rational quests for the alternative explanation of cosmic and social truths. The likes of Copernicus, Galileo and Darwin pierced at the very heart of Christian dogma thus unleashing for the first time thoughts on all issues of life including that of ornament and architecture. Laugier questioned the very existence of ornamentation and disclosed his treatise on a rationalistic approach of utilitarian and primitive architecture. Augustus Welby Pugin wrote passionately of ensuring the utilitarian aspect of ornament by describing the gargoyles sitting on the flying buttresses of Gothic Cathedrals as counterweights against the thrust of the masonry arches.

> "Nothing must be included which was not for "convenience, construction or propriety." The building must honestly express its function and materials. Ornament should consist of "the essential of the building." The structure must be expressed not covered up with the arbitrary or superfluous decoration."
> Pugin, August (1898), **True Principles of Pointed or Christian Architecture** p.1

John Ruskin went to great lengths to expound on his idea of proper architecture in his Stones of Venice and the Seven Lamps of Architecture by building up a discourse on the proper placement and motifs of ornament. Ettine Boullee created architectural masterpieces on paper to glorify libraries and Issac Newton as opposed to palaces and churches with huge edifices adorned with a single layer of ornament gracing a pure platonic form. The master architect Claude Nicholas Ledoux designed buildings with clear pristine elements devoid of any superfluous carvings or ornaments. Thus, it can be seen

that there were several moral questions of ornament and architecture. Firstly, there was the drastic question of whether its existence was necessary at all. This had a small following. The second moral question is on the utilitarian aspect to justify the existence of ornament as in the case of Pugin and the Gothic style or language. Thirdly was the question of its appropriate expression and placement as in the thoughts of John Ruskin.

2.1.4 The Different Strands of Early Modernism on the Issue of Ornamentation

The late 19th century and the early twentieth century saw several strands of architectural approaches that redefines the use of ornament. The Art and Craft movement that took Britain was lead by William Morris and John Ruskin. The two intellectuals were wary of copying classical ornament and architectural vocabulary but instead used their own motifs and developed designs for wall papers, furnitures and utensils. This idea of redefining the motifs were expressed strongly in another movement called Art Nouveau that saw the use of iron as the new expressive materials. In Victor Horta's hand, columns merge into trusses and beams in a floral configuration that supports the structural moment connections. The union between ornament and structure as echoed in Pugin's criticism and admiration of Gothic architecture came to a head with the designs of Antonio Gaudi's Cassa Battlo apartments. Here the use of reinforced concrete was stretched to its structural perfection and form within the metaphorical interpretations of dragons and mythical creatures.

In the United States of America, whilst the Chicago Tribune Tower by Raymond Hood ended the modernistic romance with Gothic architecture, the master designer, Louis Henry Sullivan and his soon-to-be famous student, Frank Lloyd Wright, showed the world what modernism could achieve in the new materials of steel and reinforced concrete. In his Wainwright Building, Sullivan showed how the proper use of ornament can be applied to grace a tall structure. In his bank designs, huge arches defining the entrance and wearing an upgraded classical garb was inscribed with floral motifs specially designed by the 'Leiber Meister' himself. However, proponents of more 'functionalist' strand as that of Henry Hobson Richardson rejected ornamentation and substituted the strength and monumentality of a new interpretation of Romanesque vocabulary. The Trinity Church and his library designs attest to the power of expressing undressed stone and cut masonry in an architectural

language that would soon echo in Le Corbusier's Monastery La Tourette and the chapel at Ronchamp almost a century later.

I consider Frank Lloyd Wright as the master builder who left a strong legacy of modernism within a humanistic vocabulary of people architecture and as the last sculptor-architect model. Untrained in the formal aesthetic of Calssicism and university education, Wright presented American society with a Prairie Architecture that was both unique and expressive. He later termed this architecture as Organic:

> "Architecture organic, perhaps because firstly deeply concerned with the integrity of innate structure, first grasped the demand of our modern American life for higher spiritual order."
> Wright, Frank Lloyd (1958), **The Living City**, p. 92

> "The real body of our universe is spiritualities-the real body of the real life we live. From the waist up we're spiritual at least. Our true humanity begins from the belt up, doesn't it? Therein comes the difference between the animal and the man. Man is chiefly animal until he makes something of himself in the life of the spirit so that he becomes spiritually inspired-spiritually aware. Until then he is not creative. He can't be."
> Wright, Frank Lloyd, **Truth Against the World**, p. 270

As with Richardson, his building materials possessed an expressive and humble monumentality amidst his platonic forms of cubes, cylinders and spheres. He developed a new ornamentation system that could be mass produced and prefabricated but which had the geometric lines of the machine. The Barnsdal Residence and the Midway Gardens restaurant showed Wright to be the complete designer with sculptures, reliefs, furnitures, fixtures and tapestry designs. Wright proposes the total integration of ornament with not only the structure but with the whole experience of space and architecture.

Herman Muthesius saw the genius of Wright and helped staged the first exhibition of Wright's work in Germany. The apprentices of Peter Behrens came to this exhibition and they were soon designing within the same spirit of mass, materials and volumes but minus the ornamental system. The young

apprentices by the name of Ludwig Mies van der Rohe, Le Corbusier and Walter Gropius went on to be master designers in their own right by expressing structure and form but abandoning the grammar of ornament. Le Corbusier, in his Vers une Architecture condemns ornament in his attack of 'styles as in the following excerpt:

> "Great Epoch has begun.
> There exist a new spirit.
> There exist a mass of work conceived in the new spirit; it is to be meet with particularly in industrial production.
> Architecture is stifled by custom.
> The "styles" are a lie.
> Style is a unity of Principle animating all the work of an epoch, the result of a state of mind which has its own special character.
>
> Corbusier, Le (1962). **Vers Une Architecture**, p. 19

The influence of Adolf' Loos's dictum of 'ornament is crime' still echoed strongly in the young modernists of that time that eventually led to a whole world rejecting this grammar of ornament.

> "Children are amoral, and-by our standards-so are Papuans. If a Papuan slaughters an enemy and eats him, that doesn't make him a criminal. But if a modern man kills someone and eats him, he must be either a criminal or a degenerate. The Papuans tattoo themselves, decorate their boats, their oars, everything they can get their hands on. But a modern man who tattoos himself is either a criminal or a degenerate. Why, there are prisons where eighty percent of the convicts are tattooed and tattooed men who are not in a prison are either latent criminals or degenerate aristocrats. When a tattooed man dies at liberty, it simply means that he hasn't had time to commit his crime... what is natural to children and Papuan savages is a symptom of degeneration in modern man. I have therefore evolved the following maxim, and pronounce it to the world: the evolution

of culture marches with the elimination of ornament from useful objects (Adolf Loos).

William JR Curtis,
Modern Architecture since 1900, p.36.

In many ways, the Werkbund which was set up by Muthesius was party to this rejection of ornament which was expressed in the works of Wright and the Art and Craft movement. The idea of functionalism as a determining element of architecture took hold of not only Germany but eventually the whole world with the advent of the International Style.

Thus, in this most creative period of architecture, ornament was seen in five different perspectives. The first perspective is that of the moral issue of propriety. The second perspective is that motifs and materials should be redefined in favour of a more vernacular and down to earth expression. The third perspective saw the idea of machine industrialization and geometricisation of ornament in new forms. The fourth perspective is the marriage between ornament and structure. The final perspective is the most enduring and that called for the total elimination of ornament from the vocabulary of functionalist designs.

2.1.5 The Consolidation of the International Style and the Total Elimination of Ornament

The International Style was simply a theme created by Phillip Johnson and Henry Russel Hitchcock during an exhibition of European architect's work in mid 20th century. The exhibition was mostly responsible for propelling the modernist vocabulary of utilitarian steel structural cages with curtain walling of glass and aluminium. The only strand of ornamentation was that by Wright and even then the great master himself had succumbed to the mystic and grandeur of structural forms. After what seemed as a brief decade of functionalist cages, architects such as Eero Saarinen began to explore structural forms that had some kind of abstracted metaphorical meanings. The Yale Hockey Rink, the TWA Terminal and the New York Airport Terminal showed the forbidden experiments in meanings. This was quite a departure from the modernists' dictum of the building as pure shelter with structure as a means of expressing the spirit of technology and of economic construction. Although

the 1950's and 1960's high rises in the USA were mainly steel cages purportedly created from pure functional necessity, critics were quick to point out that the steel mullions 'pasted' on shear walls of buildings such as the famed Seagram Tower could be construed as 'ornament' as they did not perform and constructional or structural function! Thus, in this period, there was still the prevailing strand of not putting any ornament as it was traditionally understood. However there was a strand of approach that saw an attempt at giving meanings to buildings by the expression of structural form. Can this be construed as the new idea of 'ornamentation'?

2.1.6 Early Criticism of Modernism on Meaning and Form in Architecture

One of the first criticisms against the bland modernist vocabulary was by totalitarian regimes such as those of Adolf Hitler and Benitto Mussolini. Both leaders saw that the salvation of their two countries lie in building an empire psyche for the society and to resort to architecture as the expression of historical continuity from the Roman grandeur of the past. Since modern architecture rejected historical references because of their attacks on ornament, Hitler accused the modern masters as communist sympathizers and drove them out to America. Thus Hitler and Mussolini commissioned grand gestures in architecture at many times the scale of the Roman heritage. Great heroic sculptures stood against the city back drops and huge columns with abstract capitals marched in unison fronting buildings and arcades. However, there was still no sign of the traditional ornamentation of relief and carvings but only abstract formal imitations of Roman heritage architecture.

The second wave of criticism were by those who saw the dangers of globalization in the form of the International style. Coupled with rising oil prices and the rise of politically independent states which were colonized by the west, these new architects saw that regionalism was a better way to produce good pieces of architecture. The vernacular tradition was sought for its lessons in material usage and energy efficient solutions. Much of this attempt culminated in the seminal works of the master builder Hassan Fathy who studied adobe brickwork and built townships out of mud to solve the socio-cultural and economic problems of the middle east peoples.

A final strand of critics came from the students of the great modernist masters such as Michael Graves and Robert Venturi who went on to develop

meaningful architecture through the introduction of an elitist architectural language of form, colours and elements. Almost a century went by before architecture was learning to speak again! I consider these attempts as the new ornamentation system although much of these elements were infused with columns, railings and wall planes.

2.1.7 The Language of Post Modern Architecture and the New Idea of Ornamentation

In the 1980's a revolution once again took place in the architectural world. Ornament was back. This time in its pure naked form, unconnected to structure of whatever functional purposes. The American Telephone and Telegraph Company by Phillip Johnson contained an unmistakable pediment with a baroque crown. Michael Graves went on to design the Portland Municipal Building complete with reinforced concrete garlands and statues. The garlands was a tool that contains messages of 'celebration' and 'importance' for a tight budget building charged with being the 'palace of Portland'. Michael Graves and Ricardo Bofill also introduced a new idea of considering architecture as a box full of meanings. In the Portland building by Graves and in the Taller Architectura Apartment by Boffil, they both created signs of gateways and grandiose columns by using coloured panels and glass. The modernist dictum that a column should be expressed structurally has now been totally shattered because both architects saw fit to communicate the idea of huge columns without them being necessarily structural. Thus, I consider that the idea of ornament in the Western discourse went from being a simple floral motif, to a structuralised form, and integrated structure and finally as a sign for an understood architectural element.

Finally, the work of Charles Jencks in his Thematic House brought ornament back to where it once began. In renovating his own house and as documented in his book 'Symbolic Architecture', Jencks laments the pluralism and emptiness of modern life that saw no more myths, legends and beliefs. Life in the modern age was as functional as architecture. There was no religion or superstition to glue society together in order for an artist to produce a meaningful form. Thus Jencks resorted to themes of the cosmos and the environment as the two last common 'belief system' of Westerners but he resorted to Greek mythology and a personal set of language to produce

to him a more meaningful architecture that can be read by many of his own peers.

3.1 The Search for a Malaysian Architectural Identity

The search for a national identity seems to be a must for countries which have either newly become independent or with a leadership that stresses certain groups of race as 'better' than others. To most countries, this search is a high profile event as it has strong political implications. Of all the arts and technology produced by man, architecture is the most conspicuous of them all. The search for a national identity is a most difficult endeavor and for a multi-cultural nation, the effort is even more so. To search for one's identity is also something of a peculiar nature since it implies that one has either lost the identity or does not have a clue as to who one is. In this section, we will attempt to classify the various approaches towards answering the problem of a national architectural identity without considering whether there was a conscious effort or not by the architects.

3.1.1 Natural Architectural Identity

A natural architectural identity can be defined as one which has what the modernist thinkers refer to as a 'spirit of the times' and what present post-modernist concerns of a 'spirit of the place'. A building is supposed to possess true identity if it responds religiously to the idea of both spirits. The idea of spirit of the times refers to a direct response of the users and builders to the available technology, the structural know how and the economic consideration of a particular time. Thus, the Malay house with its long gable roof, timber post, beam and wall construction and small human labor is as true to its times as the mud construction of traditional Egyptian architecture and the arched masonry construction of the Romans. In the modern age, the only natural identity which can be found as relates to the spirit of contemporary technology is the stadium and bridge construction. Long span bridges of two kilometers tend to have the inverted catenaries arch shape of suspended high strength steel whilst stadium structures use the pneumatic, tent and reinforced concrete cantilevered shell. These structures are shaped

in the manner that the structural system and the economies of construction dictate.

The idea of spirit of place refers to the direct response of the builders to climatic considerations, geographic make up of the land and the culture of a particular society. Thus the Malay house with its isolated mass, raised platform, generous *serambi's* or verandahs, full length windows with *kerawang* ventilation grilles and high roof form to ease the passage of air and shed off heavy rainfalls contrast strongly with those of temperate regions of heavy masonry walls with barrel vaults containing little openings to trap heat in and hold the snow at bay. The colonial and sino-eclectic heritage in Malaysia presents excellent examples of this type of natural identity. The sino-eclectic heritage brought with it the Chinese masonry construction in such buildings as the Kampung Hulu Mosque in Melaka and the long shop houses found in the same state. The colonial heritage presents two interesting building types which are the Palladian all masonry buildings and the reinterpretation of Malay timber buildings. In the colonial and sino-eclectic architectural heritage, innovations and adaptation to the climate were ingeniously developed in the high ceiling interiors, clerestorey windows and the use of air-wells or internal courts. Masonry has a heat lag property that absorb heat during the day and slowly releases this stored energy at night. The colonial builders were aware of this phenomenon and thus experimented with the proportion of the interior space, placement and amount of fenestration area with also some ideas of placement and sizes of air-wells. The colonial heritage also provided Malaysia with their version of the Malay House with louvered verandah and walls to replace the ornate *serambi* ballustrade, the squat Palladian proportion to replace the high raised platforms and the hipped gable roof with ventilation openings. These buildings are identities in their own right since they represent the new Malaysian architectural entity with Western upbringing and the tools of modern technology. It is a fortunate thing that the government of the day recognizes the importance of these heritage buildings but it is most unfortunate that local architects do not appreciate their design solutions and opt for a more energy active architecture of air conditioning and electric lights.

Masjid Kg Hulu-Melaka & Amalino Bridge by Santiago Calatrava

3.1.2 Forced Architectural Identity

A forced architectural identity can be defined as that which is produced by clients for the users who have little choice in the matter. The best example that we can see in Malaysia is the modern housing estates. The main characteristics of these housing estates have hardly changed in the four decades of its introduction. The estates are laid out in a grid-iron manner which suits cars better than its human occupants. The houses are of plastered masonry in-fill walls over a reinforced concrete structural frame. The common typology is the terraced or link houses with little fenestration and hipped-gable timber roofs of clay tiles. The other typology is the walk up tenement of the same construction materials and structure. Another characteristic of the link houses includes a car porch with back alleys as setbacks. On the one hand, this is the typical modern identity that litters the country but on the other hand, much of its architectural features negate the understanding of masonry construction in a tropical setting such as those of the colonial masonry heritage. The site lay out as well as the spatial planning of the buildings ignores much of the cultural lifestyles of the occupants. An obvious clue to this malady can be seen in the renovations that are usually done just as soon as the ink on the CFO certificate dries! Forced identity is a result of pure economic concerns of insensitive developers and government agencies that fail to place the priorities of the people in relation to the cultural interpretation of architecture.

Typical housing in Malaysia

3.1.3 Manufactured Architectural Identity

When politicians and professionals begin to impose their racial and political preferences, we have an architecture of manufactured identity. Most of the prestigious architectural works in the country fall into this category. On the one hand, this approach is valid from the perspective that a new nation with a multi-cultural people needs to select the so called universal traits and introduce new ones in order to develop a 'strand' that would propel the nation forward into a success story. On the other hand, manufactured architecture to suit political whims and fancies are a farce to the spirit of times and spirit of place that marks eons of 'good architecture'. In countries where the idea of democracy and good government are the more or less sole 'rights' of one party, manufactured architectural identity is a must as a political rallying cry. The next section deals with the various manufactured identity on architecture found in Malaysia.

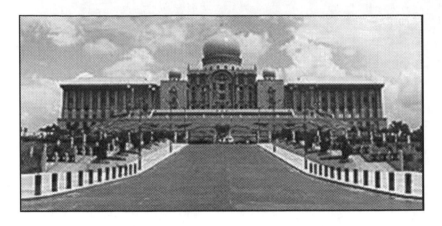

Prime Minister Office, Putrajaya

4.1 Approaches in Malaysian Architectural Identity

I have classified five main approaches in architectural design that is primarily concerned with a Malaysian architectural identity. All of these approaches are born in many different ways from the mainstream movements and approaches of architecture in the west. Except for a few, most of the approaches such as revivalism, eclecticism and the use of metaphor have a superficiality that borders more on the populist notion of architecture. Though at first machine regionalism finds much promise of exploration in ideas, its sterile product finds not much place in a society strong in its traditions and religious belief. Only a few approaches possess the potential to seriously consider the issue of a national identity but there is not much discourse which emanate from its proponents. The huge potential of post-modern architecture as presented by Jencks and Graves have yet to find the light of day in Malaysia.

4.1.1 Machine Regionalism

This approach carries with it the tradition of Mies and Corbu in considering the building as nothing more than a machine that would sieve the climate through it. Corbu's brutalist architecture as shown in his Monastery La Tourette, Villa Shodan and Chandigarh inspired the Malaysian counterparts of Kuala Lumpur General Hospital and many of University Malaya lecture theaters, Convention Halls and office buildings and Ken Yeang's Roof-Roof

house. The use of deep overhangs, 'egg crate' recessed windows, louvered shade and openings with exposed concrete construction characterised this architecture. Regionalists do not see themselves as looking for a specific national identity but merely to build a passive design shelter in response to the local climate. Some architects such as Ken Yeang carries this philosophy to such deconstructivist extremes as in the Mesiniaga in Subang Jaya. Dr. Yeang's primary intention, it seems is to answer the question of a bio-climatic skyscraper in the tropics.

Mesiniaga Building-Ken Yeang & University Malaya Lecture Hall.

4.1.2 Primitive Regionalism

Primitive regionalism is similar in spirit to that of the machine regionalist in their quest for a climatically passive design building. However, the primitive regionalist believes that materials play an important role not only as something which would weather well but it connects man to his ancient origins as part of Nature's children. Frank Lloyd Wright can be said to be the father of an organic approach which saw the potential lessons of the past traditional architecture. In Malaysia, the resort architecture of Datai in Langkawi, Sebana and Hotel Sofitel in Johor provides a tropical layout of verandahs, open buildings and lots of timber construction to suggest the fantasy of a tropical paradise. One problem with this approach is its questionable potential for public use if timber is its main character. Some believe that in order for this approach to join the big

leagues of public architecture for an urban high density lifestyle the question of reinterpreting and innovating timber construction and air-conditioned less buildings would have to be seriously addressed.

Salinger House-Jimmy Lim, Datai-Langkawi

4.1.3 Traditional Malay Revivalism

One of the earliest responses to the government's call to project a national architectural identity was the proliferation of pseudo-traditional Malay architecture. Revivalism stems from such critics as Hassan Fathi who argues for a traditional vernacular revivalism to solve the problem of housing societies. However, many architects went astray from this honorable intention and embraced revivalism as what was practiced in Europe in the 18th and 19th century after the disasters with Mannerism and Baroque architecture. The Bank Bumiputra HQ was one of the first to answer this call and Convention Halls of PWTC was also in line with the spirit. The two buildings are highly charged symbols of the Malay political power and their populist response says much about the ruling elite. Buildings such as the Losong Museum which is supposed to cater for a more general audience seems to fall into the same quagmire. The three buildings follow a similar *modus operandi* which calls for the 'ballooning' of a traditional Malay residence into a gigantic structure of concrete. The main criticism of this particular type of architecture stems from the fact that the syntax of the traditional house fits best a domestic scale structure of timber and its transformation into a different building type suggest that the Malays may not possess high imagination and creativity. A similar

revivalism tendency that swept England and America in the 18th and 19th century saw critics like Louis Henry Sullivan attacking the inappropriateness of 'everything Roman and of totalitarian values' into an American bank of a democratic one. The National Museum in Kuala Lumpur seems to save the day with its honest attempt of arriving at a new vocabulary which saw the synthesis between classical monumentality and the sedate use of gable roofs and ornamentation. It may be argued that this approach may have taken the extension of the colonial stroke of synthesising European Classicism and the Malay vernacular. The Restoran Seri Melayu offers an interesting response to the problem of scale by breaking up much of the mass of the building thus retaining the humility of the Malay house but with a new function of a restaurant.

Putra World Trade Centre & Losong Museum

4.1.4 Metaphor

The use of metaphors are identified with architects who view buildings not as mere shelters but as a totem pole riddled with messages. Although there were a few modernist who violated the cardinal rule of strict mechanical boxes, architects like Wright and Saarinen managed to get away quiet well with their own abstract rendition of flight as in the TWA Terminal and the praying hand as in the Madison Unitarian Church. Malaysian architects came out with their versions of metaphors as seen in such buildings as the Maybank *keris,* the National Libraries romance with the *tengkolok* or Malay traditional male head dress, the National theater's *sirih junjung* and the Telekom HQ 's *pucuk*

rebung. The main attraction of this approach is again its populist appeal and the human weakness for novelty. Although the intention of these metaphors are serious in the eyes of the clients and the architects, one could not help but wonder how such vocabulary would fare with a new generation that no longer recognises these artifacts as primary symbols in their lives. Another criticism is about the reading of the metaphor. Charles Jencks suggest that the use of metaphors is better when one has to guess at its meaning rather than a direct reading. The abstract nature of Corbusier's Ronchamp, Wright's Unitarian Church, the Sydney Opera House and the TWA Terminal are testimonies to the potential strength of a suggestive metaphor.

Tabung Haji, Maybank, Menara Telekom & Balai Seni Lukis

4.1.5 Modernistic Expressionism

We have phrased the term modernistic expressionism to describe the National Mosque, the Parliament Building and the State Mosque of Negeri Sembilan. The term modernistic implies the machine approach of building as a climate sieve as in the works of Ken Yeang with a rejection of direct historical reference in its image. The term expressionism is used by historians and critics of architecture to describe a certain bent in modernist architects to use abstract metaphors which are almost always 'structuralised'. The Masjid Negara or the National Mosque is an excellent and unique creation of Malaysian architecture in that it frames the whole building as a huge *wakaf*-like shelter or as a generous *serambi*-verandah structure. The building is horizontal in expression and this

serves well the vocabulary of humility in Islam. The fact that the building is a tropical model with a lot of fenestration punctured by light-wells with ponds as inner courts add to the idea of moderation in the religion. The rejection of symmetry and a strict hiearchical composition of the massing presents well the image of Islam as a religion of the people rather than the poor middle-eastern imitation of domes, arches, courts and minarets common to the other mosques of its time and particularly of the present era. The mosque is an abstraction of the Malay house as evidenced in its raised prayer hall and *serambi*. The roof which covers the mosque proper or the prayer hall is a folded plate structure which is chosen because of its metaphor of a royal umbrella. The metaphor is seen as a reference to the mosque's uniqueness as the 'sultan' of all mosques in Malaysia and is meant only for this particular building. The Negeri Sembilan State Mosque is shaped with several intersecting conoids of reinforced concrete shell structure to refer perhaps to the curved Minangkabau *gonjong* roof forms. Thus, as in the folded plate roofs of Masjid Negara, both buildings use metaphors that are integrated with the building structure. The Parliament Building presents two contrasting massing of a tower with suspended outer scales as sun shading device against a jagged pitched roof of reinforced concrete frame meant to refer to the high-pitched gable roofs of the *Nusantara* traditional architecture. The building presents a unique statement of democracy in Malaysia in its caution of not using any strong ethnic reference, its asymmetrical composition when seen from afar and finally its spartan image void of frivolous ornamentation.

Parliament Malaysia, National Mosque, Negeri Sembilan Mosque.

4.1.6 Eclectic and Ornamental Buildings

Buildings in this category stems directly from the post-modern movement that unleashed a sense of raiding the historical past. Local architects were quick to capitalize on this approach without having much time to understand the background of the post-modern ideas. Most of the ornamental buildings in Malaysia do not attempt any position on national identity but was born primarily because of the idea for fun and fantasy. Many resort developments such as the Sofitel Hotel, Sebana and the Pulai Springs Club in Johor uses carvings at door panels in some of the main assembly rooms. The Sunway Pyramids, the Palace of the Golden Horses and the Sunway Resort hotel which is the imitation of the Palace of the Lost City resort in Africa are buildings that are fully ornamental. The Putra Mosque, the Wilayah Mosque and the Shah Alam Mosques are those that are decorative in the way of using so called Islamic geometric patterns and calligraphy over their revivalistic and eclectic assemblage of domes and arches. The closest design consideration of ornamental identity are the Putrajaya lamp posts that litter the roads with its many different modern 'awan larat' modes. Buildings such as the BSKL building, the Times Squere and others resort to meaningless circles and squares adorning the top of the buildings. The Daya Bumi Complex with the Skudai Municipal Building both uses 'Islamic geometrical pattern work' as false curtain wall to perhaps identify it as an Islamic oriented architecture.

Sunway Pyramide, Shah Alam Mosque.

5.1 Reintroducing the 'Semangat Ukiran Kayu' in Contemporary Architecture in Malaysia

From the above deliberation, it can be seen that the idea of ornament had gone through many changes and development in the West. It can also be seen that in Malaysia there is very little development in the idea of ornament in Malaysia aside from the frivolous, simplistic pasting and dubious attempts as described in the previous section. The problem of reintroducing the wood carvings in Malaysia must necessarily fall under the bigger question of ornament, meaning and architecture.

5.1.1 Developing the Discourse

In order to develop the discourse on ornament and architecture, we must be clear on the question of what is ornament, what is its purpose, and what it was in the past. I choose to dwell with the question of what is ornament first as a philosophical beginning rather than to its historical roots. Normally it is more important to start with the historical meanings rather than the philosophical musing. However, I have always believed that reason must come first before embarking on any other research question.

I propose that the term ornament as used in the Western parlance was a product of modern historians who have undergone an outlook of life that are no longer religious. With the age of enlightenment, where the dogma of religion was replaced by the rationalism of science, the religious with its rituals and values were replaced with the animalistic idea of man as a biological entity in need of simple shelters just like bees or rabbits. Modern secular man saw no use for religious rituals like performing prayers and opted for a more intellectual and physical fitness program of life. Values of secularism relate not about doing good but to self propagation and survival only. In this respect, the Greek carvings that had religious meanings as well as the Gothic statues that had educational messages and also the calligraphic words of Allah are no more than 'any element that had no constructional or functional use'. Secularism does not recognizes solat as a necessary function because it is not part of the biological need for survival. However this view can be challenged by those who view man as a moral and spiritual creature with values and culture that would help create the most humane of human societies. Thus fasting, solat,

pilgrimage and many other rituals actually perform the many biological, social and spiritual needs that would truly make man a complete human being. Thus, ornament of carvings and such help to remind man of certain religious messages as well as define the sense of space which one is in. I agree with the Post-modernist that a building is a totem pole of communication. We have to be able to 'read' a building in order to be able to function and be inspired in it.

Next comes the question of what ornament in Malaysia was in the sense of its meaning. There is very little work done to document and research the forms, placement and meanings of ornaments in our heritage buildings from houses to shops, mosques, palaces, temples and kongsi houses. I suspect that very few attempts have been made to research the meaning of ornament simply because no one saw its potential use as a tool of architectural communication but merely as a unnecessary beautifying element that has very restricted use then and now. I hope that many would now come forth to research the meanings of our traditional ornaments. I suspect that many of our traditional ornaments will show an intellectual and cultural integration between our diverse ethnic heritages. Would this finding not help the state of our racial harmony that now hangs in a dangerous imbalance? I would think that ornament would help tremendously the idea of a Malaysian identity that is not too parochially interpreted as a single ethnic expression.

5.1.2 Transforming Ideas of Ornament towards Contemporary Relevance

Practitioners of architecture and educators must first of all unlearn their idea that modern architecture had a single machine strand. They should study up on the architecture of Wright, Arts and Craft and Art Nouveau to familiarize themselves with some of the discussions on the role of ornament in architecture. Architects and educators must also re-look at their understanding of post-modern discourse on meaning and architectural form in order to rethink the idea of ornament as a simple applied form to a wall and transform it into three dimensional architectural elements.

Critics of this approach might point out that in one sense we would be subjecting traditional ornaments like wood carvings to an intellectual framework that is alien and thus any product of this forced identity might produce a low quality product. It may be possible to train new architects and designers by immersing them with the world views of traditional Malay and

Chinese cultures and having them apprenticed to the master craftsmen but the logistic problems may be a factor. However, I support the idea of a small group of students and architect using this approach of apprenticeship to master craftsmen in order to preserve the heritage and pass it on as it was practiced for a long time. I am more of a strong supporter of the first approach where I find much relevance in using the western intellectual framework within the contexts of Malaysia's new political and social system. After all, architecture is not a piece of painting that sits in a museum isolated from the physical happenings of society. It must show relevance today and in the future. For instance, there is the question of motif in architecture. Of what relevance does the *pucuk rebung* has as used in Hijjas Kesturi's Telekom Building, or the *keris* in the Maybank Building, the *sirih junjung* in the Istana Budaya or even the *tengkolok* in the National Library. How many modern Malays would identify with such symbolism. What does it say about out democratic ethos of multiracialism? I think we need new motifs and thus new expressions to bring about a new Malaysia within the spirit of multiracialism and the spirit of the times.

5.1.3 Timber Economics

Finally, there is the pragmatic question of timber economics which has direct relevance to the 'semangat kayu' of traditional carvings. There are two problems that must be solved in order for timber to make a comeback in mainstream architecture. First is the question of permanence and second the question of export economics.

The question of permanence is a matter of attitude and not of technology. With the proper treatment and certain type of hardwood made commercially available, timber can last a long time as much as a century even for outdoor use. The JKR Police Barracks in Taiping and Butterworth uses timber as its outside wall panels on a four storey high rise family flats. The timber is still in excellent condition after almost half a century of use. The fire retarding quality of timber has been made longer by today's technology. There is also the added bonus that timber does not store heat like masonry and thus contribute to passive cooling strategy. I do not see why timber cannot be used extensively in buildings less than 10 storeys with the proper overhangs and shading devices. America is known to use a lot of timber not only for domestic architecture but also for auditorium halls and the like.

The second question is of pure economics. Malaysia exports her timber more than she uses them. The result is a material that is more expensive than any other. Timber is now an elitist element when once it was a popular material. Only hotels and resorts use timber to impress their clients with the fantasized idea of nature and organic integration. I do not have much expertise in the timber trading economics to offer any remedial suggestions. I only call upon those who do have the expertise to sit down with the architects and work out an idea of how timber as a sustainable and an eco friendly material can come back as a viable alternative building material.

6.1 Conclusion

I have attempted to illustrate how timber wood carvings in Malaysia has suffered the same fate of 'discontinuity' as other traditional carvings from the perspective of the discourse on ornament and architecture. The modern and post-modern discourse has been poorly understood in this region to the point that blind imitation of forms has led the way to our separating the traditional heritage into an architectural limbo. It is important at this juncture of history to look back not only of our responsibility at understanding and documenting our heritage but we also have a double responsibility of rethinking the western modern and post-modern discourse. It is only then that we might find the relevance that we seek in order to promote a more viable alternative to a meaningful Malaysian architecture. The semangat kayu of traditional wood carvings must evolve into shapes and ideas that must suit the spirit of the times in a dynamic country that has firm roots in the eternal values of culture.

Bibliography

Blake, Peter (1960). *The Master Builders*. New York: Alfred A Knopf.

Blake, Peter (1974). *Form Follow Fiasco*. USA: Atlantic Little, Brown Books

Chee Yoong, Chan (1978). Post-Merdeka Architecture Malaysia: 1957-1987. Kuala Lumpur: Pertubuhan Arkitek Malaysia.

Corbusier, Le (1962). *Vers Une Architecture: Architecture of Pure Creation of the Mind*. Colombia Universiti.

Cumming, Elizabeth (1991). *The Art and Craft Movement*. London: Thames and Hudson.

Gorton, Julia (1992). *Ancient Greece*. London: Hamlyn Children Books.

Jencks, Charles (1977). *The Language of Post-Modern Architecture*. New York: Rizzoli International Publication Inc.

Jencks, Charles (1985). *Symbolic Architecture. New York: Rizzoli International Publication Inc.*

Pertubuhan Akitek Malaysia (1987). *Post-Merdeka Architecture 1957-1987*. Kuala Lumpur: Pertubuhan Akitek Malaysia.

Pevsner, Nikolaus (1943). *An Outline of European Architecture*. Middlesex: Penguin Books.

Pugin, A Welby (1977). *The True Principles of Pointed Architecture*. London: Academy Editions.

Ruskin, John (1925). *The Seven Lamp of Architecture*. London:George Allen & Unwind Ltd.

Tajuddin M Rasdi, Mohd (1999). *Seni Bina di Malaysia: Kritikan Tentang Seni Bina Islam, Identiti Nasional dan Pendidikan*. Selangor: Design Modular Sdn Bhd.

Tajuddin M Rasdi,. Mohd (2001). *Identiti Seni Bina Malaysia: Kritikan Terhadap Pendekatan Reka Bentuk*. Johor Bahru: Penerbit Universiti Teknologi Malaysia.

Tajuddin M Rasdi,. Mohd (2003). KALAM Papers: *Housing Crisis in Malaysia: Back to a Humanistic Agenda*. Johor Bahru: Pusat Kajian Alam Bina Dunia Melayu (KALAM).

Wright, Frank Lloyd (1943). *An autobiography by Frank Lloyd Wright*. New York: The Frank Lloyd Wright Foundation.

Wright, Frank Lloyd (1949). *Genius and Mobocracy*. New York: Horizon Press.

Wright, Frank Lloyd (1957). *Truth Against the World. New York: A Wiley-interscience Publication.*

Wright, Frank Lloyd (1957). *A Testament*. London: Architectural Press.

Wright, Frank Lloyd (1958). *The Living City*. New York: Horizon Press.

Wright, Olgivanna Lloyd (1966). *Frank Lloyd Wright; His Life, His Work, His Words*. London: Pitman Publishing.

Wright, Frank Lloyd (1954). *The Natural House*. New York: Horizon Press.

18

A Tale of Two Democracies: Parliament House versus Prime Minister's Office in Putrajaya

Introduction

The main intention of this essay is to initiate an architectural discourse concerning the idea of 'democratic architecture' in reference to its design language. This is not an essay about whether a country is democratic, less democratic or even a 'feudal-democracy' i.e. a country that displays its constitution but hardly practices the very spirit that it embodies. This is an essay about architecture, directed mainly to the architects to implore them to pause before doing the biddings and prostituting for their wealthy and powerful clients i.e. the local, state or federal government. I believe that whatever outcome an architectural project comes to, it is always the signature of the architect that carries the success or failure of the project. The architect is responsible because he followed blindly the very bidding of the clients. The architect is responsible for not consulting the relevant academics or experts in such inquiries of architecture. The profession is responsible for not having an opinion or being too cowardly to express one.

I have chosen to write my thoughts concerning the comparison between the Parliament building and the grandiose Prime Ministers Office in Putrajaya. I will explain firstly my opinion that the Parliament building has many characteristics that I deem democratic than that of the building in Putrajaya.

Why is this discourse such a concern? When I laid eyes on the Putrajaya building I said to myself that this imposing feudalistic monstrosity will be emulated by the rest of the state architecture in the country and that includes the local municipalities. Needless to say, I was right when Penang announced its own version of Putrajaya; the word 'Putrajaya' is now synonymous with the ideal architecture of statehood, domes and all. The Skudai municipality at where I live and where UTM resides now embellish its streets with ornamented roadways, art nouveau lamp posts and expensive sculptural landscape. I would not venture to say anything at all about Melaka as it is a lost cause with its regimented yellow and red plastic trees. There seem to be an air of competition to be the biggest, the most lavish and the most grandiose so as to follow in the footsteps of the shiny new city of Putrajaya. All these things happen whilst there is little effort to put pedestrian pavements in the streets, proper crossings for school children, enough branch and community libraries, temples, community centers and public furniture where the public can actually use them. Are we architects blinded by our ignorance, fees or cowardice not to say anything about such issues? The silence in a media saturated world among the profession and its so called professional body, PAM, is absolutely deafening. The first lesson of democratic architecture is lost where what is discernable is the architecture for the few and not for the many.

Single Ethnic Reference

With regards to the comparison of democratic architecture between the PM office in Putrajaya and the Parliament building, I wish to deal first with the question of ethnic references in architecture. In my idea of a democratic architecture, one either uses all the ethnic references or one does not refer to any at all. To emphasize one particular ethnic reference is quiet out of character with a constitution that guarantees equal rights to all. Granted that Malaysia is a country of the Malays in respect to history, but need one shout that message to the level of breaking eardrums? The Putrajaya building with its domes attempts to claim a Muslim heritage which inevitably leads back to the Malay ethnic origin in a no nonsense attitude. The Parliament building, sporting the international style, speaks no ethnic references and resorted to the tropical heritage as its dominating theme. The ribbed prism on its podium speaks universally of a traditional roof heritage common to most ethnic groups

in this region. Though some architects may frown at my idea of a multi ethnic eclectic approach, the fathers of architectural semantics would agree with me that such an approach is viable. Of course architects have to stretch their minds a little to do some 'thinking' rather than their usual 'typological copying' modus operandi.

Regionalism and Accountability

Next, let us venture into the realm of architectural regionalism. Regionalism as an approach found favour among architects after the energy crisis. Le Corbusier, the White Master began displaying deep sun shading recesses, 'egg crate windows and chunky brute exposed concrete construction. Never mind that he was half a decade late than Frank Lloyd Wright. In Malaysia, experiments with regionalism produced some marvelous buildings such as the National Mosque with its use of generous *serambi* areas, air wells and light courts with thru-ventilated wall assembly. The Parliament building did not go as far as the National Mosque but it does display the famous 'pineapple skin' that some say functions as sun shading devices. It matters not whether there is a great savings of energy in relation to the office tower cooling load but the message of democracy is clear: you simply don't mess around with the public money held in trust by the elected leaders. The money belongs to the people who are the true 'bosses' in a democracy. What does Putrajaya show in reference to minding the public funds? There is no discernable attempt to even create any kind of shading device or *serambi* that would act as a peoples' welcome platform. Its French palatial architecture is starkly clear in imitation since those palaces never needed any shading devices in a temperate climate.

Imperial Garb

Thirdly, I wish to focus on the imperial language used in the Putrajaya architecture as opposed to the 'business-as-usual' architecture of the Parliament building. In his writings and speeches, Frank Lloyd Wright would always criticize such palatial architecture as that in Washington D. C. He was in prison for a day when he refuses to retract his cutting comments on the Madison state architecture. Wright simply feels that to emulate architecture that comes from an aristocratic or autocratic regime of the past is not a true attempt at portraying

the new ideals of democracy which gives the power of governance to the people and not to the elite. Wright's architecture would always choose asymmetrical massing over that of symmetry, the use of the horizontal expression of humility to the Earth as the Nurturer and the celebration of local materials as economic products of weathered quality. The palace architectural characteristic of strong hierarchical symmetry with expensive materials and ornamentation set amidst deep setbacks of lavish garden landscaping is truly in stark contrast to say the Parliament House in London. I feel a sense of a sure and strong nation when I see the Parliament House in London because of its easy accessibility to the public. The building is a stone's throw away and that speaks volumes about the idea of a democratic nation. For those who try to expound the virtues of security in the French palatial format, I wish to say that in a democracy, the safest security are not walls, setbacks and electronic surveillance but simply the idea that if one leaders die, there are many more that can easily take over. Unlike a monarchy whose very survival depends entirely on the survival of the offspring, a democratic architecture does not hide behind thick walls and setbacks. It meets the street where the people walk and is a true testament that this is the government of the people for the people and by that very same people. The Parliament building in Malaysia does not pretend to be a palace as one approaches the building from whichever direction. Though it is somewhat elitist in its location in the midst of a serene landscape, there is much that we can improve in future state architecture with respect to meeting the people rather than hiding from them. Anyway, any one with half a mind can testify that after the September 11 attacks, there is little point in architectural 'hiding'.

Conclusion

There are many more things that I wish to say about the idea of a democratic architecture with specific references to Malaysia. In our book, Konsep Perbandaran Islam: Suatu Gagasan Alternatif, Mr. Rosdan Abdul Manan and I toyed with the idea of a public square in the middle of the capital city where the public actually need no permission to enter. The state buildings and mosques would be relegated to the perimeter in an asymmetrical layout. The public square or *medan* is the testament to the idea of democracy is power to the people. We had also suggested that there be a cemetery adjacent to the square within view of the executive structures. This is to remind the leaders

who aptly forgets that they are mortals after all and thus the power vested in their persons are but fleeting.

The Parliament building was built during the heyday of modernism where metaphorical references was frowned upon. It could not help but be what it is now. I would attribute the idea of democracy as an 'accidental' effort in absence of a serious study on the influences of the Parliament building. Putrajaya, however, was a deliberate act. In one sense the feudalistic message it carries, truly exemplify the nature of 'democracy' in Malaysia where many of its citizens have a complete apathy to the idea of 'power to the people'. Yet, as a Malay, a Muslim and as a Malaysian I cannot bring myself to accept this language as the ideal embodiment of the original spirit of the Malaysian Constitution.

19

Dewan Jubli and Multi-racial Architecture

I wish to write today about a little known building that might just serve as a significant contribution to our One Malaysia call by the Prime Minister; The Dewan Jubli Intan in Johor. The issue of administrative architecture might have been a fore gone conclusion with the advent of Putrajaya to proclaim a clear and distinctive administrative architecture overpowering in its Malay-Muslim dominance but in the light or the March 8th election 2008 and the recent speech by the Prime Minister of Malaysia and the President of the ruling political party, the consideration of the 'democratic architecture' may be of paramount concern.

The Parliament Building of 1963 was a statement of socialist architecture with an architecture that spoke of universalism and non-ethnic references. The architecture was tropical with its sun shading devices and unadorned with ornaments or lavished with opulent materials that spoke of an accountable government.

The buildings of Putrajaya proclaimed a dominance of Malay political power in the Mahathir era. The imperial language of a palatial language was a clear reflection of the administration being looked upon as the new 'aristocrats' of Malay leadership. With the influence of Islam as an overriding force of the 20th century, the language of Malay and Islam became an administrative mantra that echoed in the political policies of that era. Nusa Jaya administrative architecture carried that idea of Malay monumentalism albeit in a slightly less grandiose manner. Among the government's preferences of architectural language for administratrive building is the Malay or Malay-Muslim revivalist architecture. This object-centered approach is popular as it is easily recognizable and straight forward. However such attempts

at simplistic revivalism such as the buildings like the PWTC Convention Hall, the UTM Chancellery, the Bank Bumiputra and many others, these buildings can come under the criticism of a regressive and dogmatic architecture. Regressive means that it looks backward and dogmatic means unchanging or undisturbed.

It seems that the architecture of administration building was set to be within the Malay-Muslim essence but the March 8th 2008 General election brought new questions about the political direction of the country. With the loss of massive votes from the non-Muslims and the young adults who voted for issues rather than on racial lines the President of UMNO has no choice but to make the following statements:

> Ladies and Gentlemen, coming back to the party's struggle, for us to continue to gain the support of the masses, Umno must be seen, perceived and accepted with confidence as a party that is solid in fighting for the *rakyat*. Umno cannot be seen as a party which is passionate in fighting for only a small group.

> In Bagan Pinang, we found that the non- Malays have accepted Umno with an open heart. Clearly, in constituencies where voters comprised a multiracial community like this, we want Umno to be accepted by the *rakyat* as a party that fights not only for the interests of the Malays and Bumiputra, but encompassing all ethnic groups in Malaysia. (The Star, Friday 16 October 2009, page38)

What then would be the future direction of administrative architecture for this country? Will it follow the Mahathirian conception of absolute and total Malay-Muslim supremacy or as with the Parliament Building,the administrative architecture should look at more regionalistic? I present here an unknown third alternative which is embedded in the architecture of the Dewan Jubli Intan built in 1955 in Johor. The following essay is an extract from the work of my student, Ong Teen Nah who managed to interview the architect, Mr. Raymond Honey.

The proposal of the Dewan to commemorate the Sultan's Diamond Jubilee had taken place prior to Merdeka. Coincidently, the preparation for Merdeka had prompted General Templer's call for buildings to reflect the national identity.

Lieutenant General Sir Gerald Templer was appointed as High Commissioner in Malaya on 7 February 1952 to take the reins of fighting the Malayan Emergency.

With the aim of creating a national consciousness, General Templer had felt that locals who saw public buildings as 'Malayan' would themselves begin to feel Malayan, fostering an awareness on the country's pre-colonial cultures and subsequently, creating an assimilation of a new cultural synthesis.

Situated within the old town centre of Johor Bahru, the Dewan Jubli Intan nestles within the historical part of the city. It is surrounded by historical buildings with strong history and reputation of their own. Among them are:

Istana Besar was formerly the official residence of the Sultan of Johor and is one of the oldest buildings in Johor Bahru. This two-storey building holds a majestic impact for visitors traveling along the coastal road and is a magnificent sight on its low hill overlooking the Straits of Malacca. The foundation stone was laid by Sultan Abu Bakar himself 1864. The building was completed two years later.

Istana Besar & Johor State Royal Museum

The palace was built by a local engineer Datuk Yahaya Awaluddin and based on a mixture of English-Malay architecture. The external design of the building is predominantly European whereas the interior provides a fascinating glimpse into the Malay royal life.

3.3.2 Sultan Abu Bakar Mosque

Perched atop a hill overlooking the Straits of Johor, the Sultan Abu Bakar Mosque is situated at Jalan Abu Bakar, not far away from the Grand Palace or Istana Besar. It is regarded as one of the most beautiful mosques in Malaysia.

Sultan Abu Bakar Mosque

Commisioned by the Sultan Abu Bakar, the foundation stone of the museum was laid by Sultan Abu Bakar himself in 1892.

The Sultan Ibrahim Building (Bangunan Sultan Ibrahim) also known as the State Secretariat Building is located on Bukit Timbalan. It was built in 1936 and completed in 1939. Officiated by Sultan Ibrahim in 1940, it houses the state secretariat as well as other offices of the state government.

Sultan Ibrahim Building

The idea to build the Saracenic character edifice was mooted by Sultan Ibrahim to symbolize Johor's progress during that time. Built by local craftsmen under the supervision of a European architect, the building blends the cosmopolitan architecture of Renaissance style with an overlay of Anglo-Malay influence.

Mr Raymond Honey's contributions to the local architectural scene were carried out in a span of 12 years, from 1950 to 1962. He began with the role of an architect in the Headquarters of the Public Works Department (now JKR).

Mr Raymond Honey was among the first individuals to address the issue of Malaysia's national identity and Malaysian architecture in writing through his article, 'An Architecture for Malaya' in the 1960 edition of PETA, now Majalah Akitek and another discussion in PETA a year later. He had also given a talk in the JB Rotary Club in 1957 addressing the issue of "Architecture Here and Now". Other than contributions in the architectural scene, Mr Honey was involved in numerous advisory matters and discussions on Malaysian Architecture.

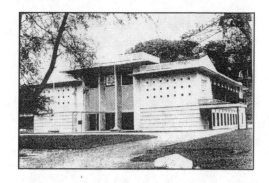

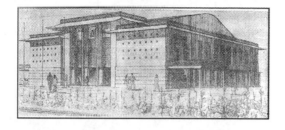

Overall front façade of Dewan Jubli Intan, as seen at present(the porch is new)
The completed Dewan Jubli Intan in its original form
(source: The Architecture of Malaysia, Ken Yeang

A rendered impression of the original design proposal for Dewan Jubli Intan
(Picture complimentary of Mr Raymond Honey)

The proposal for a Town Hall in Johor Bahru was conceived at a time where aspirations for expressions of 'Malayan Architecture' were at its infancy. It was to commemorate Major-General Sir Ibrahim bin Almarhum Sultan Abu Bakar, the reigning monarch's Diamond Jubilee in 1955.

It was a time where Malaya was still recovering from the war and in the process of fighting and eliminating the communists. Very few large buildings went up until after Merdeka for it was a time before an independent government could formulate what it wanted to do and express.

In the light of prevailing western architectural fashions of that period, the formal, symmetrical and decorated elements of the Dewan were very much out of character of the time. Mr Honey suspects that Dewan Jubli Intan was viewed with embarrassment by contemporaries of his time. The new town hall was the only public building that boldly responded to General Templer with the attempt to assimilate elements of the various cultures and races in Malaya. It introduced elements of Mohammedan, Moghul and Chinese architecture.

The foundation stone of Dewan Jubli Intan was laid by Sultan Sir Ibrahim before the building was designed. In respect to the great offices on Bukit Timbalan, the roof of Dewan Jubli Intan was originally designed to acknowledge its stamp in the town. The architect further explains that the roof is also injected with elements in Moghul architecture, representing the Indian community of Malaysia. The Moghul influence is also seen in the proportion, formality and symmetrical expression on the main façade.

Indication of the façade composition of the Dewan in comparison to the Moghul architecture

Another interesting feature of the roof is its original idea of raising and turning up the corners on the Moghul hood. The raised corners resemble the traditional Chinese roofs and represent the Chinese community in Malaya. However, around the time of Malaya's Independence, this idea was withdrawn. Mr Honey does not regret the fact that the idea did not survive. To him, it was perhaps the sort of eye-catching feature which suited an exhibition or something ephemeral.

A newspaper cutting featuring an artist impression of the original design of Dewan Jubli Intan, complete with the initial proposal of raising the corners of the roof (Pictures complimentary of Mr Raymond Honey)

The influence of the Malay traditional motifs and crafts are clearly seen in the decorative elements throughout the building. The balustrades, wooden doors, window details and openings throughout the interior are in fact, mostly replicas of old carvings from Istana Besar from the 18th Century. Some however, are of simple but geometrical motifs designed by the architect.

Interior details of timber based on traditional motifs

One of the stronger Chinese contributions to the building is the square openings running along the perimeter of the building. Each of these intricate squares was in fact salvaged from demolished actual old shophouses.

Composition of the squares Chinese
elements of the building

Finally, with all this talk of One Malaysia, how would the government respond with the building of the future public structures such as administration buildings, universities and the like? Will we still see the over dominance of Malay architecture or one that is modernized or perhaps we might take a bold step in a creative eclectic adventure of languages and ornaments of our various cultures. If the Malay language can be a combination of more than ten other languages, why should architecture stop at only one?

20

The Political Ideas of Islam and their Influence on Mosque Architecture in Malaysia

Introduction

The main purpose of this paper is to initiate a discourse on how the various perspectives and ideas of 'political Islam' influences the design decisions of mosque architecture in Malaysia between the period of 1955 prior to independence and until 1998 when the new city of Putrajaya was unveiled to the public.

The paper focuses on three different ideas of political Islam as propounded by the first prime minister of Malaysia Tunku Abdul Rahman, the present prime minister Dr. Mahathir Mohamad and that of the present head of the opposition party, Tuan Guru Abdul Hadi Awang. The three mosques chosen for discussion which are the National Mosque in Kuala Lumpur, the Putra Mosque in Putrajaya and the Rusila Madrasa in Kuala Terengganu represents the ideas of the three politicians respectively.

In brief, the National Mosque represents the idea of Islam in relation to a new country trying to manufacture a Malaysian identity worthy of its multi-religious context with a tinge of pro-Western 'progressive' idealism framed within a strong modernistic movement among its early architectural elite. In contrast, the Putra Mosque brazenly declares the dominance of Malay-UMNO politics in the local context and herald the introduction of Malaysia

as a global player in the Islam-Western political equation within an atmosphere of an intellectual uncertainty of the local architectural profession. However, the simple, unpretentious and quite resolve of the Rusilia Madrasa represents the up and coming force of Islamic 'fundamentalism' framed in a mosque not designed by any architect but possessing a socially integrative organic growth.

The Political Ideas of Islam

For the purpose of this short essay it is necessary to explain the meaning of the phrase 'political Islam'. The use of the phrase in actual fact suggest that there is such a thing as a non-political Islam or an apolitical Islam. It must be understood at the outset that Islam is Islam and such use of the phrase must be seen in the light of the users' ultimate intention in providing an academic discourse. In the Western anthropological or sociological parlance Islam is a 'religion' with a belief system and a set ritual with an underlying value system as its foundation. I wish to point out simply that Islam exists in many perspectives consciously or unconsciously realized. For instance, to the Malay community of Malaysia, Islam is but an integrated part of its culture and customs. To ordinary Malays most rituals deemed religious and magical are inherently 'islamic' when such attitudes actually raises deep frowns among religious scholars and academics who know the difference between what the Prophet Muhammad had taught and which are the 'innovations' of a particular race. Then again, there are those political masters who would appeal to certain strong uniting and inspiring aspects of Islam in the hope of developing their people or their own agendas without giving much concern over the whole plethora of 'Islamic values' as exemplified by the *sunnah* (the way of the Prophet Muhammad). And yet there are still those deemed 'sufist' who integrate various rituals and rationales of other religion into the message of Islam in order to create the idea of an all important 'inner spirituality' devoid of concern over the mundane affairs. Finally, there is also the version of Islam that sets itself a nation building agenda using the eternal values of the prophet interpreted within the socio-cultural and technological context of the times. Thus, in one sense, these are all a sample of the different political idea of Islam because it involves a process of inculcating values into a community and not merely as a private worship. With the strict institution of the congregational prayers, Islam

assures itself a strong political presence as opposed to those of other religions which had to invent community rituals in order to stay relevant.

The following sections attempts to illuminate how such political ideas of Islam manifest itself into the architecture of the mosque in Malaysia, thus putting a big question mark upon those architects and academics who are striving with the idea of a single unifying idea of 'Islamic Architecture'.

Masjid Negara and Tunku Abdul Rahman's Vision of Islam

Built in the early 1960s, the National Mosque in Kuala Lumpur still stands today as a unique contribution to the idea of mosque architecture as well as a monument to the strife for a national architectural identity. The most distinguishing features of this important monument is the generous floating verandah that forms a horizontal plane hovering shy of the earth surface. There is no mosque to date that has a verandah space that is larger than the loosely enclosed space under the umbrella like roof. The other distinguishing feature is the folded plate roof that departed from the clichéd Indian styled onion domes prevalent in the colonial days prior to independence. The third important feature is its assymetrical massing which is highly uncharacteristic of monumental state mosques or buildings of that time and the times preceding. The mosque sits relaxed in a site close to the urban fabric rather than on a hill or in the middle of a lake as if in an act of seclusion.

I strongly suspect that the Tunku, in his effort to rally the Malays behind him, chose to project the importance of Islam as a unifying tool. The Malay, before independence was a parochial minded entity loyal only to his or her own particular state. Islam remains one of the strong common features among the Malays and the Tunku set the foundation to make Islam a strong political character not only in local politics but also in the international scene. The decision to build a national monument in the form of a mosque can be seen as a political strategy towards this unifying effort. Coupled with the strong influence of late modernism that shun symmetery, grandeur and exotic revivalism, the Tunku allowed a 'progressive' idea of the mosque in a dynamic but humble expression. The use of courtyards, pilotis and fully ventilated enclosures, make the building calls onto the spirit of the place in its tropicality thus striking a common cord of identity in the newly formed country.

Thus the political idea of Islam present in the National Mosque was as a unifying tool of the Malays, a statement of common national identity coupled with a relaxed and 'progressive' idea of Islam as a local and international force.

Putra Mosque and Dr. Mahathir's Vision of Islam

Unveiled in the final decade of the 20th century, the Putra Mosque sits majestically in the center of the shiny new city of Putrajaya, the brainchild of the fourth prime minister, Dr. Mahathir Mohamad. Amidst great praises by the tamed mass media and cutting criticism from opposition parties and academics, the new city pushed its way into Malaysia's history as a prime example of authoritarian decree in a rhetorical idea of a democracy. The design was in hush-hush so much so that much debates and opinions surface only after construction had gone more than half way.

The Putra Mosque is a complete anti-thesis to the National Mosque. As the National Mosque sits in a relaxed assymetrical mass, the Putra Mosque rises up in a grand fashion with a commanding view of its huge man made lake. As the former sits within a tight periphery of the urban side of Kuala Lumpur, the latter commands large real estate as a sculptural beacon of the city. The Putra Mosque calls on a foreign eclectic revivalism of Egyptian and Iranian vocabulary in contrast to the modernist garb of the National Mosque. With such architectural attributes there is a different political idea inherent in the structure which can only be understood by realizing the strong personal agendas of Dr. Mahathir Mohamad.

Dr. Mahathir came into power as a no nonsense 'ultra Malay' leader with no aristocratic background. He was never placed in his early political career as an 'Islamist'. As one of the rare early Malay medical practitioner, he brings a clinical approach to political problems with not much concern over old ideas, concepts, customs or even values. His reign on Malaysia's political scene came with the rising tide of Islamic reformation movement throughout the globe. The Iranian revolution to oust the tyranny of the Shah and the United States set the world in a new order of political equation. The success of Islamic movements in Algeria and Sudan gave pause to the feudalistic reign of NATO, USA and the USSR. After hundreds of years of decadence, Islam was once again a force to be reckoned with.

History saw Mahathir deftly handling the Islam issue by riding with the wave of reform. His assimilation of the charismatic young idealist, Anwar Ibrahim into the cabinet set the country to be the foremost example of not only a model for Muslim countries to emulate, but also as an alternative idea to that of Western secularized notion of civilization. In a single stroke Mahathir had pushed Malaysia to almost center stage in global politics as well as checked the advance of the main Islamic party PAS for two decades by his adoption of policies deemed as progressively Islamic. With Anwar Ibrahim at his side both leaders developed universities, academic institutions, economic structures, social policies and a cultural revolution that saw dress codes of the *tudung* (women's head dress) change almost overnight the Malaysian scenery.

I, therefore, suspect that the deliberate choice of Middle Eastern and Central Asian revivalism of mosques was an attempt to identify Malaysia as the new center of Islamic civilization. Amidst the dictatorial regimes of Kings, Generals, Colonels and Presidents as in Saudi Arabia, Libya, Iraq, Egypt and Indonesia, 'moderate Malaysia' seemed a plausible cradle for the new birth. Coupled with an architectural profession which is more passive and empty of ideas, the post-modern revolution in the West had opened the door of revivalism. History saw local architects caving in to the exotic ideas of revivalism proposed by the clients. Anyway, revivalism usually means huge expenses and thus, high commission; the 'holy grail' of contemporary architecture. The irony is that the image that has come out of this equation was a new idea of Islamic imperialisme as seen in the palatial like buildings with a 'Malay-Muslim' garb.

Thus, the Putra Mosque was a possible attempt to push the Malay-Islamic agenda in order to herald Malaysia as the new center of Islam in the world and at the same time redefine the national identity more towards a single ethnic variant.

The Rusila Madrasa and Tuan Guru Abdul Hadi Awang's Vision of Islam

The Rusila Mosque-Madrasa in Terengganu is not an 'architecturally' designed building as we understand it. It grew from its original timber structure to a four storey building housing at one time about several hundred students completing a religious curriculum of which the present Chief Minister of Terengganu was a major part of. The ground floor of the building is the main

prayer space with the ablution facilities and the madrasa and library forming a side portion of it. The first floor is a series of classrooms arranged in a perimeter which overlook on a central open space meant as the overflow space for prayers. The second and third floors are dormitory rooms for boys aged 13 to 18 years.

The quiet strength of this building lies in the manner of its siting and landscaping. The mosque has virtually no fence except a small meager gateway separating the building from the main roadway. On the other three sides of the site, the mosque has no demarcation between the houses surrounding it. Even the house of the Chief Minister, a modest Malay house of timber, sits not thirty feet away from the mosque. Tuan Guru Abdul Hadi Awang makes it a point to lecture and deliver sermons on Fridays and also act as the imam on many congregational prayers. The landscaping feature is mainly of sand which was thrown up by the South China Sea a mere 200 feet from the mosque. On Fridays, the spaces around the mosque is filled with a huge market that stops an hour before the commencment of the Friday prayers. During the PAS conventions held in the city of Kuala Terengganu, the mosque served as a shelter to the thousands that come from all over Malaysia and other countries. If there was ever an idea of a mosque which is not a symbolic monument, but a full 'work house' of community and nation development, it would be this mosque. Other mosques which are hundreds of time more expensive than this one can never boast of such a social contribution.

Tuan Guru Abdul Hadi Awang, known with the affectionate name of 'Ayah Chik' which carries a fatherly connotation to those who knew him, was once an ABIM member together with Anwar Ibrahim. Being trained as a religious scholar with a post graduate degree, Abdul Hadi ventured into PAS and rose through its rank as a firebrand leader similar to the figure of Umar al-Khattab, a close companion of the Prophet Muhammad. Abdul Hadi's ideas of Islam is in line with those of Abul A'la Maududi, one of the greatest reformers and scholars in Islam who had a great part in the formation of Pakistan. His political idea of Islam is simply to establish a structure of a nation based on the model of classical Islam. True to the traditions of early Islam, the reformist in him began the important task of 'tarbiyah' or education in order to build a generation of Muslims that would not separate the idea of secular life with that of the religious. It is this focus that led the mosque of Rusila take an unpretentious form of a mere shelter for the activities of education. The ease of which one enters the mosque, and the ease of which one gains an

audience with the founder, is in line with the humble spirit of the Prophet in his own mosque of the past. The stark simplicity of the mosque testify greatly to the idea that Islam abhors all kinds of wastefulness, even in the building of mosques…especially in the building of mosques. The architecture of the mosque in Rusila presents a mere backdrop to the important work of building a whole human civilization. No where can one accuse the builders of this mosque as a manufactured identity since its unplanned growth is its identity.

Thus, the Rusila Mosque Madrasa points to the idea that Islam is an integrated system which brings the followers and the leader in a place of learning and testament to the greatness of Allah. The mosque shows that as a building, it is nothing more than a platform, or a tool, to be utilized for nation development without much care for a manufactured identity of Islam.

Conclusion

It can, therefore, be seen that the political idea of Islam as propounded by individual leaders have a profound affect on the type of architecture used for the mosque. From the progressive and relaxed expression of the National Mosque, the imperial grandeur of the Putra Mosque and finally to the humble unpretentious expression of the Rusila Madrasa, each building holds key lessons for the student of architecture and history. Although there are many more political ideas yet to be explored in this new field of academia, it is fitting at this point to reflect that architecture is and always shall remain the realm of politics rather than whimsical attitudes and thoughts of the designers. Hence, in dealing with such an important subject as Islamic architecture or specifically mosque architecture architectural graduates should do well to understand that the other studio which was never offered in their curriculum was that of political idealism and social values.

21

The Sunway Pyramids: Of Cultural Tolerance and Architectural Competence

Introduction

When Charles Jencks declared the so called 'death of Modern Architecture' in his book 'The Language of Post-Modern Architecture', he probably did not realize the Pandora's Box which was unleashed in the architectural landscape of developing nations such as Malaysia. Being strictly a country whose architects seem to have a philosophy of unadulterated imitation and a 'wait and see and then change *sikit-lah*' attitude, the license to 'do anything' under the architectural sun was lethally demonstrated in the Sunway Pyramid design of a recreation and commercial complex in the midst of Sunway's Fantasy World.

I have remained silent for a long time and tolerated the many Post Modern Classical buildings that have sprouted all around this country. Being an academic who understands why Michael Graves expresses the Portland Building as such and also the many intentions behind Charles Jencks Thematic House I took all these feeble attempts in Malaysia of empty intentions in a stride. At least that craze had a thin academic line of argument in the name of urban colonial architectural contextualism. I have also tried to squint my eyes at the sights of much revivalistic craze on Middle-Eastern and Malay architecture that have arisen in proportion to the wealth of the country, her 'Islamic-Arabic inferiority complex' and nostalgic returns to the 'kampung architecture'. Being a person

who admires the deep philosophical thoughts of John Ruskin, Louis Sullivan and Frank Llyod Wright in their rationalistic approach in reinterpreting European Classicism into an architecture that is more appropriate to its 'spirit of time and place', I felt the pains of seeing the architectural landscape of Malaysia littered with simplistic revivalism and impetuous importation of foreign cultural garb. The pain is soothed with the thoughts that at least, that kind of architecture appeals to the lay persons and offended no one race or culture and that the use of the Malay architectural vocabulary is in line with the struggle which the national language is having in this borderless world of 'multi-everything'.

The Sunway Pyramid themed mall concept, however, is a different story altogether. This is where we must stop and look...I mean... really look at what the architecture is saying, or at least, is implying. To the designers it might have merely been a mundane trip to the old architectural magazincs with probably a fierce brainstorming session to drum out a highly novel and 'unique' idea to sell to the clients and users. The solution to use the architecture of ancient Egypt complete with the Sphinx and similar two-dimensional Egyptian characters fits well the stark fantasy and exotic ambience that is becoming Sunway's billion dollar imagery. After all, if Walt Disney made his billions selling the fantasy and exotic world of his Magic Kingdom, why not us humble Malaysians? But the simple catch here is that the building is in Malaysia, used by Malaysians and nowadays this little country is a major Global Player that has, I think, a respectable position. The design raises serious concerns and issues about Malaysia respecting another nation's architectural heritage and one of the world's renowned and important archaeological artifacts. There is also the religious and cultural realm of the people of the Semitic Religions (Judaism, Christianity and Islam) to be considered in the insensitive display of an architecture that echoes of a terrible tyrannical ruler in the ancient world. Finally, the use of the Tomb and Temple architectural language raises issues of architectural integrity and morality of transformation of function.

Respecting a Nation's Heritage and Humanity's Treasure

The ancient Egyptians were seen by many scholars as quite an advanced civillization with construction techniques and mummification processes that still remain much a mystery. The ancient Egyptians were a people deeply religious in their belief of an after life. The temples and many tombs of Pharoahs and ordinary persons (usually skilled professionals like carpenters or medical experts)

littered much of the sacred burial places in the viccinity of the Nile River. Frescoes like those found in the tomb of Nakht, Thebes (1450 B.C.) and the tomb of Nebamum depict in fine detail the many activities which the occupants of the tomb will enjoy in the after life. The flat human figures, animals, plants and water holds many sacred meanings to a religious idea that has only now been understood after such works as the translation of the Rosetta stone by Champollion was accomplished in 1822. Such hieroglyphic writings adorn the walls of temples, statues, pylon walls and tombs to record important events and also perhaps as verses from solemn prayer rituals. Although the religion of the ancient Egyptians are no longer practiced in the present day their culture and way of life still represents part of the important evidences of our human thoughts and abilities. Their walls may hold certain keys to astronomical information, technological knowledge, medicinal practices or recurring natural disasters that still remains locked and must be studied for the sake of humankind.

Now such an important archaeological find and research as this belong to a sovereign nation. This nation of Egypt has seen two great civillizations thus; the ancient Egyptians and as the cradle of Islamic civillization. Such an old country as Egypt that hosts one of the earliest civillizations of man must be respected as the guardians of humanity's collective past. I, therefore, find little justification for making fun of such an important collective heritage and also one that belongs to a friendly Muslim nation. Although such practices as adorning the walls of the commercial complex with almost exact replicas of Egyptian human figures pushing carts and having drinks may be interpreted as a novel idea of bringing back ornamentation as a communication tool towards a more 'legible architecture', I find it highly discomforting that such almost exact imitations were used and not abstracted beyond recognition as figures belonging to a different culture. Being a designer myself, I am sure it is not such a difficult practice to express the figures, perhaps in the same two dimensional formats but much closer to our Malaysian characters. Why not the images of such characters created by Lat, for instance, be used in this manner? Why must we use another culture's heritage? The implication of such an insensitive practice, if allowed, may open an ugly Pandora's Box of ravaging other past cultures for the sake of pure novelty. When can we expect, therefore, the figures of Borobudur be made fun of, say, by the Egyptians? Or perhaps some intelligent architect may find the Persian two dimensional figures of Muslim characters interesting enough to adorn the walls of their architectural masterpieces?

The model of the hypostyle hall of the Temple of Amen-Re, Karnak in the Museum of Art, New York shows that the companiform columns were riddled with frescoes of figures, carved lotus and papyrus and hieroglyphic writings. The columns are spaced closely apart not necessarily for structural reasons but more so as a three dimensional scroll that tells of events and perhaps contain prayer couplets for the religious celebrations of the ancient Egyptians. These rows of columns are placed in the middle of the temple just after the courtyard with the pylon gate-wall. It is believed that only the priests and court personnel were allowed into this section of the temple. The position and treatment of the columns here suggest that the columns were not for mere structural reasons but more as vertical scrolls or library containing much information about the achievements of the particular Pharoah that built the temple. It is not a far fetched idea to even suggest that the columns are highly charged sacred objects. The almost exact imitation of the companiform columns fully etched with the floral motifs, figures and writings of the Sunway Pyramids columns raises the question of making fun of another sacred artifact. Again, I cannot find any justification for not merely following the principle of the 'talking column' and expressing it within our own cultural contexts. Are we, Malaysians, so uncreative that we have to blindly copy things without such an effort as to be a little bit more sensitive culturally and perhaps be a bit embarrassed in being a mere copy-cat?

I am told that a similar building exists in a more modest scale in the United Kingdom. This building is said to have used the same Egyptian motifs of architectural components and decorative figures using the tools sold by the commercial edifice. We must draw the line in the assumption that whatever is practiced elsewhere may be done here also. For instance, the Portland Building designed by Michael Graves was meant specifically for the American cultural, political and architectural context. His rendition of giant column-like elements and false keystone was meant to refer to the Classical heritage of Greece with respect to the Americans political aspirations. The language proposed therefore is somewhat meaningless in Malaysia with a political system claimed as a parlimentary democracy uniquely suited for our socio-political aspirations. The fact that, in Milwaukee, there is a sports stadium called Mecca Arena does not mean that we, in Malaysia, could call our shopping complex 'the Medina Mall' or something as derogatory as that. I have had to bite my lips several times at the Scottish Doctors who comes to our apartment in Edinburgh, and without taking off their shoes, proceed upstairs to the bedroom to examine my children.

We, Malaysians, were in a dilemma to ask them to respect our culture since we thought they would have noticed everybody walking around barefooted. We were too grateful for their excellent medical service to have the heart to tell them of their obvious ignorance or plain indifference. We were, in other words, being very 'Malaysianly' polite. Those kinds of cultures do not really care much about other people's feelings. The question is, are we absolutely like that in being as insensitive as making fun of other people's heritage? I should hope not.

Religious and Cultural Tolerance

Islam, Christianity and Judaism are known as the three great Semitic religions. The Jews believe in monotheism and in a long line of Prophets bearing Messages to mankind that they were the chosen people of God. The Christians believe that God came down from heaven in the body of Christ to open salvation to all mankind and not just the so called 'chosen few'. The Prophet Muhammad (peace be upon him) was held by Muslims as the final Seal of Prophethood and he proclaimed the unity of all the three religions. All three proclaimed a single religious heritage and that the Prophets were from a long lineage stretching to the Prophet Adam. The Bible, the Torah and the Qur'an, the three Great Scriptures, in unison condemns the atrocities of the Pharoah upon the Children of Israel. In the Biblical and Qur'anic versions, one of the Pharoahs was said to have murdered all the newly born sons of the Hebrews in order to eliminate the possibility of an uprising to topple the power of Egypt. The deeds of one of the Pharoahs is well documented in both Scriptures as follows:

> Now there arose up a new king over Egypt which knew not Joseph. And he said unto his people, Behold, the people of the children of Israel are more and mightier than we.....Therefore they did set out over them taskmasters to afflict them with their burdens. And they built for Pharoah treasure cities, Pithom and Raamses....And the King of Egypt spake to the Hebrew midwives, of which the name of the one was Shiprah, and the name of the other Puah: And he said, When you do the office of a midwife to the Hebrew women, and see them upon the stools; if it be a son, then ye shall kill him: but if it be a daughter, then she shall live.... And Pharoah charged all

his people, saying, Every son that is born ye shall cast into the river, and every daughter ye shall save alive. (The Holy Bible; Exodus, Chapter 1, verse 8-11, 15-16, 22)

O Children of Israel! Call to mind the special favour which I bestowed upon you, and that I prefered you to all others. Then guard yourselves against a day when one soul shall not avail another, nor intercession be accepted for her, nor shall compensation be taken from her, nor shall anyone be helped. And remember, We delivered you from the people of Pharoah: they set you hard tasks and punishments, slaughtered your sons and let your women-folk live; Therin was a tremendous trial from your Lord. And remember We divided the Sea for you and saved you and drowned Pharaoh's people within your very sight. (The Holy Qur'an; Surah Al-Baqarah, Ayat 47 - 50)

Thus, ancient Egypt with its mesmerizing Pyramids and mysterious Temples have different meanings to all the People of the Book. To others these architectural remnants speaks of engineering prowess and mysterious spiritual forces but to the Muslims, Jews and Christians alike, these are the manifestation of the Dark Forces of Tyranny.

Two other non-architectural cases can be cited about reckless design intentions and religious-cultural tolerance. The first is the case of the "Air" logo on Nike's new line of basketball shoes. The concept was to produce a style of script that would invoke the feeling of intense summer heat. However, the outcome of the design resembles the Arabic Muslim script for "Allah". After a four-month legal dispute with the Council on American-Islamic Relations, the Nike company has agreed to recall the 38,000 pairs of offending product. The logos will be sanded off then covered with patches and sold at a lower price. The company has also suggested that they have a discussion on Islamic Imagery at their Design Summit as part of their sensitivity training for Nike's employees.

The second case involves the Lego play product. The company claimed that they had donated a few boxes of the Lego system to a Polish artist named Zbigniew Libera. What happened next was that Libera used the system to replicate Nazi Death Camps which includes crematoriums, gallows and dismembered corpses. Libera, then, was said to have photographed his work along with the Lego

company's logo complete with a statement saying that his work was sponsored by that company. Several Jewish groups threatened to organize a world wide boycott of Lego products because of this 'frivolous' treatment of the Holocaust. The company went public in regretting that they had ever donated the product to the artist.

In the two cases stated above, we may excuse the insensitive attempts because of unintentional acts and simple ignorance. What excuse can we have for consciously replicating an Egyptian Temple in a country whose official religion is Islam and who is on good relationship with Modern Egypt? What will come next, I wonder? A statue of David stark naked in the middle of an urban square? Or perhaps a replica of a statue of Rodin's famous Kiss in a the middle of a Shopping Mall? It certainly goes to show that our modern professionals are out of touch with their building users (perhaps too much traveling time and overseas projects that has rendered themselves heritageless, valueless and without any spiritual nationalistic trait). It goes without saying that a dose of local cultural reality is badly in need to the professional architects in Malaysia.

If some architect out there were to say that I am ushering a new age of architectural censorship on freedom of expression in architecture, I would like to draw attention to one of the projects which I think is rather remarkable in the sense that it embodies every element of the Sunway Pyramid designs without the risk of offending any one race of culture in particular. The project is "The Palace of the Lost City" Hotel designed by Wimberly Allison Tong and Goo. The site is on a barren piece of land in South Africa 100 miles from the nearest city. The site is unremarkable in its location and historical context. Thus the challenge to create a fantasy world where one would escape to in exotic Africa came to a dramatic conclusion of incredible design feat. The architects, instead of starting with a building design, created a story of a lost African tribe that built a city in the present site and that the city was destroyed with the exception of a ruined palace. Thus the theme centered on creating a fake religious belief in animal worship and plantforms. The result is a remarkably detailed expression of animal and plant ornamentation integrated with the structural elements, fixtures and furnitures in the building. It is a remarkable feat of thought bordering on the best traditions of Hollywood. This project contains no referents to any religion, unlike the Walt Disney film "Aladdin" which controversially represent Islam in a false manner. I have always liked Disney films and I certainly wish that they would stick to caricaturing their own culture instead of others and that when they do they ought to be sensitive enough to invite comments from those who are

a part of that culture. For the Malaysian architects, the Palace of the Lost City is an example of what real creative thinking can achieve. Of course the key word here is "thinking", which somehow seems to be a strange word amongst designers in Malaysia in this present age of electronic scanners and digital photography.

Architectural Competance

The Sunway Pyramids Commercial Complex consists of a juxtaposition between two building types from ancient Egyptian architecture which are specifically the tomb and temple. The issue at hand here is the idea of transferring and transforming a particular building type into another function. In this case the transfer of architectural language is from a somber and sacred tomb and temple architecture to a fun-loving and carefree expression of a commercial cum recreational complex. If the precedent used was, say a Chinese Temple architecture which was turned into a string of Leisure Malls, that would pose a certain controversial issue but at least the precedent is from our own heritage. Here, the precedent is from another nation's cultural heritage. The question I am raising here borders on the principles and morality of design. Can the designer operate in a valueless environment in his or her choice of architectural precedence? Are we to allow such an endeavor if the product falls outside the realm of what we might term as 'architectural decency'? I would like first of all to touch on the question of transforming functions and then on architectural language adaptation.

In the 18th and 19th century Europe and America, what was considered as the battle of styles in architecture between the uses of Greek, Roman and Gothic revival architecture was rampant. The Greek and Roman revival battle was said to have been brought about by rationalists who believe in a world not necessarily governed by the dogma of Christianity. The rise of science and free political thoughts based on the works of past philosophers such as Plato and Aristotle sparked a creative fervor in the various fields of pure sciences, engineering, geography, archaeology, history, psychology and many others. In America, where a new nation was born and unshackled by monarchy and papal rule, a fresh start based on Greek utopianism was heralded as a new beginning for a free and democratic society. The age of enlightenment in Europe saw the religious and monarchy rule being questioned by free thinking philosophers and scientists. In finding a world view that would replace the Christian based dogmas, the scholars found the Classical works of the past as a guide. In the

field of architecture, measured drawings of the ruins of Rome and Greece were meticulously done by the aristocratic architects. Books on the architecture of antiquities were published and the Renaissance garb were replaced with exact proportions of Greek and Roman architectural vocabulary.

The architecture of the Greek temple such as the Parthenon and Erechtheion along with the Roman temple such as the Pantheon were used as precedence for many new building types. These new building types were Museums, Art Galleries and Universities. Other building types such as townhouses, railway stations, offices took the urban language of Renaissance architecture as it is seen more suited for commercialism. Thus the sacred temple architecture was transformed firstly into the modern sacred buildings that houses man's cumulative knowledge of himself and state administrative structures. The British Museum and University of Virginia are some of the many buildings in the United Kingdom and United States that were rendered in Greek and Roman revivalism of the sacred architectural language. The lesson here is that the transformation of a particular building type such as a temple should be carefully and sensitively treated such that its redefinition in another capacity is almost within the same spirit of sanctity. There ought to be some respect for the former sacred function such that the new life of the language is not further from its original intent. The semantics and syntax of the use of words in communication usually undergo a similar transformation of use in order to adapt for the sake of survival. Architectural expressions in the exterior treatments of buildings can be considered as words that carry much meanings within the context of the culture of the users. In the case of the Sunway Pyramid, the transformation of the architecture of the tomb and royal temple does seem inappropriate in its present form as a recreational complex. Probably a Roman Bathhouse or sports coliseum may have been the better choice for the revival concept approach for a recreational building.

In the present time, there have been a number of casual liberties taken by designers in using other sacred imagery such as the mosque and pagoda to be infused into recreational and exotic architecture. I have seen images of Indian mosques typology and the Malay mosque typology in the architecture of hotels. Even though I would be the first to say that there is nothing sacred in the religion of Islam in relation to the use of domes and pointed arches or even minarets, I must stress that these architectural elements have been accepted as vocabularies denoting a mosque. If the people have accepted the language as such, and if I were to change it, much care must be undertaken so as to

produce a result that would show a gradual transformation of language. One of the Sunway Hotels uses the Indian-Islamic architectural vocabulary whilst the Johor Sofitel Hotel uses the pyramidal roof form of the Nusantara Mosque typology. These insensitive attempts by designers to make the jump from a sacred architectural vocabulary into and uncomfortable expression of recreational architecture shows the desensitization of values among the professions. As I said before, the designers insensitivity may be due to too many overseas projects and collaborations with Western architects that dull their cultural upbringing. It is a terribly fearful prospect for the profession in this country.

Another method of using architectural precedence is in the manner of expressing them to create a different architectural message and eventually to further develop the design vocabulary. The art of abstractionism and the use of principles instead of pure imitation is looked upon as a highly creative act with acceptable and original results. One of the best architects to have the developed Classical architectural vocabulary was Louis Henry Sullivan from the United States. When his contemporaries were dabbling with grandiose revivalism and mindless eclecticism, he was one of the few who stressed rationalistic interpretation to blind imitation of the Classical vocabulary. The Transportation Pavilion, the Ryerson tomb and the Wainwright Building in Chicago are the masterful creations of a man who understands the basic aesthetic principles of Classical proportioning and a man with a rationalistic philosophy of form following function. There is not a single trace of imitation but the buildings are Classical architecture interpreted in the era of the machine. Simple abstractionism can also do wonders in creating a vocabulary that is both original and alludes to the past precedence used. The stripped Classical vocabulary approach was used by the French born Paul Cret. The buildings designed by Cret such as the American Battle Monument Memorial Chateau Thierry, the Federal Reserve Board Building, Washington D.C and the Folger Shakespeare Library, Washington D.C. shows an abstracted monumental design that alludes to the Parthenon of the past but is stripped of much ornaments. The Sunway Pyramid designers should take lessons from such simplistic approaches and not resort to almost direct imitation. If the Egyptian form, lighting, proportions and mass were elements of compositional intrigue, the designers could have abstracted the design of the commercial cum recreational complex without an obvious trace of the ancient Egyptian Temple language. As for the figures and ornamentation, other types of human caricatures and or geometric decoration and scripts can be used.

Conclusion

The state of architecture in Malaysia concerning its aesthetic approaches in design is in a critical situation. Mindless imitation, insensitive eclecticism and revivalism show Malaysia going through a stage which the West had already gone through more than a century ago. The lack of academic criticism spurred the sporadic attempts of imitation and importation of architectural styles by the barrels. Several serious thoughts ought now to have occurred upon perusing this article.

Firstly, designers must realize that Post-Modernism have opened doors towards a more meaningful architectural products for the local users. Pure imitation or facial adaptation of foreign architecture must be treated carefully within this framework. Secondly, the choice of precedence ought to be subjected to a general approval of the heritage borrowed from and of the people that would eventually use the buildings. Care must be taken in transforming and adapting the architecture of religious structures even though the religion is no longer practiced and the product remain an archaeological curiosity. 'Kesopanan dan Kesusilaan' still remains one of the pillars of the Malaysian constitution the last time I checked. The fact that some fashionable architectural firms overseas rejoice in making fun of oriental or Eastern products does not mean that we ought to stoop that low or reciprocate. Respect for the Orient has never been one of the Western world's important political agendas. Our multi-racial and multi-religious heritage as seen in the mixture of Chinese, Malay, Arabic, Hindu and European architecture of Malaysia speaks of a nation comfortable with each other's tolerance of our kaleidoscope of lifestyles. Finally designers in Malaysia must try to use their minds more than their electronic scanners and digital cameras. The principles of adapting foreign architecture or even the traditional vernacular within our cultural and climatic framework abounds in works as far back as four or five centuries ago. The aesthetic thoughts and philosophies of master architects that have tried to deal with the idea of a national architecture abounds in the writings of the past that is waiting for a bright Eastern mind to adopt and adapt. Of course it requires a little effort in reading, reflecting and deep thinking, something I'm told is a weakness among designers in this part of the world. The product of the Sunway Pyramid reflects not only the firm's competence but certainly on the critical state and quality of the whole education system and the idea of professionalism in the practice of the profession in this country.

The Sunway Pyramid, Subang Jaya.

Making jokes of sacred images from tombs. Truly Malaysian?

Bastardizing the sacred Egyptian motif.

22

The Crossroad of Malaysian Architecture: The Clash of Modern and Traditional Cultural Values

Introduction

As with most developing nations throughout the world, Malaysia's rise in the modern world has been rapid and at one time cultural values inherent in its communities and also the ideas of a democratic nation were left far behind. However, in the 21st century, these questions of traditional cultural values and the ideals of a democratic nation have surfaced to challenge the towering typologies of housing, administrative centers and educational institutions that has seen uncontrolled growth and change. This essay briefly outlines the development of the important building typologies and place the fundamental questions of cultural clash of values as its main theme. The message it attempts to impart is that the cultural clash has caught up with the nation's rapid rise into modernity and that we as the people must manage this clash honestly and creatively to forge a stronger unity and understanding. Failure to address this phenomenon could see the cultural clash tearing us apart and inhibit out next generational leap into a more civilized country.

Architecture of Commerce

The rise of shopping complexes in major cities of Malaysia may be an indicator of its economic strength. The design of such centers are lavish and borders, some of them on the world of fantasy. Novelty seems to be the order of the day and the shopping activities in Malaysia have accepted the approach quite well. The addition of leisure activities such as multiplex cinemas, skating rinks, video arcades and children play centers adds much to the experience of a family outing. Amidst all these successes, there are three aspects that should still be of concern to the professionals and the public at large. They are the theme, the public space and the Surau.

With respect to the theme, we can see such varieties in the Sunway Pyramid and The Mines. The issue here is the questionable use of architectural vocabulary borrowed from ancient and sacred monuments such as temples and sacred symbols. Although the 'Disneyland' spirit is sensed in this effort, there should be such care as to dwell on the religious and cultural sensitivities that these building evoke. One should take lessons from the design of the Palace of the Lost City hotel in south Africa where the designers had to rely on a Hollywood approach in creating from scratch a mythical culture and religion in order to frame the hotel design within the storyboard approach. Such great works of creativity offend no one as it is fictitious and done within a taste that is well refined the whole edifice speaks of a fine example of fantasy artform. With the sensitivities of Malaysia's three main races and a variety of minority cultures, professionals ought to be more critical on their choice of theme or concept and certainly so in their artistic renditions of their building creations.

The second aspect is the lack of public spaces in these public places. It seems that every square inch of space in these shopping complexes are geared to make money and there is no public spaces left except for accidental ones like extra wide seats from planter boxes. I remember an incident where my students and I were questioned and 'chased out' by security guards and management officials simply because we were just meeting to discuss some academic assignments. It seems 'a grave sin' to be sitting anywhere in a Malaysian shopping malls without buying anything. I have been in Britain and the States where shopping malls are piazzas, meeting places and a hangout place where one can past the time of day comfortably without having to buy anything. As with housing I think it is about time that the authorities stipulate required percentage of

public spaces and furnitures so that shopping malls should not be considered as oversized shops but quality indoor spaces for community interaction.

The third aspect is about the location of surau or prayer spaces for muslims in shopping complexes. With the exception of Kota Raya Shopping Complex that has integrated a whole mosque fascility within its building, there is no other shopping malls that gives the important prayer fascility the dignity and safety aspect that it deserves in this muslim dominated country. At the risk of sounding like a racist or a religious fanatic, I feel there is great potential in properly designing a surau in the shopping complexes that would reflect the identity of Malaysian Architecture. It does not have to be as big and as obvious as the Kota Raya complex but it deserves much to be treated with care and dignity. As it is the location of suraus are simply like toilets and storage facilities that create dangerous places where crime can occur. I would always advise my daughters never to pray alone in these facilities and ask God's forgiveness for fear of my children's safety. Suraus are elements that are yet to be explored and posses the potential of giving such buildings a nation building experience as well as the ringgit sense so important to clients.

Architecture of Travel

The design and construction of such facilities as the KL Central station, the Kuala Lumpur International Airport and the numerous LRT stations mark and achievement that goes beyond mere shelters but symbols and identifiable Malaysian icons in their own right. The use of day lighting techniques in the KL Central station and the KL International airport marks a milestone that should serve as an important educational tool to local architects. The use of structural expressions in the tropical approaches of the LRT stations are commendable and should serve as clues to other public buildings bent on answering the question of a signature national architecture. Although the two iconic buildings were designed by foreign architects the LRT stations come close to this spirit and it is hoped that others would follow suit and be more professional in dealing with clients bent on a more feudalistic imagery or expression for public buildings. Certainly the idea of the tropical verandah as mooted by Ken Yeang in his writing should serve as a beacon of design that speaks not only of energy conservation but also of social friendly architecture badly needed in this country.

Also a word must be said about the use of structuralism and metaphorical expressions I termed as modernistic expressionism is tastefully handled to create not only symbols or icons but also to celebrate the adventurous sense of travel. The central space of KL Central is well expressed with steel trusses and daylighting with views of people bustling in their travels as well as incoming trains penetrating the building. The smooth flow of passenger traffic with the shopping complex atmosphere make this one of the success stories of Malaysia.

Architecture of Power

After centuries of totalitarian political power of the Malay Sultanate and decades of colonial grip of the country a new country with a parliamentary democracy was born in 1957. For the next few decades the new country a delicate balancing act between the indigeneous Malays and the immigrant Chinese, Indians and many other races. From a 50%-50% racial mix of Malays and non-Malays which was the legacy of the British colonial administration the country has progressed into a more Malay dominated presence that has now reached 65% population and a rapidliy rising middle class. The country exist presently under a tethering balance between the dominant Malay administration with its hold on civil service, police and the military as well now on education with the other races more dominant in their economic presence as can be discerned from the many retail and commercial activities in the country with the exception of the Malay heartland of Kelantan and Terengganu.

The Sultanate architecture of the Malay royalty consists of the timber and masonry palaces. The timber palaces are as small as a large house and as big as several large houses. There is no record of the timber palaces being as lavished as the kratons of Indonesia. The distinguishing features of these palaces over the residential architecture is the presence of much carvings in the wall panels and other construction components. Many of the palaces are also more symmetrical than houses and they are raised higher. The distribution and type of spaces are obviously in complete contrast to the peasant's or the nobles' houses as it contains the treasury, audience hall and private bedrooms of the monarchy. The recorded palaces of Kelantan and Terengganu testify much to this typology of royal architecture.

In contrast, the masonry palaces such as the one in Jugra and in Johor presents western influences in the architectural expressions. The palace at Jugra

mirrors the influnces of middle eastern masonry palaces of the khalifah's and past Muslim administrators complete with tri-lobed arches, ornamentation, khat inscriptions and courtyards. The Johor palace however speaks more of palladian classical architecture much influenced by British architects.

With the birth of a new democratic society known as Malaysia, all eyes fell on the building of the Parliament House in the capital city. What would the architecture be for this new nation? The Public Works architect of that period, Ivor Shipley, envisioned a modernist-socialist response that makes few references to any ethnic group. The building expresses the notions of hardworking office bearers as the tower which provided the private rooms of the parliamentarians is dressed in the business-as-usual vocabulary with a unique sun shading device to indicate the idea of national accountability in the financial management of the country. It is sad that no work exist as yet to establish the true forces that shape the parliament design and there is yet to be an interview with the ageing architect now residing in Australia. The assymetrical masing of the building as seen from the main approach complements the miesien interior of humility and dignity resounding much the worker revolution of old in Europe. The present renovation totally destroyed any message of a government led by ordinary people and in turn is replaced by an imperial language of pomp and glitter foreign to the ideas of democracy. The office of the Prime Minister and the national monument of Masjid Negara all echoes a language much more down to earth and reaching out to he masses with a modernist architecture that spreads horizontally with regionalistic overtones in their expression.

The Kota Darul Naim administrative complex in Kelantan shows much promise of a Malay styled democracy quiet in tandem to the races' humility. It comprises of several buildings or humble sizes expressed in a traditional Malay architectural vocabulary composed in a completely assymetrical layout that produce many courtyards in between buildings. The scale and humble expression could have led to a more promising design of administrative centers throughout the country but this was not to be so as this building pales in the grandiose shadow of Tun Dr. Mahathirs legacy of Putrajaya.

With the building of the new administrative center for the federal government in Putrajaya, there seems to be a desire by the leadership to replace the colonial and Sultanae architecture with a more overpowering imperial expression. The palace-like grandeur in the office of the Prime Minister as well as in his official residence blare a deafening echo of totalitarian regimes of

old. In many ways this architecture is the absolute expression of a democratic Malaysia which some have validly criticized to be in the wilderness. The single ethnic reference in architecture vocabulary creates a no-nonsense Malay dominance in politics and the lack of sun shading devices creates the impression of a freer financial control which does not see much public accountability. The new administrative centers of the rest of the country such as in Johor's Nusajaya echoes humbly the imperial garb of the federal government tainted slightly with a modernist language of shading devices and platonic spaces. Thus, in one sense the architecture of Putrajaya and Nusajaya clearly reflect the identity of a type of democracy that Malaysians have allowed to develop and for a long while the imperial language will stand and replace totally the socialist message of the Parliament building and the humilty of Malay expressions of the Kota Darul Naim.

Architecture and Nation Building

Among the many roles that architecture can play in a society, many may find it surprising that nation building is part and parcel of the architectural potential contribution. But for architecture to be so, the professional community must be committed to the ideals of the country and not merely act as a form of service industry. Architecture possesses the will and spirit of being the visionary for a nation. Architects must engage the people and the leadership and clarify the many issues that would result from poor design and how better solutions could lead to a more prosperous society in more ways than one. The veteran architects and academics must set the pace for a new crop of professionals armed with a spirit of building a great nation based on the traditional cultural values and the modern ethos of democracy such that the clash of values will yield a positive result. It is hoped that with this essay, the strife to create a true nation of harmony, civility and creative prowess would begin in earnest in order to evolve....a kingdom of conscience.

23

Conservation and Abandoned Mosques

In the midst of our country going on a downward spiral in our race relations, I, as a Muslim, wish to contribute to remind my brethrens in Islam as well as Malays, that we should not be too arrogant in claiming that we are the 'perfect human society' simply because we are Muslims. Today's essay shall prove that we Malays and Muslims in this country cannot even decide on a simple issue as mosque conservation. The result is that there are many mosques which are still in good condition but abandoned and left to rot, many mosques that have been conserved using hundreds of thousand Ringgit but left unused as well as mosques which has great historical value being simply demolished.

Why has this occurred? Because the so called religious scholars cannot decide on an issue called 'conservation and adaptive reuse'. These same 'ulamak' or religious scholars now scream at the top of their lungs that Allah's name should not be used by the 'unbelievers' and that only Muslims shall own the word Allah forever and ever but these same 'ulamak' shows complete ignorance when faced with a modern problem of mosque conservation, adaptive reuse and treatment of historical artefacts. Islam is not at fault here. Arrogance is. And the worse arrogance is one that denies any need of gaining knowledge as one has already received a 'perfected religion' embodied in the Qur'an and the Sunnah.

This topic came to my attention a few years ago in a conversation with my close friend and colleague, Associate Professor Dr. Syed Ahmad Iskandar Syed Ariffin from the Department of Architecture, Universiti Teknologi Malaysia.

We were talking about his book which was converted from his Masters thesis on the principles of conservation in Islam. He had done a detailed study of the Qur'an and the Sunnah whilst adding on the case study of the expansion of the Prophet Muhammad's mosque in Madinah, Saudi Arabia. The gist of the book allows artefacts in Islam to be dynamically used in conservation whether by expansion or by a different use. The simple principle of conservation, in a nut shell, boils down to the fact that buildings of historical; value (and there's a whole discourse on what actually constitute 'historical value') must be able to be used in a different capacity as close as possible with the original function and intent of the building. If need be, the building can also be 'intervened' by making adjustments like expansion, adding air-conditioning and modern facilities to help it's new lease of life.

Seldom is a monument simply left as a sculpture to be viewed in a museum fashion. With this guideline, many buildings have been conserved in their historical splendour by being used in a different capacity. The problem comes, when that building is a mosque. I mean, it is a problem, if you are a Muslim scholar who thinks that his religious education is enough to equip him with the necessary knowledge to educate modern Muslims about all the modern affairs like health, social, intra-religious, intra-racial issues and political affairs. My experience in listening to these *ulamak* is that they are totally incapable of functioning as teachers to modern Muslims in Malaysia or any where else. Yes, they can preach Islam to a limited group of Muslims, preferably those who live in the kampung and village that is almost cut off from the mainstream modern societies of Malaysia or anywhere else.

Dr. Syed then told me that there are a few mosques that he knows which have been abandoned and there are also mosques that have been conserved but not given any new function and thus becomes something of a 'white elephant' or a sculpture. I was immediately interested to do a study to formulate the religious guidelines to help religious authorities in mosque adaptive reuse. So we convinced a Senior Lecturer from Taylors University College, Madam Norhayati Ramli, to conduct a Masters level research for two years and find out how mosques were being used other than their original intent.

To our surprise and shock, in a limitedly funded and short term research, she had uncovered 17 mosques that were literally abandoned, conserved and unused and many were simply demolished although still in excellent architectural condition.

What were the outstanding religious issues that cannot be resolved? Well, many of the traditional mosques were the religious acts of waqaf. There is a strong Prophet's Hadith which relates that a Muslim's reward cease upon death except in three items; the offspring that he or she left to do good deeds, the knowledge that one leaves behind that is beneficial to mankind and finally the buildings or wealth that one leaves so that the community can use beneficially. Thus, the history of Islam is filled with mosques, musalla or surau, madrasah, wells, khans, shelters, orphanage, shops and houses to be used in a most beneficial manner to the larger community usually understood popularly as Muslims. The mosque in traditional times is the physical embodiment of the religiosity of Muslims in intending for it to be used for prayers. Thus, those Muslim who are left behind in this world must ensure to their best ability to make the mosque function as it was originally intended. What the Muslims of the past wanted was a long lasting act of piety so that rewards can be accrued when they are resting in their graves as long as the building remains intact and in use as intended. What these Muslims fail to understand at that time was that there was a possibility of the mosque not to be able to function as a prayer space as originally intended whilst the building is still structurally sound. The most normal case where this situation arises is when the community has grown and a bigger and safer mosque is necessary to be built. Thus the architect builds a bigger mosque, sometimes adjacent to the old one but sometimes a bit farther away. There is also the situation where the community which the mosque served ceased to exist as people move away or the surrounding properties are bought up by non-muslims. How does one treat the old mosque then? The religious department with their ustaz and ustazah do not know what to do as their religious training in the madrasah do not cover this curriculum of adaptive reuse. So, they would simply use the Prophet hadith of 'if you are unsure about something, it is better to leave it until you are sure about the matter'. That is a sound advice by the Prophet, but he did imply that one must use knowledge to move out of the ignorant status (that is at least how I interpret the hadith). Apparently many Muslims simply interpret it literally and leave many modern issues plaguing the muslim community. The committee would not even allow the abandoned mosque to be used even as a madrasah or as a religious school! There is a mosque which has been conserved with hundreds of thousand of Ringgit and the Tok Siak or the Caretaker of the mosque is forced to live in a dilapidated building whilst the mosque sits gleaming in isolation in

the sun. Another mosque was suggested to be turned into an Islamic Gallery or Museum and Research Center but until today, the mosque is left unused. Some mosque are left but are being used by travellers to take a rest. There are other abandoned mosque which has drug addicts making them their den.

Dr. Syed and I do not see this as a problem. Dr. Syed's first suggestion is that if a surau can be 'upgraded' by the religious authorities to a mosque status, then it should also be possible to downgrade the mosque to a surau status. The difference between a surau and a Masjid in Malaysia is that the former is disallowed by human law (not divine law) to be used for the Friday Congregational Prayers whilst the latter can. Thus, the old mosque can still function as a place of prayers. The second thing that Dr. Syed suggested was that architects and planners must incorporate the old mosque as part of the new mosque complex so that it would serve as an overflow space and also other features such as education or others.

I think that Dr. Syed's suggestions are 'too conservative' (well, he is a conservationist!). I would invoke the Prophet's tradition about not being wasteful as this is a great sin. I have argued in many writings that having expensive domes or more than one minaret for mosques constitute the act of being wasteful eventhough we are building a 'House of God'. What more a Crystal Mosque that does not perform the role as a prayer place and community gathering. The cases of abandoned mosques and demolished ones speaks volumes about this kind of wastefulness in the Muslim society. I would also invoke the definition of 'Ibadat' or worship in Islam as explained by the great Indian scholar Abul A'la Maududi in his books towards Understanding Islam, Fundamentals of Islam and Let Us be Muslims. He stated that worship in Islam does not simply mean the ritualistic act of prayers or salat but actually any and all acts done to please Allah which has benefit to mankind. Thus, to feed one's family is considered 'worship' and to speak kindly is also that action. With this definition, I would argue that the mosque can be used in any manner that would benefit the Muslim community generally. To me, there is nothing wrong for the mosque to be used as a museum, as a kindergarten, as a religious school and many other activities that do not discredit the image and laws of Islam.

Finally, if Islam is said to be a dynamic religion that is progressive and not tied to the camels of old, then it must think itself in a global manner and not be too parochial, The religious departments must sought the help of professionals and only a concerted effort will produce a policy that is beneficial to all.

i.	1. Masjid Lama Jamiul Ehsan Masjid Lama Pekan Setapak.
ii.	2. The old Masjid Tinggi Bagan Serai, Perak.

i.	3. Masjid Kampung Air Baloi, Pontian, Johor
ii.	4. The Old Mosque of Sungai Melong, Pontian, Johor.
iii.	5. The Old Mosque of Pulau Sebatang, Pontian, Johor.

i.	6. Masjid Jamek (Lama) Air Baloi, Pontian, Johor
ii.	7. Masjid Lama, Simpang Renggam, Pontian, Johor.

i.	8. Masjid Lama Pedas, Negeri Sembilan
ii.	9. Masjid Lama Kampung Astana Raja, Kota, Rembau, Negeri Sembilan
iii.	10. Masjid Lama Kampung Kuala Dal, Padang Rengas, Kuala Kangsar, Perak
iv.	11. Masjid Lama Jamek Pasir Panjang, Port Dickson, Negeri Sembilan
v.	12. Masjid Lama Jamek Tanah Datar, Cengkau, Rembau, Negeri Sembilan
vi.	13. Masjid Lama Al-Rahmaniah, Jalan Besar, Trong, Taiping, Perak

i.	14. Masjid Lama Kampung Pulau, Kota Rembau, Negeri Sembilan
ii.	15. Masjid Lama Kampung Beringin, Seri Meranti, Negeri Sembilan.

i.	16. The Acheen Street Mosque, Georgetown, Penang
ii.	17. Masjid Sultan Abdullah, Pekan, Pahang.

An extract from the Masters thesis registered at UTM by Madam Norhayati Ramli, a Senior Lecturer from Taylors University College.

Masjid Lama Jamiul Ehsan or known as Masjid Lama Pekan Setapak.
Lot no. 346, Jalan Pahang, Pekan Setapak, Kuala Lumpur. Conserved by the Department of Antiquity but left vacant and unused. (Source: Norhayati Ramli)

View of the old Masjid Tinggi Bagan Serai, Perak which had undergone a major restoration in mid-year 2006. RM200,000 of public funds andabandoned. (source: Norhayati Ramli)

Side View of the old Masjid Kampung Air Baloi, Pontian, Johor. This beautiful and intact mosque was demolished because no decision was made as to it's possible adaptive reuse.
(Source: Azizan Ahmad, 1998)[2]

View towards the *"Mihrab"* of the Masjid Lama Kampung Kuala Dal, Padang Rengas, Kuala Kangsar, Perak. This one of a kind architectural masterpiece of traditional heritage mosque was never conserved and simply left to rot because of indecision as to its future use. Who are the Department of Religious affairs helping?
(Source: Norhayati Ramli)

Front view of the Masjid Sultan Abdullah, Pekan, Pahang after the restoration works completed at the end of 2006. The new mosque is only 50 meters away and this 'old one' is left abandoned. There was a decision to convert it into a museum of sorts but this never happened. If the decision was followed through it would have set a most important precedent of mosque adaptive reuse. (source Norhayati Ramli)

24

The An-Nur Mosque, Universiti Petronas Malaysia, Tronoh, Perak Back to a Humanistic Agenda

There seem to be a prevailing assumption amongst clients, architects and the laity that the more monumental the expression of the mosque the better it seems to express the grandeur of Islam and that the more Allah would be respected. Because there is no specific guideline that is laid out in the Qur'an and in the teachings of the Prophet Muhammad, proponents of grandiose mosques justify their stand by referring mainly to the great precedence of the Abbasid, Ottomans, Moghuls and Persians in the centuries that are littered with monumental edifices considered undeniably as Muslim heritage. Thus, the cult of expressing monumentality such as in the symmetrical massing, the overwhelming presences of the domes, the massive gateways, the imposing minarets and the quadruple volume of height in the verandah or main prayer space has held its way with clients that have immense wealth to spend. Though we are still far away from reaching a most humanistic expression of mosques rather than its gigantic and megalomaniacal scale of present mosque designs, I was pleased to find a mosque designed to mark perhaps the demise of the Giant Mosque Scale in Malaysia. The An-Nur Mosque in Universiti Petronas Malaysia seems to me to have been able to capture the humanistic scale of mosques despite its wealthy patron. As its name implies it represents a shining light at he end of a long dark tunnel of 'Islamic megalomania'.

The An-Nur Mosque has several striking features that have made me feel that professionalism amongst the architect profession is not yet dead as I have presumed in many of my speeches and criticism. The mosque costs RM 24 million and is to fill 8,000 worshippers. The mosque is sited close to the entrance to the university and floats in a man made lake that used to be a tin mine. A glance, a walk through and a prayer during Friday has made me give the thumbs up to the architect and firm that dared to educate the world on the concept of humanism and humility. Although the mosque still possess a few weaknesses, I feel compel to write more about its successes than its weaknesses which I consider minor and anyway these weaknesses are present in greater proportion in other mosques I have used.

The first aspect of design is its asymmetrical massing. The mosque is unlike that of the grand Wilayah Mosque, UTM Mosque or Shah Alam Mosque with strict symmetry from entry to the Qibla wall. The mosque has two sections which are the enclosed prayer space underneath the domed structure and a serambi space with a hypostyle forest of bulbous columns supposedly a metaphor for palm trees. What is interesting to me is the decision of the architect to join an asymmetrical serambi spread with the symmetrical domed mass. The result is a massing that is less feudalistic and more outreaching.

The second aspect is the scale of the serambi space. The serambi is unbelievably humanistic in the sense that one might be entering the old vernacular mosques and not one belonging to the giant called Petronas. The forest of white slightly bulbous columns are arranged in approximately 4 meter bays that is topped by a clerestory window and a white small dome. If this mosque were in Indonesia, I can imagine groups of halaqah or study groups of students teaching one another the Qur'an and the Hadiths as I had done in Milwaukee. The bay system created is absolutely inviting worshippers to form small circles of knowledge that should be the back bone of Islamic intellectuality and freedom of discourse.

The third aspect is its sweeping horizontality and diminutive nature of the entrance iwan. I had to look twice to actually find the gateway. Since I was used to the massive iwan gateways of the Putra Mosque and those of UTM, I did not notice the presence of a short and stout gateway entrance. The gateway seems to be drowned by the strong sweep of horizontality that to me reflects the Islamic idea of tawadhu' or humility and humbleness. The fact that I did

not notice the gateway even as I was entering the mosque through it testifies to this remarkable balance of quiet grandeur.

The fourth aspect is the scale of the main dome structure. The dome is designed small compared to the square space underneath, thanks to the spiral-like fins that seems to portray a twister of wind culminating in the dome structure. Instead of creating a huge dome for the entire space, the architect has managed to scale down the dome by this whirlwind effect of movement that gives it a dynamic quality that makes one forget that there should be a dome three times bigger than the one at present.

Finally, the most remarkable aspect of all is the non-presence of the minaret. At first, when I saw the mosque for the two days that I was there, my mind has already placed one or two minarets on the mosque so that I did not bother to look for them. It was only when I saw the pictures I had taken that I searched for the minaret or minarets. There were none in my camera files! I checked the souvenir book about the mosque and was surprised that it too did not have a minaret. With a stroke, the designers have brought back the integrity of the Nusantara Mosque of Kampung Tuan and Kampung Laut where the minaret was not a necessity.

The weakest aspect of the whole design is the front façade of the whole building which sends an unfriendly message. The designers had to place the toilet function against the front façade and that perhaps may have not been wise as it covers all views of the worshippers performing their ritual ablution. I think this is an important sight to see because, as a congregant, I feel much inspired and more prepared for prayers when I see other acts of ablution before I perform mine. It is like going to the library and being encouraged by the sights of books and people reading them. The other weakness of ablution is present in most of the mosques I have visited. The fundamental aspect of ablution as stipulated by the hadith is that one should not try to dry the wet members as these will shine as testimony in the hereafter. This is not a wajib at but an encouraged one for the sake of symbolism. Thus the designer of the mosque must figure out the time it takes for the wet body members especially the feet to dry in the humid tropical air. I would say that the distance traveled would have to be about five meters and I should be walking on timber decks with gaps in the floorboards to let the water drip down and the give time for the timber to absorb the moisture and also rounded pebbled floor to give friction and trap the water droplets. What we have in mosques nowadays are the shiny

and slippery tiles which makes the feet still wet when one arrives at the carpeted floor. One can get a whiff of the damp carpet in most mosques because of this.

There are two other strong weaknesses that the designers had no control of and thus I suppose these should not be criticized to severely. The first is the terrible qibla wall that is made up of some foreign tiles requested which throws the whole purity of modernism out the window. It is really a horrible sight to see that I wish to speak of it no more. The second weakness is the fact that campus mosques should be placed within the hustle and bustle of the student union building and the administrative structures with linked covered passages. Shops and food courts ought to be placed on one side of the mosque courtyard. This would truly create the 'working mosque' and not the 'mosque-as-prayer-mat' idea.

All things considered, I am most relieved to find a significant trace of intelligence and professionalism in the architecture profession as well as a liberal stand by the client. Although it is still shy away from the unique qualities of the National Mosque with its strong characteristics of tropical architecture generous serambi, sweeping horizontal lines and open friendly façade, I would say that the An-Nur Mosque has returned the dignity of Islam from the autocratic pedestal of unrestrained monumentalism.

The absence of the minaret is applauded

A human scale serambi space which is a credit.

The weakest part of the whole design, the mihrab.

25

Building Friendlier Mosques

The title does not imply implicitly that Islam, the Muslim community or the institution of the mosque at the present time is unfriendly. Even the very best of intentions most of the time are misunderstood because of an inadequate knowledge in communication whether by body or building language. As an architectural academic who has undergone training in the science of Environment-Behavior Studies or more popularly phrased as Architectural Psychology, I find that most Malaysian mosques are 'unfriendly' architecturally not only to non-Muslims but to Muslims themselves. I would like to recommend several strategies of architectural design that would open up the mosque to the community. Most of these ideas are abstracted and adapted from my books, 'The mosque as A community Development Center' (Penerbit UTM, 1998) and 'Peranan dan Rekabentuk Masjid Sebagai Pusat Pembangunan Masyarakat' (Penerbit UTM, 1999).

The first strategy is about the size or scale of the mosque. It seems that the prevailing attitude is that the bigger the mosque is the more grandeur one would make Islam to be and thus please Allah immensely. I feel that such attitude treats the mosque more as a 'temple architecture' then as a community center. If the mosque were to be considered more for bringing the Muslim community together and nurturing them in the brotherhood of Islam, then a smaller mosque would create more chances of people knowing one another. In the modern housing estates of today I would surmise a figure of about 1,000 congregants to be the maximum. One favourite argument against this idea is

that the more mosques there is the more friction one would create amongst Muslims. That has yet to be proven academically.

The next strategy is the siting of the mosque. Mosques should be sited right smack in the center of the activities and integrated with the urban fabric. The older mosques in the middle-east located in urban centers hardly reflected any façade as they were engulfed by the market place and this affords a generous quality of accessibility. Many mosques nowadays in Malaysia sits on an isolated site with four streets surrounding it and this effectively cuts off the mosque from society. Siting mosques on hills may be an ideal romantic gesture but it would make walking difficult. On the subject of walking, it is better to design mosques with a 5 to 10 minute walking distance than the 5 – 10 minute car distance as this would save energy and lessen the pollution of the air. Walking would create more friendly opportunities to greet neighbours of all races and religions rather than the isolated environment of the vehicle.

To me the most devastating architectural element of the mosque is undoubtedly…the fence. In the older days of Kampung Laut and Kampung Tuan Mosques, there was no fencing. I have always wondered what the rationale of the fence was. Is it because Muslims follow the example of the first mosque where there was a fence around the compound? Well, I must tell the readers that the Prophet's Mosque was also his house and thus a fence is quite normal for a house. Furthermore, the Prophet was in hostile territory and one could also argue that the fence is a common shelter against the warm and dusty winds of the desert. Then why the fence? Some say it was to keep the dog out as it is considered a dirty animal. In the traditions of the Prophet it was recorded that sheeps come and go in the mosque compound. There was a prostitute who the Prophet Muhammad said made Allah pleased by giving water to a dog. Thus, who are the fence trying to keep out? The non-Muslims? Well, then how can the mosque perform the role as a 'dakwah' center to explain Islam to others? The National Mosque is a wonderful building and one reason is that it does not have a fence. Thus there are two architectural options here, get rid of the fence entirely or make the fence not look like a fence. If I were designing a mosque for a particular community, I would firstly move the front fence 10 to 20 feet from the lot line so that I could 'give-up' some of the mosque land for the use of the whole community with functions such as street furniture or bus stand and even a small playground. I would make the paving similar to the inner mosque compound so that the message is clear that the land belongs to

the mosque and that the mosque is generous enough to give something to the community. I thought that gesture can be called an 'architectural dakwah'. Next, I would replace the metal and masonry fencing with nice planter boxes with wide seating slabs topping its container. I would zig-zag the fence and not make it a straight line and this would create pocket spaces for seatings, plantings or the small goreng pisang stall. I would not make the plants in the planter boxes taller than five feet to afford a view into the compound. I would also place serambi-like structures or wakaf huts as the perimeter 'fence' and thus the whole mosque would be physically fenced but psychologically and socially more open.

The mosque compound should not be filled with parking. Parking should be outside or somewhere on the site which does not speak of the main front or side. The mosque compound should be free from cars and filled with street furnitures, playground facilities and proper lighting amenities that would create a 'laman-serambi' or a compound verandah-way. In this manner, there would be more people in the compound than cars and thus create the idea of friendliness rather than isolated arrogance.

Finally, the building mass of the mosque should be broken up into several smaller mass and linked by a covered walkway. In this manner the mosque would not appear too big or monumental but more sedate and humble thus communicating and air of informality. By breaking up the mass it is easier to create cross-ventilation and cool the mosques and this strategy comes complete with the added bonus of energy conservation with natural lighting.

The mosque is not a temple to please Allah as He does not need such gestures. The mosque is a place to facilitate Muslims to worship and love one another whilst inviting non-Muslims to share in the spirit of tolerance and brotherhood of man.

26

Mosque as a Community

Introduction

Much discussion surrounding mosque designs have centered mainly on the problem of building stylization. We propose that the solution to mosque designs in the present situation be looked not at thee object-building but through examining the needs and problems faced by Muslims in the present. We believe the answers lies in determining what the 'curriculum' of the modern mosque should be before proposing the architectural guidelines for it. The 'curriculum' of the mosque will answer the needs of the Muslim community with the mosque as the one of the main mechanism to bring about positive social changes. Thus, we propose that the curriculum of the mosque have as its objectives to develop the Muslim community intellectually and developing a strong brotherhood. The mosque thus serves as a Community Development Center to bring about positive changes in the Muslim society. This essay is a summary of the arguments and ideas from two of our books entitled *The Mosque As A Community Development Center: Programmes and Architectural Guidelines* (Penerbit UTM, 1998) *and Peranan, Kurikulum dan Reka Bentuk Masjid Sebagai Pusat Pembangunan Masyarakat* (Penerbit UTM, 1999)

Mosque Traditions of the Prophet Muhammad

During the time of the Prophet Muhammad, the Mosque played a strong political and social role in the early Islamic community. One of the most important roles of the mosque was as the education center where the Companions learned many aspects of Islam and heard the new Revelations from God through the Prophet. Both men and women strived to learn Islam at the mosque. The *hadith* or traditions are as follows:

It is reported on the authority of Abu Huraira that the Messenger of Allah (peace be upon him) said," Get together, for I am going to recite one third of the Qur'an before you." And those who got together gathered at his house(the mosque). Then Allah Apostle came out and recited the Sura Al-Ikhlas. (Source: Sahih Muslim)

Zainab, the wife of 'Abdullah(b. Mas'ud): I was in the mosque when the Prophet saw me and said," Give Sadaqa (alms) even though it is with your own jewelry. (Source: Sahih Muslim)

Ab, Sa'id al-Khudri said: I sat with the company of the poor members of the Emigrants(Ahlul Suffa, or those who stayed in the Prophet's mosque). Some of them were sitting together because of lack of clothing while a Reader was reciting to us. All of a sudden the Prophet of Allah (peace be upon him) came along and stood beside us. When the Apostle of Allah stood, the Reader stopped and gave him a salutation. He asked," What were you doing? "We said," Allah's Apostle! We had a reader who was reciting to us and we were listening to the Book of Allah the Exalted. "The Apostle of Allah then said : Praise be to Allah Who has put among my people those with whom I have ordered to keep myself." The Apostle of Allah then sat among us so as to be like one of us. (Source: Sunan Abu Dawud)

The challenge for modern Muslim societies is to rejuvenate this role to address many present problems as well as reemphasizing the true spirit of Islam. One cannot use the argument that since there are many existing educational facility, the mosque should age gracefully and concentrate only as a house for ritual worship. The day the mosque 'retires' or is 'retired' to the mere function of a prayer place only would be the day Islam dies in all aspects of its true teachings. We must develop the intellectual and social programs that would ensure the survival of the eternal idea of the mosque as a community development center and thus guarantees the existence of Islam for future generation.

Mosque Community Curriculum for Intellectual Development

The main purpose of the Intellectual Development Program is to create a Muslim individual who has a critical mind, who has awareness of his Islamic and ethnic heritage and be able to source information necessary for survival.

Muslims are faced with many serious challenges today. Ethnic violence have erupted because ethnic groups do not understand each others' socio-cultural needs and thus do not respect one another. There are even serious disagreements among Muslims of different sects and *madhab* that have created shameful unrest. Honest leaders find difficulty developing Muslims who do not understand the political realities of their nations and heritage. At one time Muslims have been 'ripped off' economically by con artists who were hustling false share schemes. It showed that Muslims were not even aware of simple economic laws on investment. We have also found out to our great shock that many older generation Muslims refuse to come to terms with many sound scientific findings and prefers to believe their religious 'teachers' who brand this field as some sort of Great Satanic Deception of the West. Finally we can also see that many religious teachers are still teaching Muslims through the old traditional pedagogy and shy away from using technology and experimentation of new teaching methods.

The program for intellectual development calls for a total revamp of the present curriculum. Muslims must not only be taught about rituals of prayers and tafsir of hadith and Qur'an but they must also be taught history and to celebrate the sacrifices of past and present 'heroes' in Islam who had saved or developed their peoples. The teaching of the Sirah and the deeds and morals of these important individuals must be 'alive' in the spirit of every Muslim young and old. Aside from lessons in Islam, Muslims must also be exposed to knowledge about the various ethnic groups and their cultures around the world who are also Muslims so that they understand the greatness of Islam in the world and that these people will not seem mere statistics to them in times of giving aids. There must also be lessons on the religions of the different cultures who live amongst Muslims; for instance the Muslim Malays in Malaysia live amongst Chinese and Indians who are mainly followers of Buddhism and Hinduism. Interfaith discussion is necessary for us to tolerate one anothers' peaceful existence. The burning of mosques and temples in the past is a regrettable events and should not be condoned by anyone especially

Muslims. There must also be lessons on the ideas of science and the use of technology in our daily lives. It is fearful that, in Malaysia, we have seen 'false prophets' predicting the Qiamat and Muslims were fooled because they could not understand basic sciences. Many Muslims are also fooled by faith heelers, traditional and modern 'medicine men' with regards to health.

Much of the implications of these programs relate directly to the methods of instruction. These may include lectures, discussions, viewing videos, reading or even performing cultural shows. Exhibitions can also be held as it is an important educational mechanism. The design of the mosque must cater for these needs in the sense of providing the audio visual equipment and their proper placements, spaces for libraries or electronic viewing or stages for performances. Special storage facilities for exhibition materials must be included in mosque designs so as the ease of changing and exhibiting them can be achieved. Classrooms and story telling corners would be a most welcome addition to children and youngsters. Libraries, resource and hobby centers would be appreciated by the teenagers and adult population.

Mosque curriculum for Strengthening Brotherhood

Islam encourages the development of a strong brotherhood so much so that the Prophet had said that a Muslim shall not go to Paradise if one had no love for one's brethren in Islam. The state of the Muslim society is in deterioration in relation to this aspect of Islam. With the proper programs the mosque can make critical changes in strengthening the brotherhood of Islam in each community.

Much of the disintegration in the Muslim society, and of other societies as well, is caused by the assimilation of working and living patterns brought about by the West. Western imported technologies and city planning principles which destroyed the traditional settlements did much to encourage social disintegration. The separation between working pattern and living environment has given rise to a neither here nor there situation in which people spend half the day working and commuting to work. What little that is left of the day is spent at home where most families are independent in terms of acquiring food, recreational and medicinal needs. Individuals could not influence their societies for there are neither long enough in the cities nor are they present at length in the housing estates. There is little time for social interaction

among the families in a housing estate. Furthermore, the disappearance of the extended families due to poor house designs, economic considerations and an active government welfare program help to worsen this situation. Adults and teenagers find themselves without any role in the society since 'everything' is taken care of. The main task of adults seem to be making money whilst teenagers need only perform the act of studying. Thus with much spare time on their hands, teenagers fall into the world of drugs, electronic entertainment and other disruptive past time.

Muslims in communities no longer posses an identifiable Islamic identity. Although the community may have possessed a monumental mosque complete with exotic arches and *muqarnas* ornamentation, Muslims are empty of their own sense of Islamicness. In the first place there are few celebrations of the rites of passage. Circumcision ceremonies are no longer held at homes and replaced by a quick stop at the hospital or clinic. The *marhaban* ceremony is kept within family circles and most of the times ignored. Marriages are more fashionable at hotels where private catering absolved community responsibilities in helping out. Much of these kinds of happenings that were present in traditional societies are slowly becoming extinct and along with it, the brotherhood of Islam.

Programs must be implemented to make each Muslim feel a sense of Islamic identity and to foster communal feelings of brotherhood. Celebration of the rites of passage such as birth, circumcision and marriages must be reinstated as important events to be celebrated by the whole community at the mosque. Celebration of historical events in Islamic history should be increased so that the community can come together more often and the Islamic heritage is remembered by children, teenagers and adults. Teenagers can be given some responsibility in terms of joining clubs or military-like organizations such as the Police Cadet Corps at the mosque instead of at schools. Library Clubs, Drama Clubs, Historic Society can all be instituted at the mosque rather than at schools. In this way teenagers will be directly involved in community services. The mosque administration must then identify its congregates to lead the teenagers in all the activities stated. In this way there will be many Muslims who will pride themselves in contributing to the society and learn to become leaders in the small organizations. To inculcate team spirit, games and sporting events must be organized such that friendly rivalries may occur between different mosques and *qari'a*.

The architectural implications of the above program include the design of small rooms as clubhouses, library space, and perhaps workshops. Mosques must also be equipped with a compound that can be used as parades and also as outdoor activities during celebrations and sports. The space in the mosque must be designed in a manner that a stage for performing arts can be integrated.

Architecture Design Implications

There are many aspects of design that are affected by the implications of the curriculum previously mentioned. We present here only one aspect which is related to sizing the mosque

There is no specific guideline that is agreed upon by the religious scholars as to the ideal size of the mosque. In architecture, there are two fundamental factors controlling the determination of size. The first factor is related to occupancy while the second concerns the aesthetic or symbolic intention of the building. If the question of size is related to the aesthetic intention of symbolizing an object, it is relative to the economic constraint and the visual impact of the building in its surrounding context. The world is filled with such grandiose schemes by monarchs, caliphs and governments in this respect. With the advancement of long span structures, today's mosque can fill tens of thousands of Muslim. This is basically a result of several factors. Firstly, there is no set condition for the ideal size of the mosque. Secondly, since the mosque is more regarded as a house of God and the place of prayer, the clients and designers feel justified in creating the grandiose scale of the building because to them it is almost literally a house of God. Thirdly, the impact of sheer size is crucial in creating a visual symbol.

We suggest that the present criterion of mosque size has been based entirely on the notion of the house of God and that its main concern was that of prayer. Since the eternal idea of the mosque is to provide the opportunity for the Muslims to organise and develop their community it follows that the consideration of size must take into account the ideal and manageable size toward this aim. One of the main functions of the mosque is that of education and also to unite the Muslim in a strong brotherhood tie. In this respect the question that must be raised is what should the ideal size be for a leader and the administrative committee to manage the activities toward these ends. It is important to question whether the building of huge mosques for tens of thousands worshippers is appropriate.

Conclusion

The problem of the mosque in Islam must be seen in the larger context of social engineering rather than mere exercises in aesthetics or romantic revivalisme. The mosque has the great potential of changing the Muslim society if it is considered closer as an educational institution than a House of Rituals that prohibits so many activities under the false guise of 'sanctity'. We believe that over sanctification of mosque brought about by scholars of architecture and religion have deteriorated the eternal idea of the mosque as a center for community development in Islam. Rather than deal with the question of which ornament to use and how big a dome should crown the prayer space Muslims ought to pay particular attention to the programs and functions of the mosque that would benefit the people more than it would the egoistic few.

27

Is the Dome Islamic?

I have decided to deal with this question of whether the dome is an exclusively 'Islamic' element in architecture. The impetus for writing came when several events occurred to make me think that this was an important piece to write. I have always known as an architect even during my student days that the dome was neither 'Islamic' nor necessary for mosques or any architecture related to Islam. But when a student from UITM asked me to help him with his dissertation of whether the dome is still relevant in Islam, I decided to gather my thoughts and asked him to write it up nicely in Malay so that we could publish a book together. The greater impetus came when in a consultancy meeting, a former senior civil servant who was a planner attacked my stand on Islamic architecture by defending that the dome is the best representation of Islam. Another planner who was a consultant to the developer which I was also engaged by, added the notion that the dome was 'perfected' by Muslims and thus the dome is justifiably the unique exclusivity of the Muslims! Wow…such feats of delusions of grandeur! Muslims really like to pour it thick. I have never met such arrogant Muslim attitudes about many issues in my journey into the hadith of the Prophet Muhammad who came off a humble, quiet and rational man. Well, today, I will show that the dome is NOT the exclusive right of the Muslims, it is NOT also the crowning achievement of engineering by Muslims and it is also IMMORAL at some points to actually construct domes for mosques or other related buildings in Islam.

First of, the reader should know that thousands of years before the Prophet Muhammad was born the masonry dome had already existed. Taking cue perhaps from the natural cave formation that arches over an empty space in a cave, the ancients began to arrange stones in a circular manner with the top layer of stones in ever decreasing diameter of concentric rings until they near the small hole at the top. These holes were either topped up with other roofing materials that threw off rain and snow or simply let open to act as a natural chimney for the hearth below. The greatest dome builders, according to Western historians were the Romans who constructed the Pantheon (120 AD) which spanned more than a hundred feet. The dome was of finely cut stone and a great feat of engineering. There are also many fine domes in Indian temples and palaces as well as some parts of China which predates the Prophet Muhammad's birth and therefore, Muslims should forget the idea of the dome being originally created by them.

As to the claim that Muslim perfected the dome architecture, I have two points with regards to this extraordinary claim. Some historians have mentioned that the Muslims perfected the dome architecture by creating the pointed or bulbous or onion shaped dome to reduce the thrust of the foot of the dome. Even if this claim were true, this experiment was made from the trials and errors of the Gothic Cathedral builders who first experimented with the pointed arch and vaults. Secondly, if the Muslims had 'perfected the masonry domes of half a century ago, are we supposed to build domes of that material and in that manner in the present time? Did the Shah Alam Mosque use a masonry dome? Did the new Steel Mosque or 'Masjid Besi' in Putrajaya use finely cut stone? It would not be safe and that type of construction could not span the distances that steel domes can. By the way, did the Muslims invent steel domes? Or did the Muslims invent the shell domes of reinforced concrete that spans hundreds of meters over empty space? My favourite engineer was Pier Luigi Nervi who lived in mid 20th century. He was a master of reinforced concrete construction and was able to design lamella ribbed domes and vaults that spanned many hundred feet using lightweight V-shaped ribs of only 20 feet length. The largest span 'dome' was in the shape of a double curved and double shelled segmental arch perfected not in a Muslim country or neither was invented by a Muslim engineer or architect. Thus, what justification can the Muslims have for claiming that the dome is the specific exclusive right of Islamic Architecture when we no longer build them in the same way as

the ancients once did. And, furthermore, there were many more building typologies like Hindu temples, Ancient Religions and others which had used domes well before the birth of Islam in the 7ᵗʰ century. How could some municipalities of Malaysia deny the use of domes on other religious structures and claim the exclusivity only to Islam? Identity? Well, there are other architectural characteristics of the mosque that can be highlighted such as the single minaret, the geometric ornaments, the Islamic Calligraphic Writings and the open veranda of prayer spaces. Such religious verdict put Islam in the negative side.

Thirdly, I come now to the 'immorality' of building domes for mosques or other Muslim buildings. Now, have you readers ever been to Malacca? Have you seen the Masjid Kampung Hulu or Masjid Tengkera. Or have you seen the Masjid Lebuh Acheh in Penang? What about the Masjid Kampung tuan in Terengganu or the famed Masjid Kampung Laut in Kelantan? There are no domes in all of these traditional mosques but the pyramidal timber roof forms. Are these mosques any less religious than the Shah Alam Mosque or the Putra Mosque. Hey... what about the Masjid Negara? Should we strip it off it's national status because the architect was 'stupid enough' not to put a dome? The mosque of old had responded to the technology and economic means of the times by building the roofs of timber. The strength of timber is in its bending properties like steel. It affords a more straight kind of architecture whereas earth, masonry and concrete do not have bending properties and thus they have to be curved to withstand the compressive forces only. So the traditional Malay mosque of old was morally right as it responded directly to the pure needs of the time and the place. The Shah Alam and the Putra Mosque is 'immorally wrong' because it wants to look like something else from the middle east and ignore the cheaper steel truss or portal frames that could have spanned much easily. There are even congregants who complain to me the terrible acoustics of spaces that have domes with its lengthy reverberation time. The domes of the Christian Cathedrals is romantic because of the special hymms that accentuate the choir singing God's Praises but the mosque needs a clear sound for Qur'anic recitation as well as the ceramah. Again, another immoral point against the use of the dome.

Finally, there are those who claim that one of the Verses of the Qur'an had alluded to the construction of domes when Allah says "And we raised the sky as a canopy above them...'(Surah Ar' Rad), I would like to point out two things

here. Firstly Islam has never subscribed to iconoclasm or the sanctification of a physical object. Never. The Ka'aba is in the Masjid-al-Haram and the only sanctity there mentioned by the Prophet is the site where Abraham and Ismail built the first mosque. The Ka'aba is not a sacred object as it was destroyed in a flood and later rebuilt. It is the site and the historical symbolism that is dear to the Muslims. The Prophet's Mosque is considered sacred because of the respect of the Muslims for the grave of the Prophet. But the Prophet clearly forbade anyone to worship graves in the hadiths. Thus what was sacred is the site not the object of the building. The Masjid-al-Aqsa is sacred because it was the site of the Ascension or Isra' Mi'raj. Not the Dome of the Rock or the mosque itself. So where does the proponents that the dome is sacred get their idea of the sanctity of this element? Secondly, Allah merely mentions the 'canopy' to the Arabs because there had no way of understanding the atmospheric layer that is a circular sphere around the earth and not a dome.

So did the Muslims invent the dome. Nope. Were the Muslims master builders of the dome? Perhaps at one very limited time but not at the present. Is the dome a sacred element in Islam? I definitely think not. So should you build big domes on mosques in Malaysia? The answer is…what in heavens for?

28

Islamic Civilization Park: A Question of 'Civillizing' Islam

In this chapter, I wish to dwell on the topics of symbolism, Islam, education and the values of the Prophet Muhammad (peace be upon him). The subject matter under scrutiny is the recently built Islamic Civilization Park in Terengganu which some reports have said to have cost the people of Malaysia over RM 200 million. The message of this essay is that a good and noble intention of educating Islam to the public should take into account the values of the Prophet of Islam himself and that professionals should learn to view architectural projects from a value centered perspective rather than the simplistic object-centered one. As with the buildings in Putrajaya which has much 'Islamic' symbolism or at least a populist understanding of Muslim foreign architecture, I feel the Islamic Civilization Park has repeated much of the missed opportunities such a project present itself. I will firstly deal with the concept of a 'Religiously Charged Theme Park' concept and then present the problems with the architecture of 'replicas'. The third part of this writing proposes a different approach to the same intention of educating about Islamic culture and values with respect to architecture.

First comes the subject of a 'religiously charged theme park'. If I am not mistaken, this would probably be the first of its kind. The ones that comes closest to my mind is the Mini Malaysia Park in Melaka, the 'World Theme Park in Disneyland' and the Columbian Exposition in Chicago in late 19th century. There are of course many others but I wish to compare and contrast these examples. The Mini Malaysia Park has full scale replicas of traditional

houses with 'fake people' living in some of them. The theme park in Disneyland in the USA features scaled down versions of various kinds of buildings from a multitude of cultures but they are very careful in choosing any building type that would be religiously sensitive like a mosque or a temple. The Columbian exposition in Chicago that was to herald the coming of the new millennia, the 20th century, poses a different set of questions. The politicians, engineers and architects opted for the gleaming 'White City' of classicism. The lone critic of the move, Louis Henry Sullivan, was of the opinion that this architectural decision was not only a sham to American Democracy but also to the building profession. In his criticism, he points out that none of the buildings could reconcile the architectural language of the tall building or the Sky Scraper because Greek Classical architectural language never developed high rise languages. Sullivan said the future architectural landscape of America would be the sky scraper and not low rise structures of classicism. Yes, classicism was beautiful but the language and intellectual framework of its architecture must be evolved to suit the new structures made possible by the engineering feats of steel, reinforced concrete and glass. Revivalism was not the answer.

Now, the question that is of concern to us here is how does the Islamic Civilization Park address these intellectual issues? The first problem is about religious sensitivities in the theme park. Walt Disney did not dare to approach it but we Malaysians freely let it happen. Isn't there a moral issue somewhere in using religiously charged building as mosques and tombs as 'tourist sculptures'? Would the Prophet Muhammad allow the building of a mosque made of crystal or otherwise simply for 'show'. It was he who said in a hadith that 'thou would vie with one another to build lofty mosques but non-will pray in them',. It was also he, on his death bed prohibited his wife Aisha from contemplating the construction of any ostentatious tomb over his grave in an authentic hadith documented by the eminent scholars Bukhari and Muslim. The Mini Malaysia also did not deal with any religious issues as the buildings were all residences of various sizes. Finally the lesson from the Columbian Exposition was that revivalism should not be the order of the day. Much of the architecture in the Islamic Civillisation Park that is built to support the scaled down replicas are of revivalism and that speaks of Islam as a religion that is not progressive and 'impractical' economically. The great thinker, politician and religious scholar, Abul A'la Maududi once wrote that Islam is the simplest religion as it has no need of any structures or paraphernalia for the worshippers to pray.

The strength in Islam is the humanistic values of love, tolerance and mutual respect. There are architectural solutions that can translate these values which I will explain in the writings to come.

Next comes the problem of building replicas. The question here is in what manner would replicas be of any use? Many do not understand that an architectural product is the result of the available material and technology of the time, the climatic condition of the place and the political agenda of the clients as well as architects. How could a scaled down version of the Taj Mahal, a tomb, and the Al-Hambra, a palace, present Islamic values? The Prophet himself prohibited the building of tombs and certainly never lived in a palace. His companion, the second Caliph of Islam, umar al-Khatab onece admonished his general for living in ostentation and constructing a gateway separating himself from the people. I interpreted the action of Umar as a very democratic gesture but it is so difficult to find democratic values of islam in so many palaces and monumental tombs or tomb-mosques. The next thing about replicas is the construction materials and technology. The great domes and arches of the past were built with masonry and constructing them with reinforced concrete with 'masonry-like' tiles does not present the effect of 'weight' and massiveness as natural only to stone and masonry. Thirdly is the question of lighting and interior warmth. The windows and openings of the old structures were a function of the ability of stone to span short distances and the climate of the place. The original buildings did not come from a tropical place. The original buildings would make the interior unbearably hot in the tropics that would require greater openings. Finally, the great buildings of the past was a product of the landscape. How are we to duplicate the backdrop and colours of the sky amidst the hills and mountains where the buildings are carefully sited? What is to become of the message of Islam as exemplified in its architecture?

We are in dire need of a 'value centered' discourse on Islamic architecture and not be trapped in an 'object-centered' one. How do we reconcile the regressive architecture of such buildings like the international Islamic University, ISTAC, IKIM, the Federal Mosque, the Prime Minister's Office in Putrajaya and the Islamic Civilization Park with the values of the Prophet Muhammad? This was a man who said that 'one should not waste water in ritual ablution even if performed at a flowing river. This was the man who cannot be identified when sitting at a gathering as he looked like any of his

fellow Muslims. This was a man who prohibited his companions from getting up to show respect for him when he chance upon a gathering.

In the coming articles I would expound my views on how to convert the values into built form. Before that I wish to recount the architecture of two Muslim professionals who created a more humane and progressive architectural works this century. The first is the architect Hassan Fathi and the second is the engineer Fazlur Rahman. Hassan Fathi was an architect who practiced in the middle east in the sixties. He came home to find great need of housing for his people. He turned his back on modern technology of reinforced concrete or pre-fabricated panel construction as this would inflate the price of the houses beyond the rich of the poor. He decided to humble himself and learnt the traditional craft of building with mud brick which was the vernacular material and technology of his country. With modern scientific analysis he studied the structural strength of the traditional materials and its heat insulation properties. He was thus able to create many housing schemes with low rise mud brick construction that gave jobs to craftsmen, fired up local construction economy and create a scale of building and spaces that was socially and climatically acceptable to the people and not alienate them with modern materials like our own low cost housing. Now this is what I call Islamic Architecture as its concern came from the values of helping the needy which sparked a whole new way of looking at revivalism of traditional crafts.

Note: Fazlur Rahman was an engineer with Skidmore Owings and Merryl, one of the largest architectural firms in the USA. When the government of Saudi Arabia approached the firm to help solve the problem of processing the million of pilgrims that come to perform the Haj, Fazlur Rhman hit upon an ingenious solution for the Jeddah Haj Terminal that was economically, climatically and socially acceptable. He saw the architecture of the Bedouin tents as an inspired age old solution of living in the desert. He proposed a tent structure that created a huge canopy of shelter that let the air flowing over the smaller boxes of offices and spaces. He saved millions in construction cost of wall cladding and air conditioning. Now this is progressive Islamic Architecture that was

29

Islamic Architecture in Malaysia: a Case of Middle Eastern Inferiority Complex

Introduction

To the well informed, architecture speaks volumes about society. Unlike any other kind of 'language', architecture never lies. In whatever manner a building is composed, it will always contain the intention or ignorance of the patron, user and architect. The design of mosques in Malaysia is no exception. We can actually read the state of the Muslim society from the myriad of domes, minarets, polished tiles, ornamentation, *muqarnas, mashrabiyya, maqsura, mimbars, mihrabs,* courtyards, *sahn* and the various kinds of compositional syntax introduced by the architect or ordered by the client. In this short article I wish to draw attention to the curious reason why we went from the architecture of the National Mosque or Masjid Negara to the architecture of middle eastern eclecticism exemplified by such mega projects as in the Shah Alam Mosque, the Wilayah Persekutuan Mosque and the 'jewel' of them all, the Putra Mosque in Putrajaya. The common message of the middle eastern clad mosques seem to be that Islam has finally found its roots and true universal identity as opposed to its 'lost' years of international architecture. I seek to disagree with this common understanding and will present only three arguments in the form of criticism to support my contention that Masjid Negara possessed much that can be qualified as integrity in Islamic Architecture in Malaysia rather than the present mosques that have been hailed as the epitome of Muslim civilization.

Architectural Ethnicity

My first argument or criticism of the malaise in mosque architectural language in this country is that the present mosques show a serious case of Middle Eastern inferiority complex. No where can this be said to be superbly exemplified than a trip down south to the Universiti Teknologi Malaysia, Johor Bahru. Amidst the congregation of pseudo-Malay traditional architecture *of serambis, pemeleh, tiang seris, bumbung panjang, limas potong Belanda* and *tebar layar* that form the faculties, administration, dormitories, sports complex and lecture halls, one can discern clearly the crown of the campus which is sited at the highest point...a blue tiled eclectic composition of six Ottoman minarets, Iranian iwans or gateways, Arabic hypostyled halls and topped with a huge Egyptian dome. Not a day that goes by that I ask myself the question, why couldn't the architects and clients complete the traditional revivalism with a Nusantara type mosque? I am sure the academics, professionals and university leadership is aware of the two tiered and three tiered pyramidal roofs of Kampung Laut Mosque, the Kampung Tuan Mosque or the Papan Mosque in Perak. Why should we resort to s foreign architectural tradition when we have our own? I was told by a veteran politician from Melaka that he had to fight against the team of architect in order to force the choice of the present architectural language of the Melaka State Mosque. I have also read statements by architects and religious scholars that a mosque is not a mosque if it does not have domes, minarets and *mihrab*. Well I guess that certainly rules out most of the traditional timber mosques in the Malay World because they never had any one of the 'required' elements! The attitude thus prevailing seems to indicate that Muslims in Malaysia have an inferiority complex against the Middle East, the birthplace of Islam. I have no reservation for saying so because neither the Qur'an nor the hadiths of the Prophet Muhammad (peace be upon him) make any mention as to the required expression of the mosque to be from its birth place. Islam is a religion that crosses geographic and cultural boundaries. It does not put racist or ethnic preference as the measure of a true *mukmin*. Thus, we can see why the National Mosque in Kuala Lumpur does not have this problem of inferiority complex. Its whole architectural expression does not suggest any other foreign influence but is uniquely suited within our socio-cultural context.

Spirit of Times

My second criticism of the present approach in mosque architectural expression concerns the idea of *spirit of the times*. I will show that the Masjid Negara possess this idea well and thus show Islam as a progressive and dynamic religion. The present mosque vocabulary of Middle Eastern eclecticism presents the idea of Islam as a regressive and dogmatic belief system. However, before commencing on a critic of present mosques in this regard, an explanation of the philosophy of the *spirit of the times* is necessary. The expression was given prominence in the intellectual architectural discourse concerning the true form of a modern architecture in Germany, France and England. The true style of a building is said to be one that respect the spirit of the age in relation to its technology, availability of materials and the new political systems. For instance, the traditional timber mosques of Malaysia were built according to their spirit of the times in relation to the construction and structural technology of that period. The Malays knew only the column and beam system of timber and that explains the domestic scale and short spans of the structural bays. In the middle east, the construction of traditional mosques were of mud or stone which gave rise to massive load bearing walls with small openings spanned by arches and domes. Many people do not understand that arches and domes are necessary structural elements to span long distances if one was using stone or mud construction. Thus it can be said the mosques of the past respected their spirit of the times. Masjid Negara or the National Mosque in Malaysia was built in the modern era of reinforced concrete construction. Its wide span of beams, use of hyper roofs and the huge folded plate roof covering the prayer hall expresses the spirit of the structural material. However, the present mosque designs of arches, domes and small fenestration 'pretend' to imitate the traditional masonry construction of the past! In order to span a huge space, we have a whole plethora of structural system from steel space frames, rigid frames, trusses, tensile structures, folded plates and hyperbolic shells. Horse shoe arches and onion domes are of bygone days except if one was building for the poor like what Hassan Fathy had done in the adobe construction of Africa and the middle east. Thus, we can see that Masjid Negara expresses the idea of Islam as a religion that is dynamic and progressive of the times rather than one that is static and even dogmatic as exemplified by the 1001 nights architectural vocabulary.

Spirit of Place

The third criticism on present mosque design language concerns the idea of the spirit of the place. This philosophy states that the true essence of a building lie in its response to the specific climatic, geographic and culture of the place. I will speak only of one of the elements that make up the spirit of the place and that is climate. Now if we were to leave our air-conditioned office, houses and cars, we might be able to notice that we live in a hot and humid tropical climate. This fact seems to escape ordinary Malaysians who include architects but it is something, which the foreign tourist understands fully well! The climate, it seems is Malaysia's best tourism commodity. In relation to architecture, the language of tropical design is always pitched roofs, long overhangs, louvered windows, wide verandahs, air-wells, light court, cool ponds of water and lots of fenestration. If we were to glance briefly at the Putra Mosque, the Sarawak State Mosque and the Shah Alam Mosque, we would be able to see that, in contrast to the Masjid Negara, those mosques do not show much of what tropical architecture should be. Small openings and massive enclosed fortress-like walls are the architecture of a temperate region where the little fenestration is to keep the cold out and the heat in. The use of massive walls as heat storage 'tanks' during the day so that it could reradiate heat during the frigid nighttime is definitely not a tropical feature. The designers of Masjid Negara understands this well when they put a wide open *serambi* area, high ceilings, large fenestration, air wells cool ponds of water at the interior and a raised platform on *pilotti*. It saddens me that in one of my public seminars, an architect observed that he prefers air conditioned mosques and saw no reason why we should build tropical ones when we are capable of using mechanical means of comfort. This argument reminds me of a local politician's view of the meaning of 'extravagant spending'. According to the new 'morality' of this politician, one is not being extravagant if one has a million ringgit and spends it all because extravagance is only when one spends a million ringgit when one does not have that much! Now I was always taught that if one has a million ringgit and spends even ten cents on something, which we can do without, that is actually the idea of extravagance! The prophet Muhammad (peace be upon him) once remarked "Waste not water for ablution even if you're performing it over a gently flowing river". I have always taught my architectural students that they should never forget the tropical response to architecture even if one is designing a tall air-conditioned tower. The architects of mosques in Malaysia seem to be

too concerned at honest imitation of foreign traditional heritage at the expense of the idea of Islam as a simple and moderate religion.

Conclusion

There are many more criticisms that can be leveled at present mosque designs in Malaysia. I have merely grazed the tip of an iceberg in expounding the three criticism above. Amidst the euphoria of Malaysia having the biggest, the tallest and the most exotic, these criteria have never been accepted as necessarily exemplifying a thinking culture. It only shows our inferior mentality and diminutive aspiration when we have to proclaim to others about our so-called 'greatness'.

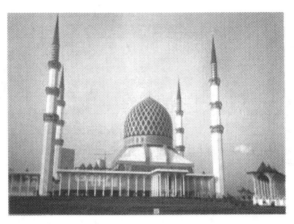

Post-Modern Revivalism in Malaysia:
The Shah Alam Mosque

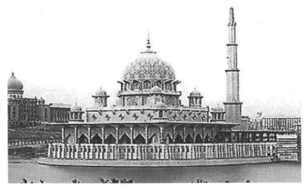

Post-Modern Revivalism in Malaysia:
The Putra Mosque in Putrajaya

30

Multi-million Ringgit Mosques:and where is the Suffa place?

In the simple minds of the Malays and many ethnic Muslims, around the world, building the biggest and most expensive mosques would be the greatest gift of man to Allah The Most High. I am not sure where they get the idea from but it is certainly not from the saying or hadith of the Prophet Muhammad (peace be upon him). Or perhaps the Malays and other ethnic Muslims interpret the saying that if one were to build a mosque for the muslim community, Allah will reward with a big house in Paradise. Ergo, the bigger the mosque, the bigger the reward. Well, I think the Muslims forgot one teensy weensy little detail about the mosque, the spirit and values of its institution, not the architecture. Before the architecture must come the values, and culture of the would-be users. Before the mosque, must come the idea and responsibilities of the Muslim community towards the individual and vice versa, what are the responsibilities of the individual to the ummah or Muslim community? Muslim scholars are always pointing out that in Islam, unlike in Christianity or other religions, there is no priesthood. The whole community must ensure that there are learned scholars or ustazs to explain Islam not only to the Muslims but also active engagement with non-Muslim societies for mutual benefits. If not the whole community would be in grave sin. The other responsibility of the community and the individual is the 'amar maaruf nahi munkar' or the encouragement of good deeds and the discouragement or the

prevention of evil deeds. All these objectives and principles can be spelled out in terms of activities and functions which in turn can be used to generate actual spaces, furniture and structures to fit the activities. Now that then is REAL architecture. Not the I-saw-a-beautiful-Ottoman-Mosque-and-then-copy-that-one approach to design by architects. In today's column I wish to question one important feature that is totally missing not only in the multi million ringgit mosques but from most mosques in Malaysia; the Suffa place.

When the Prophet fled from the hostile forces of Mecca and made for the sanctuary of Medinah, he built his home where his camel stopped to rest in order to diplomatically settle the many invitations of land and sites from the Medinans. His adobe brick home was a simple affair of several small apartments in a row for his many wives, a generous wall system that fenced up a square-ish compound with two roof structures covering the link to the apartment and another one way at the opposite end. In the middle of the compound is a courtyard open to the sky. It was nothing more than a typical Arab house which can still be seen today. Now read the following two hadiths concerning the spirit of the mosque of the Prophet when he was alive:

> Anas bin Malik reported that some people came to the Messenger of Allah (peace be upon him) and said to him: Send with us some men who may teach us the Quran and the Sunnah. Accordingly he sent seventy men from the Ansar. They were called the Reciters and among them was my uncle, Haram. They used to recite the Quran at night and ponder over its meaning and during the daytime they brought water in pitchers to the mosque, collected wood and sold it and with the sale proceeds bought food for the people of the Suffa (the poor who stayed in the mosque of the Prophet) and the needy.

> Mundhir bin Jarir reported on the authority of his father: While we were in the company of the Messenger of Allah (peace be upon him) in the early hours of the morning, some people came there who were barefooted, naked wearing stripped woolen clothes, or cloaks, with their swords hung around their necks. Most of them, nay, all of them belonged to the tribe of Mudar. The colour of the face of the Prophet

underwent a change when he saw them in poverty. He then entered his house and came out and commanded Bilal to pronounce adhan. The Prophet then performed prayers with the Companions and then addressed them, reciting verses of the Quran : "O people fear your Lord" until the end of the verse "...Allah is ever a Watcher over you" and then he recited Sura Hashr:" Fear Allah, and let every soul consider that which it sends forth for the morrow and fear Allah." Then the audience began to vie one another in giving charity. Some donated a dinar, others a dirham, still others clothes, some donated a sa' of wheat, some a sa' of dates till the Prophet said," Bring even if it is half a date. Then a person from among the Ansar came there with a money bag which his hands could hardly lift. Then the people followed continuously, till I saw two heaps of eatables and clothes, and I saw the face of the Messenger of Allah glistening like gold on account of joy. The Messenger of Allah said," He who sets a good precedent in Islam, there is a reward for him for this act of goodness and reward also of that who acted according to it subsequently, without any deductions from their rewards; and he who sets in Islam an evil precedent, there is upon him the burden of that and the burden of him also who acted upon it subsequently, without any deduction from their burden.

A popularly accepted reconstruction of the Prophet's Mosque in Medina during his lifetime. It shows the many rooms on the side of the mosque that belonged to the Prophet Muhammad's wives. The mosque typology is exactly similar to the vernacular mud walled house forms of the Arabian people at that time.

The suffa were the people who lived in one part of the mosque; the roof covering the space opposite the other one linking to the apartment of the wives of the Prophet. They were of three kinds. The first were the Muhajirrun or the Meccan people who fled the city in order to start a new Islamic life in Medinah. These Muhajirrun left everything including their house, property and relatives. They had as the Malay say 'sehelai sepinggang' or literally the clothes on their bodies. Although the Prophet had made the muhajirrun as

relatives-in-Islam with the Ansar of Medinah, most of these people did not want to seek help from their new relatives in terms of shelter and opted to stay at the mosque. The other kind of suffa are the actual poor who had nothing to begin with and thy stayed at the mosque for shelter and perform the task of maintaining the building. The third suffa are the Medinans who had a home, wealth and relatives but they opted to be close to the Prophet and became voluntary slaves to him in order to learn and benefit from the closeness to their beloved, the Prophet. Thus we can see that the mosque of the Prophet in its humble simplicity of adobe bricks and date palm columns but shone in the spirit of caring as well as the brotherhood of man.

The question I have for Muslims is simply, where is the suffa place in our modern, monumental and lavishly decorated mosques? Where can the poor and needy find shelter in these multi million ringgit structures that boasts of man-made lakes or hills? I have walked and prayed in many monumental mosques, and I have yet to see a mosque which has a suffa place where homeless people, whether they were drug addicts or prostitutes or simply travelers or struggling students living in the mosque. Most of the time the mosque committee or security guard would throw you out into the streets then defile the sanctity of the mosque. As an architect and as a muslim I will say that such acts of inconveniencing the guests of Allah in his Houses are a grave sin in Islam and that there is no barakah or blessings in such mosques, however many minarets or domes it has. It is curious to me to know that the Gurdwara Temples prepare a meal of anyone who comes to the temple daily and it is called the 'langgar'. They would provide food for any one and not just the faithful. What of the multi million ringgit mosques? Or any community mosques in Malaysia? Food is cooked only during the Ramadhan and no food is prepared for the needy at any other time. The spirit of the suffa in the Prophet's mosque should be a great lesson in the development of mosque management system as well as the architecture of the mosque. It is a place of shelter where the needy can reside and those of wealth can open their hearts and wallet to feed these people on a daily basis. Now that is the true spirit of the mosque, multi million ringgit or not.

So finally I must stress to the mosque committee as well as to the architect, the spirit of welfare is the most important spirit that can transform the Muslim society as well as provide a new expression of humility and people-architecture for the designers.

31

The City of Putrajaya: Feudalistic Imagery Against Democratic Islamic Architecture

1.0 Introduction

As the world saw the setting of the 20th century and the first rays of light onto the 21st century, the shining jewel city of Putrajaya appears to materialize into the future landscape of an uncertain Malaysia. Why uncertain? At the writing of this chapter the ruling coalition of Barisan Nasional or the National Front which once ruled with the iron hand of one determined Dr. Mahathir Mohamad set to make a hundred or a thousand year reign on Malaysia, now stands on the precipice of destruction by a surprising coalition of opposition parties led by the man whom he had signed off to prison under trumped up charges but has fought his way back to once again stake his claim to the leadership of a new country. If Anwar Ibrahim succeed his bid, there will be a new Malaysia and the fate of the fairy tale kingdom of Putrajaya may be transformed. It may be awkward to start this chapter with a political note but that was what Putrajaya was. A political statement.

In this essay, I will place the political backdrop that shaped Putrajaya by reading the political intentions of Mahathir and the ruling UMNO party against the backdrop of global and local politics. I will then also raise the question of what an Islamic city may take as its underlying principles and hopefully expose the problem of typological and morphological referencing

by architects and planners in the design of buildings and cities. It is important to set the two political and intellectual framework about Putrajaya and the idea of an Islamic city because neighbouring countries such as Indonesia seem enthralled by the monumental sights and seek to emulate this costly adventure.

2.0 Brief Background of Putrajaya

Putrajaya city came into being in June 1993 with the selection of Perang Besar in Selangor as the main site to move the federal administration of the country from the overly congested Kuala Lumpur and Klang Valley areas.[3] The site is located within 20 km from the new international airport and 25 km south of the capital city of Kuala Lumpur.

The planners of Putrajaya envisioned a 'Garden City' concept with sustainable development in environment and social concerns. The structure plan comprise of 14,780 hectares and provides a living environment of a projected 600,000 people. There will be twenty precincts altogether. The core administration and mixed development takes up 5 precincts which includes the cultural, civic and commercial precinct. There are 17 neighbourhoods planned as self sustained entities with adequate community facilities. A memorable and unique feature is the creation of a man made 600 hectare lake that creates an important micro-climate of coastal breezes that blows onto the air conditioned administrative structures. At the center is the Putra Square and Dataran Putra with boulevards connecting important buildings in axial composition as in such cities as Washington DC and Canberra.

3.0 Framework of Criticism

I believe in the value centered approach to evaluating any Islamic city. Architects and clients are of course much excited and enthralled by the 1001 Arabian Nights' imagery but these typological analysis has many drawbacks.[4]

3 A concept paper by Mr. Shahoran bin Johan Ariffin, Deputy Director, City Planning
 Department, Putrajaya Corporation, President, Institute of Landscape Architects Malaysia
 (ILAM) and Chairman of ASEAN Landscape Consultative Committee (ALCC)

4 Please refer to my paper in Reconstructing the Idea of Islamic Architecture from the
 Sunnah and Modernist Ideals, Jounal of Architecture, Great Britain 2007.

The main body of my personal work comprises the effort of documenting the textual religious sources that can be used as one of the basis for design in an Islamic built environment. The methodology simply requires a reading of every single Qur'anic Verse and every single authentic hadith and reclassifying those deemed relevabt for built environment.

The first principle of Islamic architecture is that it adheres the eternal values of the sunnah which shall be the guiding moral anchor both as a human and as an architect.[5] The second principle is that the architects need to understand the 'cultural dynamics' of a particular context. Cultural dynamics do not only include the idea of traditional customs and way of life but also the modern or contemporary patterns of work, play and residing in any nation. Thus the eternal values of the sunnah must be clashed against the cultural dynamics of the place.

The third principle is that of regionalism in which the architect must be a khalifah or guardian of a 'rented planet'. The earth does not belong solely to man but to other creatures as well as to Allah who owns all. Thus, the idea of environmental sustainability must be a foregone conclusion to the designer of Islamic architecture. Furthermore, if there is no nature to appreciate, there is difficulty in reminding oneself of the existence of Allah. I believe the imagined Paradise is simply the organic environment physically surrounding us now and that we should learn to live with nature and not overwhelm it with our dictatorial presence.

4.0 The Administrative and Executive Zone

Among all the building and spatial design that would draw much controversy both in the professional as well as the political realms, it would undoubtedly be the main administration buildings particularly the Prime Minister's Office building, His Official Residence and the Putra Mosque. Although the controversial act of digging up a vast body of water once raged terrifically, the end result seem to put critics on the opposite side with the generation of a micro-climate that affords breezes and a panoramic lake shore development that becomes the main character of the city of Putrajaya. The

5 The full discourse can be heard from a taped session kept in the archives of KALAM, Universiti Teknologi Malaysia.

gamble paid off. However, that alone was not sufficient to cover the feudalistic attempts at creating a 'mini kingdom' like atmosphere with the three buildings mentioned previously.

First and foremost is the Prime Minister's Office. It is a massive and monumental structure that sits on a raised landscape that uses the proportion and architectural language of the Versailles palace. The only difference is that the elements used are that of the vocabulary popularly known as 'Islamic Architecture' with the onion dome green in color dominating the view. There are four criticism of Islamic Architecture or even that of a Malaysian Architecture that can be leveled at this building. Firstly, the single ethnic reference of a Malaysian administration building would irk the non-Malay perspective of a united Malaysian. Why did Mahathir settle on the language? I would surmise from reading his political strategy for the past 20 years is that he wanted to make a bold political statement that Malaysia is an important global player in the Islamic world and on Islamic issues. Mahathir also wanted to curb the rising tide of Islamic consciousness among the younger generation in Malaysia who were much influenced by the Iranian Revolution and also of the anger at the invasion of the USA on Afganistan and of Iraq. Many of these young voters would have been attracted to the Pan Islamic Party in Malaysia or PAS that serves as the biggest threat to the ruling coalition under UMNO. Mahathir wanted to give UMNO the image of Islam that is grand and imperial, progressive and invincible not only to the rival muslim political parties but also to stave off any thought of trying the patience of the Malays by the non-Malay populace. It was against this backdrop that Mahathir had purposely proposed or supported a single ethnic referent as opposed to the universalist language of the old Parliament House built in the 60's.

The 'awe inspiring' Prime minister Office Complex. With its setback, lofty siting, symmetrically axial placement, expensive materials and ornaments and a 'closed up architecture', this building approach more of a feudal palace than the structure of a democratically elected government.

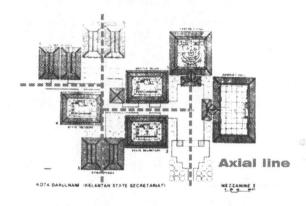

Kota Darul Naim State Assembly. Humble and unpretentious architecture with assymetrical massing and sedately orchestrated traditional vernacular references of the Malay built form.

The Parliament building with its bold statement of non-ethnic based politics with tropical architectural language that presents an accountable government to the people. This was in the 1960's. Under Mahathir, Putrajaya reflect that the people should pay tribute to the government and should not question any of the government's decision.

The second criticism comes from the fact that the building does not seem to present any kind of tropical identity with the luxuriously ornamented façade not even having and sun shading devices or 'serambi' architecture or verandah language that is prevalent in the traditional vernacular architecture as well as the loggias of the British colonialist architecture. This does not make for a critical argument of against 'wastage as in the Prophet's hadith about such cases:

> Anas bin Malik said: the Apostle of Allah (may peace be upon him) came out and seeing a high-domed building and said: What is it? His companions replied to him: It belongs to so and so, one of the Ansar. He said: He said nothing but kept the matter in mind. When its owner came and gave him a salutation among the people, he turned away from him. When he had done several times, the man realized that anger was connected with him and the turning away was because of him. So he complained of that to his companions, saying: T swear by Allah that I cannot understand the Apostle of Allah (may peace be upon him). They said: He, went out and saw your domed building, so the man returned to it and demolished it, leveling it to the ground. One day the Apostle of Allah (may peace be upon him) came out and did not see it. He asked: What has happened to the domed building? They replied: Its owner complained to us of your turning away, and when **we informed him about it, he demolished it. He said: Every building is a misfortune for its owner, except what cannot, meaning except what cannot be done without.** (Sunan Abu Dawud, Vol. III, p.1444-1445)

The final criticism is the use of overly strong axial arrangements that connects the Prime Minister Office with every important edifice much like

a totalitarian regime rather than a democracy. Although many would point that the USA may be the best example of democratic power and that it has a monumental and overly strong axial arrangement, that does not eliminate the debate that went on prior to the design of Washington as a capital of non-axial or organically arranged structures to form the governmental complex. The use of the huge square in the form of a circle with tall pillars remind one more of Mussolini's statues than a statement of nationalistic democracy. The square was undoubtedly made to view processions on independence day and perhaps not allowed to have peaceful demonstration against the government of the day. The last 15 years have seen Mahathir dealing an iron hand by putting demonstrators without trial in the stockade with the flimsy argument of national security. Mahathir is known as the one leader who has made the most arrests and detention without trials and proofs or evidences of all the prime ministers Malaysia has ever had. The architecture then approaches more of a palatial grandeur and speaks of only beautiful accolades to it and very little of democratic overtures. Frank Lloyd Wright's organic architecture would emphasize the trees and natural landscape with the building virtually a backdrop to the scenic picture of Nature.

Wright believes that 'Nature is the Body of God you will ever see'. As the Qur'anic Verses show that Allah's greatness can be viewed through his own creations as follows:

> And is He Who spread out the Earth, and set thereon mountains standing firm, and (flowing) rivers: and fruit of every kind He made in pairs, two and two: He draweth the night as a veil o'er Day. Behold, verily in these things there are Signs for those who consider!

> And in the earth are tracts (diverse though) neighbouring, and gardens of vines and fields sown with corn, and palm trees-grown out of single roots o otherwise: watered with same water, yet some of them We make more excellent others to eat. Behold, verily in these things. (Ar-Rad Verses 3-4)

Putrajaya City decimated much of nature and rearranged and regimentalised it to bring the symbolism of the all powerful executive. In Islam, the leader

should ot necessarily be a grand person sitting on a throne as in the following hadith:

> Narrated Anas bin Malik: While we were sitting with the Prophet in the mosque, a man came riding on camel. He made his camel kneel down in the mosque, tied its foreleg and then said: "Who amongst us you is Muhammad?" At that time the Prophet was sitting amongst us (his Companions) leaning on his arm. We replied, "This white man reclining on his arm. The man then addressed him, "O Son of 'Abdul Muttalib."
>
> Muhammad Muhsin Khan (translation), The Translations of the Meanings of Sahih Al Bukhari, (9 vol., Beirur-Lebanon: Dar Al Arabia, n.d.) vol. 1, p.54

The leader is a trustee of the people and he must be humbled to think that he or she can lead by example and not by coercion. The architecture for this idea approach more the accessibility of the Parliament House in London and the assymetrical massing of Kota Darul Naim.

The Putra Mosque is designed in an eclectic language as a sculptural show piece rather than as a facility for prayer. It is located on the shore of the lake with its verandah space on three sides overlooking the lake with boat access directly to the mosque. It is placed next to the monumental square beside the Prime Minister's Office. The mosque is supposed to cater to the daily and Friday Prayers for the administrative elites but this is quite impossible due to its far walking distance from the Prime Minister's building and any other governmental structures. The only time it is moderately filled is during Friday Prayers where the decree of having it done there and not many other places. The only 'congregants' to the mosque daily seem to be the tourists from many countries and local Malaysian. The first criticism is the location of the mosque. Aside from the problem of walking accessibility, there is the symbolic concern of the mosque and the Prime Minister's Office and Residence. The designers and planners have undoubtedly made references to such imperial places as the Baghdad Circular city where the palace and the mosque are placed next to each other at the central location of the settlement. What does this politically symbolize? Of course, the planners hope that it symbolizes

the prime importance of Islam to the country's leadership but it might also be construed as religion being the pawn of the administrative elite. I am of the view that mosques should represent the democratic power house of the community where each precinct has a mosque of itself that would serve as a check and balance between the leaders and the people. Creswell had once documented how Ziyad Ibnu Abihi was fearful of the tribal influence from the surrounding community mosques and he set out to politically control and subdue all inhabitants by building a huge and splendid looking mosque to entice worshippers to it. In that manner he and his advisors can have complete control over the masses in proclaiming any religious issue, edict and proclamation.[6] The Putra Mosque seems to be a symbolic culture of control through its expensive structure and decoration, but not through its daily functions and Friday Sermons. The Sermons in most community mosques are officially speeches written never to criticize the administration which departs far from the true spirit of the Friday Prayers.

Next is the criticism against the middle eastern language used by the architects. Malaysia is a tropical country full of trees in its dense forest. The traditional mosques of old use much timber and forms a unique architecture of a raised square box topped by a three or two tiered pyramidal roof. The Kampung Laut and the Kampung Tuan are the best traditional timber vernacular mosques. When masonry technology was introduced by the Chinese immigrants and the Portugese, Dutch and English, the mosque of Malacca like the Kampung Hulu mosque and the Kampung Keling Mosque use a masonry walled square anchored to the ground with the three tiered pyramidal roof curved like the Chinese temples.[7] In the modern times, the National Mosque designers took a bold step and introduced the folded plate 'umbrella' roof form which departs entirely from the middle eastern domes and the timber pyramids. The Masjid Negara in Kuala Lumpur is a national mosque that saw the unique idea of creating generous *serambi* or verandah spaces that is three times larger than the prayer space. Such horizontal expression is reminiscent of Wright's humility of organic architecture to God's sacred earth line. There have

[6] Please refer to the second chapter of my book, 'The Mosque as A Community Development Center', Penerbit UTM, Johor, 1998

[7] Please refer to my book The Architectural Heritage of the Malay World: The Traditional Mosques, Penerbit UTM, 2000

been many other mosques that was designed after the Masjid Negara like the Negeri sembilan state Mosque and the Penang State Mosque that uses modern technology within a framework that departs from the revivalist excuses. The strength of Masjid Negara over that of the Putra mosque is that it shows Islam as a progressive religion and not dogmatic as envisioned by the tired and uncertain revivalism of the Putra Mosque. Does the dome and arch truly represent Islam? The three mosque other than the Putra Mosque do not think so. The Prophet Muhammad had warned his followers about over designing mosques for show and not for community function in some traditions:

> The construction of the mosque. Abu Sa'id said, "The roof of the mosque was made of the leaves of date palms." 'Umar ordered a mosque to be built and said, "Protect the people from rain. Beware of red and yellow decorations for they put the people to trial." Anas reciting a part of a Hadith said, "They will boast of them (mosques) rather than coming frequently to them for offering prayers." Ibn 'Abbas said, "You (Muslims) will surely decorate your mosques as the Jews and Cristians decorated (their churches and temples). (Sahih Al Bukhari, Vol. I, p.260)

> Ibn 'Abbas reported the Apostle of Allah (may peace be upon him) as saying: I was not commanded to build high mosques. Ibn 'Abbas said: You will certainly adorn them as the Jews and Christians did. (Sunan Abu Dawud, vol. I, p.116)

With the revivalist language, the perennial problem of putting fans become cumbersome to the point that pillars must be put up to fix the fan to cool the congregants. If mosques were designed no larger than a two storey structure, many issues such as economy and function can be ascertained adequately.

The 300 Million Ringgit Putra Mosque as the shining sculptural piece of how a state can control a religion effectively to its own personal advantage.

The National mosque or Masjid Negara that presents a bold universalist, modernist, progressivist and tropical idea of Islamic Architecture for Malaysia.

5.0 Housing and House Design

There are three important and positive differences between the housing layout in Putrajaya and that of the normal everyday housing design in Malaysia of the past four decades. The first is the elimination of the grid-iron layout in place of a more meandering street arrangement. Such layout makes the housing more 'village like and romantic forcing drivers to slow down instead of whizzing past the streets in the other housing in this country.

The second difference is the wonderful presence of street pavements with shady trees covering the fiercely hot afternoon sun. For four decades, municipalities of Malaysia's districts have given approvals to housing developers without asking that all streets to have pedestrian pavements. Even housing that cost between RM200,000 and RM400,000 were and are still without such basic facility. One can see in the wealthy country of Malaysia where children who cycle and walk to school along with the joggers line the roads in a dangerous conflict with vehicular traffic. It is not convenient for pedestrians to walk on the grass as it is wet most of the time and often uneven that might cause tripping and falling.

The third difference comes in the form of the treatment of the back alley of the terrace houses. Ever since the introduction of the terrace house in Malaysia, there has always been a twenty foot minimum back alley that is supposed to serve as a fire break, a service alley for the septic tanks as well as the requirement for the fire truck access in cases of fire. These back alleys are never kept clean by the municipalities and eventually it becomes infested with rats and cockroaches that strive in the garbage dump atmosphere in Malaysia. The increase cases of dengue fever by mosquito infestment is much more in modern housing estates than in the traditional villages. The blame squarely lies with the municipalities that spend money only in clearing and manicuring the front streets and not the back alleys. These back alleys are now a criminal paradise as they become isolated in use. The Putrajaya back alleys are different in that it does not allow for any vehicular access whilst still maintaining the twenty foot distance. The planning by laws have allowed the residences to put up a back yard fencing that covers up to six feet to avoid privacy violations. What is left is a six or seven foot paved walk path that is quite pleasant to traverse and the meandering back alleys provide a picturesque vista along the way. The visual affect is quite stunning as in the modern housing estates of

Malaysia it is a straight jacket street with a single one point perspective filled with overgrown grass and garbage.

There are still many design issues yet to be solved or even acknowledged by the designers and planners of the Putrajaya Housing. With respect to the architecture of the house three fundamental issues are still wanting. Most important of all is the issue that the planners feel particularly proud of is the 'no fence' policy. The planners maintain that by following the traditional 'kampung' environment or those of the American suburbs, there will be better communal interaction rather than the present practice of having five foot high fences in the local terrace house design. What the planners fail to take note is the cultural and behavioral contexts of house users and owners. In the traditional kampungs or villages, there is usually one ethnic group living there. Thus problem such as ownership of dogs and Islamically unclean practices does not arise. But in the modern Malaysian housing estates it is hardly to the country's interest to isolate each of the three major races of Malay, Chinese and Indians to their own neighbourhoods. Thus house users feel the fence is essential to keep unclean animals away. Furthermore there is the problem of the traveling salesmen that would pop up right in front of one's door unannounced. In the normal fenced up terrace house, the owners and users would feel safer with the setback distance front the front door but the with Putrajaya house owners, this is no longer so. Observation of the house precinct revealed that some owners have begun to fence up their property albeit in a subdued manner not reaching over three or four feet high. Behaviorally, the planners must understand that house owners have a stronger sense of territoriality when they have such a small space to themselves as opposed to the generous lawn area in the traditional villages. Another reason for the fence that local terrace house owners argue would be safety for their children. In the kampung days, there were no fast cars or motor cycles zipping a few feet away from their front doors. Thus there is an absolute necessity to keep the front gate locked up so that toddlers and young children can be safe in the secure grounds of the house.

Putrajaya Housing Precinct 16. No fence rules.

Taman Melawati Housing in Johor. Double Storey Terrace with fence provided.

Individual owners have resorted to violating the 'no-fence rule in Putrajaya

The picturesque scenery of the backyard in one of the Putrajaya Precincts is a far cry from the local housing's back lane but it is still a problem in terms of privacy violations from the window design.

Local housing back lane in Malaysia. Above picture is Taman Melawati in Johor built in 2001, bottom picture is Taman Sri Skudai in Johor built in the70's. Both unused and left to deteriorate by the municipal council of Skudai.

The next issue is privacy violation from the visual aspect and that of smell. The back to back windows in the back alley still affords privacy violations although the lower floor has the back yard fence to obstruct views.[8] There should be proper window design and orientation to tackle this need. The ritual burning of joss sticks by the Chinese is also a major issue as the smoke from the car porch would meander into the next door windows via the attached porch roof. Proper ventilation ducts or 'chimneys' could solve this problem but it is difficult to address this issue if it is not acknowledged. The following hadith shows the extent of tolerance as practiced by the Prophet concerning those of other cultures:

[8] Please refer to my book, Housing Crisis in Malaysia: Back to a Humanistic Agenda, Penerbit UTM, 2006

It is narrated on the authority of Ibn Abu Laila that while Qais b. Sa'd and Sahl b. Hunaif were both in Qadisiyya a bier passed by them and they both stood up. They were told that it was the bier of one of the people of the land (non_Muslim). They said that a bier passed before the Holy Prophet (may peace be upon him) and he stood up. **He was told that he (the dead man) was a Jew.** Upon this he remarked: Was he not a human being or did he not have a soul? **(Sahih Muslim Vol. II, p.454)**

The hadith clearly showed that the Prophet respected the Jew who was not a Muslim and this should signal to others that Islam is a gracious religion that lets others practice their religious rituals freely. The Islamic city must prepare places of burning incense or joss sticks at certain locations outdoors than just denying the rights of the Chinese non-Muslim community.

The other element which is lacking is the idea of the serambi or verandah. In the traditional Malay house the serambi is a social element that treats guests who were strangers as well as friends coming to call on the family. The hadith on guests is as follows:

Abu Shuraih att-Ka'bi reported the Apostle of Allah (may peace be upon him) as saying: He who believes in Allah and the last Day should honour his guest. Provisions for the road are what will serve for a day and night hospitality extends for three days; what goes after that is sadaqah (charity). And it is not allowable that a guest should stay till he makes himself an encumbrance.[9]

In the modern housing estate, terrace houses are designed with only the car porch in place of a front serambi. With the presence of the car porch which usually numbers two cars to a family, there is little left for a social serambi. Designers of the Putrajaya housing have not attempted to reinterpret the serambi in the modern contexts such as to place it in an inviting manner above the car porch or even redefining the 22'X70' standard lot to a wider frontage.

[9] Sunan Abu Dawud, Vol.III, p.1058

The serambi in the modern context could serve not only as a social element but also as eyes on the street to avert crime in the housing estate. There have been a serious spate of child murders, rape and kidnapping the last 10 years and it is a frightening thing to happen to a family. The hadith concerning efforts made to avert dangerous events are as follows:

> Abu Huraira reported Allah's Messenger (may peace and blessing be upon him) saying: A person while walking along the path saw the branches of the tree lying there. He said: By Allah, I shall remove these from this so that these may not do harm to the Muslims, and he was admitted to Paradise. **(Sahih Muslim, Vol. IV, p.1380)**

> Abu Barza reported: I said: Allah's Messenger, teach me something so that I may derive benefits from it. He said: Remove something troubling from the path of the Muslims. (Sahih Muslim, Val. IV, p.1380)

The two hadith clearly indicate that if there is any thing that designers or planners can do to make safe places for children and others then it is obligatory to address that issue.

Finally, the lay out of the housing does not include much public furniture along the paved walkways to serve as social nodes, children school bus stops or even as eyes on the street. There is also not much thought given to children play fields which should be placed in pockets of neighbourhoods and one can see endless walkways without breaks.

6.0 Community Buildings, Markets, Schools and Surau

In the new and shining city of Putrajaya, the housing precinct are equipped with generous community facilities that are quite scarce or ill equipped in the local estates. The precinct provides a community zone which has a Community Center, a Marketplace, a primary and secondary school complex and a Surau. There are all zoned and placed in proximity of walking between one another.

The Community Center is a welcome addition because the multi racial nature of the citizenry is in badly in need of one.[10] What the normal housing estates in Malaysia are provided with is a Dewan Serbaguna (Multipurpose Hall) or a Dewan Orang Ramai (People's Hall) or a Dewan Raya (Big Hall). All these halls have one thing in common despite their variations in scale. They all have a single huge double volume space usually spanned with reinforced or steel portal frames. They provide the function of playing badminton, marriage ceremony and occasional lectures or meetings usually for the ruling party and the other political parties are usually denied undemocratically access to these facilities. There is a fence and a heavy gate surrounding the big hall with parking as its landscape feature. Nothing else. The administration of the halls is done through the municipality furthest away from the local contexts. Almost to a great length of the time, the halls remain empty. In the Putrajaya Housing, the Community cenbter provides various spaces for use such as classrooms, a badminton sized hall, a cafeteria, shops and administration office. In a country such as Malaysia, there must be an active administration philosophy that would create many events that would help the races come together and enjoy each other's company as well as learn from one another toward living harmoniously in this country. The market place provides the normal wet and dry business without any other architectural feature that would expand its function. Because the market place is just a few feet away from the community Center, perhaps there is no need for the designers to depart from the established typology. It is a great pity that the Community Center is designed as a three storey building because the grounds surrounding the buildings remain dead as parking spaces. With much land allocation in the new city, the designers should have played with the ideas of having courtyard gardens and landscaped frontal approaches that would make the human-ground connection to be more lively and meaningful. As it stands now, the place is dead on the outside but lively on the inside. The need for social interaction is paramount in Islam. The religion forbids its adherent to isolate themselves but must be in the thick of things. One is only allowed to desert one's community in the case of severe persecution. The Prophet has mentioned in the following hadiths on the importance of socializing and the responsibilities towards the neigbours and community:

[10] With respect to this important issue, the book on housing as previous mentioned should also be consulted.

Abu al-Darda' reported the Apostle of Allah (may peace be upon him) as saying: Shall I not inform you of something more excellent in degree than fasting, prayer and almsgiving (sadaqah)? The people replied: Yes, Prophet of Allah! He said: It is putting things right between people, spoiling them is the shaver (destructive).

(Sunan Abu Dawud, Vol. III, p. 1370)

The Market place which is located next to the Community Center.

A nice eating environment but not much furniture to sit in for chit chatting but there should be more public furniture.

Local 'Community Hall' dubbed Multipurpose Hall.

The Surau or a small mosque is located within the hub of the community zone straddling the school and the market place. The size of the Surau indicate clearly that the performance of Friday Prayers are disallowed here. What is good of the surau is the presence of quarters for the prayer leader or the imam and for the muezzin or the person who makes the call to prayer. Other than that the Surau still suffers much of the major problems plaguing the mosques in Malaysia. The landscape of the mosque is still for parking and not designed to pull communities inside. There is still a lack of mosque facilities that would attract the young and the other ages to specifically spend more time at the mosque. On the subject of religious building, there does not seem to be the presence of any other religious structures like churches or temples.

The Surau is too small to be used for Friday Prayers. Much of the same problems as mosques in Malaysia appear here too. There is the hideous fencing and the lawn is not used as a social gathering space.

The Precinct seems dead amidst all the facilities because there is no presence of street vendors and hawkers. There is also no place to conduct the Pasar Malam or Night Market that is the unique signature of life and micro architecture in this country. Although the walking-cycling facilities are in place to reduce traffic to and from the schools and community facilities, the street life is scarce and the planners must look at aspect of enlivening this sterile atmosphere.

7.0 The Commercial and City Center

The commercial and city center is designed as well as a Westernized tropical city like Singapore has for all these years. Wide paved pedestrian streets with planted trees and public furniture is a far cry from the stingy pavements of traditional Kuala Lumpur. In the place of the goreng pisang or fried banana seller or the Chinese hawkers selling cool drinks, kiosks of Mc Donalds, or Starbucks and other westernized food kiosks would spring up. What makes up the city? In Kuala Lumpur, some would say the democratic opportunity of making small businesses and nooks and corners with inexpensive food and goods that bring and ambience of humanity. Others, particularly the elite administrators would opt for order and monotonous activities. For all its glitter, Putrajaya City Center would turn out just exactly like any Westernized city streets and thus all that flavour which makes this place Asian would not be there. It is doubtful that the city planners have made any effort to legalize and accommodate small food vendors and hawkers. You see one western city paved walkways in the city, you've seen them all.

How would the city planners attempt to answer the values as presented by the Prophet Muhammad as regards public spaces:

> Abu Sa'id al-Khudri reported the Apostle of Allah (may peace be upon him) as saying: Avoid sitting in the roads. The people said: Apostle of Allah I must have meeting places in which to converse. The Apostle of Allah (may peace be upon him) said: If you insist on meeting, give the road its due. They asked: What it the due of roads, Apostle of Allah? He replied: Lowering the eyes, removing anything offensive, returning salutations, commanding what is reputable and forbidding what is disreputable.[11]

The other caharacteristic worth noting in the traditional city of Kuala Lumpur is the seemless five foot walkway that was started by the British in order to shade urbanites from the rain and the fierce noon day sun. Although there is some attempt at making the five foot way, its narrowness and disproportionate

[11] Sunan Abu Dawud, Vol. III, p.1346

scale leaves much to be desired. There is also no linkage in between building blocks and the structures stand apart in about a 150 foot of distance. In some buildings, the arcade is visible but not accessible as it forms part of a restricted lobby or other special areas.

The stingily narrow five foot way amidst gigantic columns.

The 'western' pedestrian pavements making its way into the Malaysian culture.

8.0 The Precinct for the Dead

In discourses of Islamic cities, the cemetery is hardly mentioned. This is a curious thing since in Islam, reminders of death is part of the cleansing process of the soul. The Prophet had exhorted his followers to think of the dead often and he himself has many times visited the Baqi or the cemetery close to his home in Medinah. The cemetery at Putrajaya is situated at Precinct 20, the last of all the precincts. One would never know of its existence because there does not seem to be any signage to remind the inhabitant where the dead reside. The planners have adequately provided cemeteries for all religious followers and the buildings, furniture and facilities related to the rituals have been taken care of. One question that planners of Islamic cities should ask is where can the dead be placed within the urban environment? This seems to be an unintelligent question but the seriousness of this issue is simply the philosophy of life that Islam maintains. One can see the integration of several small plots of cemeteries in the traditional cities as well as in the tropical villages of Indonesia. The dead used to be buried in a specific open land which is just next to a village or in small family plots and even in the compound of the mosque or inevitably next to it. Is this simply because of the problem of mode of transportation? It is hardly the case when one considers that the oxen and the horse have been around to carry the dead in far off places isolated from city life but the city inhabitants of the past find that having their loved one closer to them makes it easy for them to visit as well as the idea of mediating about the after life. How is it that a religion such as Islam which campaigns for eternal life and repeats frequently the briefness of mortal life is being exemplified by a huge undertaking of the present life by massive buildings and road works but there is no integration of the dead as a firm and 'drastic' reminder of the briefness of mortality? The culture of visiting the dead can be clearly seen in the following hadiths:

> 'A' isha reported that whenever it was her turn for Allah's Messenger (may peace be upon him) to spend the night with her he would go out towards the end of the night to al Baqi' and say: Peace be upon you, adobe of a people who are believers. What you were promised would come to you tomorrow, you receiving it after some delay; and God willing,

we shall join you. O Allah, grant forgiveness to inhabitants of Baqi' al-Gharqad. Qutaiba did not mention his words: 'would come to you.

(Sahih Muslim Vol. II, p.461)

It is narrated on the authority of 'Amir ibn Rabi'a (may Allah be pleased with him) that the Prophet (may peace be upon him) said: Whenever you see a funeral procession, stand up for that until it moves away or is lowered on the ground.[12]

The dead must be buried in a manner that a procession of the dead must pass by many parts of the city so as to exact a maximum exposure of consciousness about mortal life. However if the dead is relegated to an obscure corner of a city, it will take cars whizzing past with the dead body without the dead contributing to the awareness of the after life through the procession through the market place and public areas.

Entrance to the Muslim Cemetery

[12] Sahih Muslim Vol. II, p.454

The Buddhist Cemetery

The Hindu Cemetery

9.0 Conclusion

In summing up, Putrajaya represents a crossroads of Malaysian city of sort, one that is directly related to the political fate of the nation. Though it tries to present a modernistic city with a lot of concern for public needs and of a high-tech sustainable

environment it still fall on a hard feudalistic mindset of the ruling political party that imagines itself a kind of second 'Malay Sultanate' full of powerful and authoritarian Malay leaders. As a Malaysian and as a Muslim, I am not able to bring myself in accepting the feudalistic side of the city but am much thankful to the modern and progressive sides of it though there is a lot more for improvement. The intention of trying to create a 'civillized' public architecture with templates of good western idealism fall short of cultural needs but the change is much welcome than the sterile local public architecture and housing. Whichever the verdict one might cast upon the city, Putrajaya is already an historical landmark for a long time to come.

References

Al-Ash'ath, Sulaiman. Sunan Abu Dawud. 3 vols. Translated by Prof. Ahmad Hasan. New Delhi, India: Al Madina Publications (P) Limited, 1985

Al-Mughirah Al-Bukhari, Muhammad bin Ismail. The Translation Of The Meanings Of Sahih Al-Bukhari. 9 vols. Translated by Dr. Muhammad Muhsin Khan. Beirut-Lebanon: Dar Al Arabia, n.d.

Al-Qushayri, Abul Husain Asakir-ud-Din Muslim. Sahih Muslim. 4 vols. Translated by Abdul Hamid Siddiqi. Lahore-Pakistan: Sh. Muhammad Ashraf, 1976

Mohamad Tajuddin, Housing Crisis in Malaysia: Back to a Humanistic Agenda, Penerbit UTM, 2006

Mohamad Tajuddin, The Mosque as A Community Development Center, Penerbit UTM, Johor, 1998

Mohamad Tajuddin, The Architectural Heritage of the Malay World: The Traditional Mosques, Penerbit UTM, 2000

Mohamad Tajuddin, Malaysian Architecture: Crisis Within, Utusan Publications and distributors, Kuala Lumpur, 2005

Abdullah Yusof Ali, The Holy Qur'an: Translation and Commentary, Amana Corp, Brentwood, Maryland, 1983, USA

32

The Architecture of the Diplomatic Mosque

I have never written about the architectural problems of the world simply because my philosophy is 'Malaysia first....the world...er.. nanti-lah dulu.' But in today's column I will raise the issue of the problem of traditional classical revivalism in the language of mosque architecture in the modern world, especially in Europe and USA. Until about a year ago, I thought that only Muslim countries like Malaysia, Indonesia, Saudi Arabia, Egypt and others are the only ones bitten by this middle-eastern Islamic architectural garb. When my former student came to me about a Masters Thesis on mosques in Denmark, I discovered that many mosques in USA, Britain, Denmark and other European countries which have the wealth to spend, would in all probability design their mosques in the classical middle-eastern garb, complete with domes, arches and ornaments. I will dwell on the possible answers as to why this has come about and after that I will expound why this is bad for Islam, Muslims and our posterity.

Okay, for the first question, why do these wealthy mosques like the ones in Washington,....,..... decided on this traditional garb for the architecture of the mosque. Well, firstly, I think the Muslims who are now permanent residents in these various countries are very assertive, vocal and wholly pragmatic, a characteristic of their host country. If these people were half as assertive, in Malaysia, they would be in deep trouble! But then again, there's the problem with our leadership. Too frighten of change and not enough sense to take this beloved country of ours to a higher level. So firstly, these Muslims are

highly assertive and if they wanted a 1001 Arabian Night-like mosques the architect will just accommodate whoever is paying them. Secondly, they feel that Islam must have a united language which would reflect the unity of Muslims all around the globe. Thirdly, the different language of architecture which contrast significantly with the architecture of the host country is needed to proclaim the uniqueness of Islam. Finally, both the architects and the clients do not know that there can be another language of Islamic architecture that would be more sensitive to the host country.

Well, to the mosque committees of USA, Britain, Italy, Denmark and other non-Muslim countries, I wish to inform them that it would be better for the language of mosque architecture to be more sensitive to the local architectural language then to be so brazen about an identity that should never have been considered as universal. Firstly, why should one particular language be entertained when the immigrants in any of these countries are diversified? In Edinburgh, where I studied, we had Saudis, Egyptians, Iranians, Indians, Indonesians, Malaysians and many others. The traditional mosque language in these original countries of the immigrants are as different as night and day due to the climate, geographical make up and availability of technology. Why must the middle-eastern language take center stage? Secondly, the modern architects and present mosque committees have disregarded a simple truth about Islam and its dynamic message; namely that Islam can penetrate into any culture wherever they were on this earth and sit comfortably within their rites and belief system. Islam did not come to these places as a drastic change but of assimilation and enculturalisation. The Wali Songo of Indonesia spread the religion by adapting and adopting many songs and poetries of the host country and culture thus introducing interesting literary heritages. In the realm of architecture, the masons, carpenters and craftsmen adopted the languages of temple architecture, house architecture, and palace architecture to define a new architectural typology of the mosque. The meru roof shaped mosque of Demak and Kampung Laut finds precedence in previous building typologies that has no relation to Islam whatsoever. Thus, the existence of a myriad of architectural language shows truly that Islam is accommodating, that Islam is sensitive to the host culture and that Islam is ready to adapt and adopt. This message is important at a time when the Western non-Islamic world accuses Islam and Muslims as intolerant people and arrogant enough to set up their empire upon this earth and force others under their swords. To me, by having

this middle-eastern domes and arches, they can fuel this political myopia and Bush-like 'you are either with them or with us' simplistic gangsterism mindset.

What if the mosque architecture reflected the architectural language of the host country, what message would it make? Well, it would say that Islam is here to be part of the citizenry with its own faith and moral values that would be akin to the universalist values of the highest kind of humanity. It shows that Islam is dynamic, able to change and adapt to its surrounding just like an efficient and visionary manager in a corporate climate. It would also shed off the notion that Islam is so tied up to its past that it is absolutely intolerant of the modern issues of the world.

Now of course some will cry out "but then where is the difference between us and them?' should we not be different? I will say, why must we be different for the sake of being different? I choose to practice the excellent values of what my Prophet had taught me. I do not practice Islam simply based on the traditions of my fore fathers because they can opt to be wrong in their interpretation of the religion. The mosque with the dome and the arch is reflective of such a dogmatic, draconian and intolerant individual.

We can be different in mosque architecture by emphasizing on our real values and not to formalistic language of architecture. For instance, in the designs of mosques by my students, I ask them to pay particular attention to providing spaces for musaffir or travelers and also for the Suffa poor. I also ask the students to cater to the needs of women and provide them with better facilities and spaces instead of the 'forgotten space' with curtains and upstairs room. I also ask them to landscape the mosque so that the teenagers, the elderly, the children and the non-muslims might be attracted to come because Islam is accommodating and not the 'rejecting' type. I ask the students to think of new ways to make the mosque more energy sustainable and economically viable. I ask the students to stay away from monumental sculptural expressions that would be a great wastage. I ask students to think of building mosques in phases so that it would expand effortlessly and organically as the congregation grows and are more confident of newer functions. I can go on and on about activities, values and forms that would reflect more the Islam of the Prophet and not the Islam of an individual race. Islam is not racist.and its architecture should never be such.

The mosque is the representative of Islam in the countries that it resides. Care must be taken in this fragile political climate to choose the right language

for it. Call it architectural diplomacy, if you must. For those who may accuse this approach as 'cowardice' or that it is 'too compromising' I choose to answer that the Muslim character is as a peaceful person moving with quiet dignity, strong in his resolve but humble in his morality. We do not need to shout out our faith and proclaim that we love god more than others. God does not want to hear those loud and boisterous screams but looks for how we treat others in compassion for the sake of pleasing Him. In this the mosque designer must learn ...not in tired, old and misspelled architectural language of the past.

33

The Wright Way

One of America's greatest architects, known for his churches, offers many lessons designers of mosques should heed. Take his renowned Unitarian Church (in Wisconsin, the United States), for instance (*pic right*).

It offers a great lesson in this era when huge mosques that can house hundreds of thousands are preferred. Wright's church is lower than the trees that surround it, making a clear statement that God's creations are more important than man's. Mosque designers should try to break up the scale of their works and ensure the dominance of trees over the main building (except over the minaret) to encourage contemplation of God's creation.

Frank Lloyd Wright's house of God does not overwhelm God's creations – note how his First Unitarian Meeting House stays low to the ground and allows trees to dominate it.

When it came to materials, Wright preferred to use natural materials, such as stone and timber, and he would not plaster over the stone or paint the timber, as he wished their texture to be discerned by all.

This aspect of organic architecture is one of the most important lessons builders of mosques could learn. Natural materials have the power to remind man of his primeval origins. Stone and timber were here long before man set foot in this world. This connection to the primitive past helps to bring man down from the high pedestal upon which he has placed himself with the help of technology. With modern gadgetry humbling Nature, man has forgotten that he is a mere "keeper of the world" for Allah until a particular time.

The most prominent characteristic of Wright's architectural works is his preference for strong horizontal expression, something he associated with the horizon of an open prairie. This concept is, again, another primeval reminder of a connection with Nature, and it also acts as "weight" to "tie" the building down to the ground, thus creating a secure sense of shelter.

Many mosques are designed standing vertically upright without a *tawadhu* sense of humility. The church in question – and, in fact, most of Wright's buildings – has a quality of humility that we do not find in many so-called "Islamic" works in this country. And that is an irony, indeed, considering that the meaning of "Islam" is "submission to the will of Allah"!

Wright was never an advocate of revivalism, nor was he ever known to condone eclecticism in any form whatsoever. From his Prairie School period to his Cubist era, and finally to his structuralist preference, Wright always believed in the idea of the "spirit of the times".

This idea simply postulates that each building truthfully produced in an era reflects the technological prowess and the economic conditions of that particular period. Revivalism, which seeks to lie about true conditions and makes simplistic nostalgic references, can never be taken seriously as an important rationale to produce works of socio-political importance.

Thus, Wright rejected the use of typological church models in his designs of both the Unity Temple and the Unitarian Church. He believed that religion is a progressive and not a dogmatic practice. With his rejection of the established typological reference of religious architecture, Wright underlined the idea of religious practice as a true independent relationship between the individual worshipper and God without any intermediary whatsoever. This is an important lesson for the design of mosques nowadays, which seems to relish the notion of a sacred vocabulary and syntax in references to Middle Eastern, African, and Mediterranean domes, arches, minarets, courtyards, and ornamentation.

Siting a church in a way that does not overpower the landscape leads one to the idea, again, of humility in the face of God's works. There is absolutely no mistaking the presence of a mosque in the contemporary context, as clients prefer them up on a hill, sitting like a monarch surveying his peasantry.

Besides the Unitarian Church, lessons can also be drawn from two other works by Wright.

The Darwin D. Martin House Complex in New York offers important lessons how landscaping elements can be integrated in organising spaces. Instead of lumping all the spaces into a single mass, Wright created three volumes connected with passageways.

What this ingeniously does is provide for leisurely but ceremonious journeys to all the different spaces in the house past plants and trees in the small courtyards created. A mosque could benefit from such a strategy, as this would not only encourage the contemplation of God's natural creations but also sooth the spirit – and cool the building, as natural material would absorb solar radiation!

Wright's concern for sustainable architecture can be seen in his preference for natural materials and his energy conservation strategies. In the design of the Friedman house, for instance, Wright buried much of the building in the soil, which acts as natural insulation against heat and cold. He also oriented the building to capture the rays of the winter sun to heat the house.

In tropical Malaysia, an emphasis on openness and the use of pools of water for cooling and encouragement of convective air currents is desirable.

However, many mosques disregard this principle, and some have even opted to use mechanical means of cooling just so that they can use the fortress-like images of Middle Eastern mosque typologies.

Islam encourages actions of conserving resources and abhors wasteful acts of any kind. The Prophet was known to have admonished his followers not to be wasteful in performing their ablutions even if the water was from an abundantly flowing river.

The American architect advocated many principles that are directly relevant to the design of mosques not as monumental and glorified symbols but as product that dissolve into the landscape while emphasising the lessons of Nature. Such mosques would perform their duty of reminding the Muslim of humility.

34

A Tale of Two Mosques: Criticism from Wright's Perspective of Organic Architecture

Introduction

The main purpose of this paper is to present an alternative approach to mosque design with particular reference to the context of Malaysia and the Malay World or the Nusantara. The gist of the message is that we can learn much from Frank Lloyd Wright's principle of Organic architecture particularly from those of his church design.

The paper contains two main parts. The first part of the paper examines Wright's Organic Architecture with specific reference to the design of the Unity Church and a few other buildings as containing some important lessons of mosque designs from the perspective of the Sunna. The second part of the paper uses the principles discussed to criticize the Putra Mosque and the Masjid Negara.

Wright's principles of Organic Architecture: lessons from Mosques

Wright would have liked to be known as a 'student of Nature' The way he glorifies Nature in the sense of learning from it, humbling his architecture to it and constantly reminding people of Nature's presence in his use of natural materials and his planning organization of buildings, one would be forced

to think that Nature was Wright's true religion. Though he was a Christian but his preference for the Unitarian principles comes close to Islam's *tauhidic* approach towards the creation. In this section, we will examine four of his works in order to draw some strong ideas towards rethinking the priorities of mosque architecture per se and to Islamic Architecture as a whole.

We will first of all examine Wright's Unitarian Church. There are many important design principles inherent in this work that can offer lessons to mosque architecture. First of all let us consider the scale of the building. In an era where huge mosques that can house hundreds of thousands at one time are being preferred, it is humbling to find a church with a small community scale. In our two books we have been arguing for smaller mosques that would encourage the *qari'ah* or neighbourhood to strengthen their Islamic brotherhood. Monumental architectural works that are so prevalent in today's mosque also has the characteristics of arrogance in its huge size and expansive setback distances. The Unitarian Church is lower than the trees that surround it making a clear statement as to which is more important; man's creation or God's? Mosque designers should try to break up the scale of their works and ensure the dominance of trees over the main building (except the minaret) be obvious so as to encourage contemplation of God's creation. In Surah Ar' Rad Allah the Most High commands man to contemplate His Creations:

> 'And it is He Who spread out the earth, and set thereon mountains standing firm, and rivers and fruit of every kind He made in pairs, two and two. He draweth the night as a veil over the day. Behold, verily in these things there are Signs for those who consider.'

> 'And in the earth are tracts neighbouring, and gardens of vines and fields sown with corn, and palm trees, growing out of single roots or otherwise: watered with the same water, yet some of them We make more excellent than others to eat. Behold, verily in these things there are Signs for those who understand!'[17]

> (Surah 13 Verse 3 and 4)

We will next look at the use of materials. For mosque designs in the present day, highly polished marble and tiles seem to be the order of the day. Wright prefered to use natural materials such as stone and timber. Wright would never think of applying a coat of plaster or even of painting the timber components as he wishes their texture to be discerned by all. We find that this aspect of organic principle to be one of the most important lessons in mosque design. The use of natural materials has the power to remind man of its primeval origins. Stone and timber were here long before man set foot in this world. This connection to the primitive past helps to bring man down from the high pedestal which he has created for himself in the modern world. With all his modern gadgetry and humbling of Nature man has forgotten that he is a mere 'keeper of the world' for Allah until a particular time. The use of natural materials can also help man discharge his duty as the vicegerent of Allah as they are sustainable materials. The materials do not need any maintenance and projects an eternal quality that brings great maturity to its aging process. If man were surrounded by plastered concrete walls and metal curtain partitions he would be surrounding his own 'greatness' and not the greatness of the Creator.

The most characteristic of Wright's architectural works is his preference for the strong horizontal expression of his buildings. In many writings, Wright has referred this horizontality to the horizon line of the open prairie. This horizon line is again another primeval reminder and it also acts as 'weight' to tie the building down to the ground thus creating a secure sense of shelter. Many mosques are design standing vertically upright without a *tawadhu* sense of humility. The church in question. as well as most of Wright's buildings, has a quality of humility that we do not find in many so called 'islamic' works. The non-existence of the idea of humility in Islam is an irony to the meaning of its word as 'submission to the will of Allah'.

Wright was never an advocate of revivalism nor was he ever known to condone eclecticism in any form whatsoever. From his Prairie School period to his 'Cubist' era and finally to his structuralist preference, Wright had always believed in the idea of 'spirit of the times'. The idea of spirit of the times simply postulates that each building truthfully produced in an era reflects the technological prowess and the economic condition of that particular period. Revivalism, which seeks to lie about true conditions and simplistic nostalgic references, can never be seriously taken as an important rationale to produce works of socio-political importance. Thus Wright rejected the

use of typological church models in his designs of both the Unity Temple and the Unitarian Church. He believes that religion is a progressive and not a dogmatic practice. With his rejection of the established typological reference of religious architecture, Wright has liberated the idea of religious practice as a true independent relationship between the individual worshipper and God without any intermediary whatsoever. This is an important lesson for the design of mosques nowadays which seems to relish the notion of a sacred vocabulary and syntax in its reference to middle eastern, African and Mediterranean domes, arches, minarets, courtyards and ornamentation.

The siting of the church as not overpowering the landscape or striding the hill in a commanding posture leads one to the idea of, again, humility to God's work. There is absolutely no mistaking the presence of a mosque in the contemporary context as clients prefer them up on a hill like a monarch surveying his peasantry. The asymmetrical massing brings about the idea that religion is not a totalitarian production as all are equal under the eyes of God, priest, imams, ministers and generals alike. The idea of monumental symmetry is a production of feudalistic society where both kings and clerics would hold the masses in their iron grips simply because they were the keepers of knowledge and the holy books or *kitabs*. In the present day, everyone has access to the *kitab* and thus everyone can keep their leadership in check based on a single frame of reference. This is actually the ideal of 'democracy' which relates to the liberalization and distribution of society's power. We, therefore, feel that the church shows better 'Islamic democracy' then any most that are found in Malaysia.

Besides the Unitarian Church, lessons can also be drawn from three other Wright's work. The Martin house offers important lessons in the integration of landscaping elements with the strength of organization of spaces. Instead of lumping all the spaces into a single mass, Wright had separated it into three volumes interconnected by passageways. What he has ingeniously done is to provide a leisurely but ceremonious journeys to all the different spaces in the house by encouraging the dwellers to view the plants and trees littered throughout the gardens in the small courtyards created. As with the quoted verses in Surah Ar' Rad, the mosque can benefit from such a strategy that would not only encourage the reminder of God but also sooth the spirit and cools the building by solar absorption.

Wright is most concerned about sustainable architecture which can be seen in his preference for natural materials and his energy conservation strategies. In the design of the Friedman house Wright buries much of the building in the soil for a natural insulation against heat and orients the building to capture the winter sun rays to heat the house. In the tropics such as Malaysia an emphasis to openness and the use of pools of water for cooling and encouragement of convective air currents is desirable. However, many mosques disregard this principle and some have even opted for the use of mechanical means of cooling just so that they can use the fortress like images of the middle eastern mosque typologies. Islam encourages actions of conserving resources and abhors wasteful acts of any kind. The Prophet was known to have admonished his followers not to be wasteful in performing ablution even if the water was from an abundantly flowing river.

The use of integrated ornamentation is another of Wright's strength in design. This subject is relevant to Islam as everyone is aware of the so called legacy of Islamic ornamentation in the form of written scripts or geometric patterns. Wright never advocated the direct revivalism or imitation of traditional ornaments but chooses to select his own motifs and composition of ornamentation. Muslim architects must understand that in this way, better meaning can be ensured to the ornaments and can be easily appreciated and understood by local cultures. In the Unity Temple, Wright displays his powers of integrating ornament into the building's exterior characteristics and he had also rendered the interior ornamentation within the De Stijl or Cubist perspectives as part of the ceiling moldings, fixtures and wall paneling. In many other designs, Wright integrates the heating coils of houses and furniture as a complete organic entity for the buildings. Thus, the interconnectedness of the fixture, furniture, finishing and other ornamental details all add up to a complete unifying *tauhidic* approach.

We can, therefore, see that Wright has many principles that are directly relevant to the design of mosques not as a monumental and glorified symbol but as a product that disintegrates into the landscape whilst emphasizing the lessons of Nature as the main theme of reminding the Muslim of its humility and humble origins.

Putra Mosque versus Majid

In this section we present a criticism of the Putra Mosque and Masjid Negara from the perspective of Wright's philosophy.

With regard to the use of architectural language, we can obviously see the weakness in the Putra Mosque. Its reliance on the eclecticism and revivalism of a foreign tradition makes a statement as if Malaysian Muslims have an inferiority complex to that of the middle east. Where, in the Qur'an or in the Sunna does the Prophet make reference to the iconoclastic stature of the elements of domes, minarets and arches? The three elements thus mentioned have never existed in the Nusantara typology of timber mosques in this region. The use of domes, and arches are a result of an ancient understanding of masonry construction. The Masjid Negara does not have this problem since it does not have an iota of reference to the traditional Middle East and thus can stand proud as a wholly Malaysian product. As to the criticism that the middle eastern language can produce a pan Islamic internationalism, we must make the stand that Islam never insisted on a unifying imagery but merely insist on some fundamental ritualistic practices.

With regards to the use of regionalistic response to the climate, Masjid Negara epitomizes this creed in a wonderful display of *serambis* or verandahs, air wells, large pools of water for cooling, a generous fenestration area and a depth-to-height proportion that encourages convective air currents throughout its structure. The Putra Mosque with its small fenestration area, large use of masonry is forced to rely on mechanical means of cooling that wastes energy and resources. The fact that it sits on a man made lake worsens the idea of sustainable architecture in its almost 100 million dollar venture.

As regard to their massing composition, Masjid Negara settles on an assymetrical approach in contrast to the imperial symetery of the Putra Mosque. Thus Masjid Negara presents an informal invitational gestures to worshippers in contrast to the stiff and regimented tones of the Putra Mosque.

The siting of the Putra Mosque leaves much to be desired and someday scholars will write about the effects of pollution on worshippers using vehicular transport to grace the monumental palace like structure. Masjid Negara sits in the midst of Kuala Lumpur near the train station and within walking distance from many public structures. The Putra Mosque is surrounded by a formal gateway that presents an irony of an open public structure whereas Masjid

Negara sits comfortably without a monumental gateway and therefore projects a language of friendliness.

The horizontal expression of Masjid Negara presents a humility that is the characteristic of Islam whereas the stark verticality of the Putra Mosque presents an arrogance perhaps befitting the client that commissioned it.

Both buildings do not rely on the use of natural materials and thus was unable to project the idea of eternity and primeval origins.

Thus, in almost all respects, Masjid Negara presents a regionalistic model that can better present the idea of Islamic architecture in the Nusantara as opposed to the false and wasteful projections of the Putra Mosque. Architects, for this reason, would do well to learn much lessons from Masjid Negara in not only mosque designs but any building that carries the idea of sustainable identity as its main agenda.

Conclusion

Simplistic revivalism in mosque design can be seen to be interpreted as providing Islam with the attributes of a regressive and uncreative culture, a dogmatic sense of rigidity, an over priced piece of arrogant sculpture and 'white elephant' to be praised but never used efficiently. As designers of mosques we should try to veer away from the cocoon of historicism and attempt to question the fundamental basis of our works. The early modernists such as Wright and Corbusier questioned almost every facet of what society felt to be truth in architecture and also what they had held deer as the idea of 'life'. It is our time now to forget about the so called glorious 'Sinans' of our civilization and seek the truth from the direct spirit of the Prophet Muhammad's Sunna and derive our agendas within the framework of present socio-economic and regionalistic concerns which are then synthesized using a creative interpretation of traditional and modern architectural vocabulary. As with the idea of *jihad* such a struggle will always bear honest fruit for the 'struggle' itself is the actual goal.

35

Architecture of the New Malaysian University

I feel that the university holds the future leaders of the country. Some others feel that the university is just a factory to produce potential workers like engineers, architects and scientists. Then again there are others who feel that the university is the place where knowledge is discovered, patented and money must be made from the findings. I view that the university is the conscience of the whole nation if not mankind. What use is there of talking about money and fame when if we can consciously decide what is really important in terms of values and the idea of wholesome living as humane human beings, the question of money, fame and inventions are moot. Things that we strive for are actually by-products but yet we make that the primary aim. It's like sweat and sweating. Is the object in life to sweat? Even though sweating is important and provide a healthy body, it in itself is not the most important thing. The important thing is a useful life within a healthy one. How one achieves and mastermind that makes all the difference between engaging in sweating or not. So, in effect, a university, whether its curriculum, organization and architecture depends entirely upon the perception one has on the use of knowledge. Today's piece is about how the university should be designed from a student centered perspective rather than the ideas of a few Ministers or Vice chancellors who are too capitalistic, racist and egotistical in their mindsets.

First is the question of what is the university student. To me they are the future leaders, entrepreneurs and philanthropies of the future. If we take this view then we should treat them like delicate eggs in a rattling wagon. They are

precious. They are the future. They will be your children's leaders, employers, business partners and consultants and who knows, they would be yours too! So here's a wish list for the future Malaysian University for the Dawn of the New Malaysia (not my original phrase, of course).

Firstly, I would tell the administrators, as a student, that I would like my hostel apartments to be as close as possible to my main study field. Each faculty should be designed together with enough places for the student to live and should be a brisk 5 minutes away from classes. The present public universities, designed in a mini kingdom like way reveal hostels that are so far away that there is serious problem of time, travel and security for the students at large. I don't care if the administrators think that having a hostel too close to the faculty would cause the 'corporate' image to suffer, there are ways and means in architecture to handle the students' dirty laundry. Just get an architect who actually remembers that he or she was once a student (well, surprisingly, it's more difficult to find one actually!)

Next, I would like to request that all students who follow a certain religious faith be given the proper religious facility to pray and congregate in. Why should the Muslims be the only one given a huge mosque? What about the Hindus, the Christians and the Buddhists? Where are their temples? Since these religious faiths are in the minority, I do not feel that there will be a grand cathedral or a huge Buddhist statue in the public universities but certainly, the provision of basic structures to house the worshippers must be provided. It could be in a three storey building with each faith occupying a single floor or it could be grouped in a modest piece of land on the university grounds. Special rooms for the offices of the priests or monks must be provided as each faith must be tied in with the ones outside the university ground.

Third comes the recreation facilities and intercity travel terminal. I feel that it is necessary to have a 'shopping complex' kind of a facility for the students to wind down or 'lepak' to ease out any stresses. The university shopping mall should come with the usual eight lane bowling alley, snooker tables, video arcade, McDonalds, Kentuckys, ciniplex and ping pong tables. The complex should also be equipped with a bus terminal for the traveling needs of 20, 000 students going home in the weekends or the many religious celebrations in this country. The nation should be thankful that the university students in Malaysia are loyal to their parents and this keeps our society cohesive and strong.

Fourth on my wishing list is the proper architecture for the Student Union. This is the place where the future parliamentarians reside, the future board members of powerful firms meet to discuss and the military leaders of the new world security plans and strategize. If the students are so divided racially as they are today, and can't make politics work between themselves, then we as a nation are in deep trouble. If the students cannot interact with present political leaders and corporate giants, then let us shut down the universities as they are nothing more than glorified boarding schools. There should be proper offices for the student bodies, meeting rooms, and most importantly, a square to encourage freedom of speech and expression within the stipulated ethics and manners of the Eastern culture. There should also be a room to house the best student works and also a hallowed hall of fame for the most enterprising students in the various social, political and academic engagements.

Lastly, I would tell the administrators of the university to tone down the overbearing 'Pak Guard' architecture and bring down any fence or gateway that would symbolize an autocratic despot propped up by a military regime. I have not met a student yet who respects the security guards who treat them like Hitler treats the Jews. Let us also tone down the palatial grandeur of the chancellery and relegate it somewhere obscure to give greater prominence to the true legacy and user of the university …i.e. the students.

So there it is; the New Blueprint for the new Malaysian University. This is guaranteed to produce visionary political leaders, humanitarian corporate executives and generous philanthropies. But ..of course…if we want simple minded workers, uncaring professionals, self indulgent political leaders and money minded corporate executives there is a number of public universities now that can serve as the perfect architectural precedents.

36

Building Better Libraries

It is an undisputed fact that a thinking person is a reading person. If a country wishes to have for its citizenry a sound future leadership and a competitive workforce as well as a more independent people, then reading and books are indispensable items in whatever curriculum or program of education. In architecture, the library is the traditional home of these two items. Of course, one can argue that the internet is rapidly replacing books and thus, the presence of a library, and so the future of such a building type hangs in an uncertain limbo. But I personally think that we as a nation should not get ahead of ourselves and think that we are like a first world nation if we have computers and LCDs in every classroom. Reading is a cultural trait that needs to be nurtured. And books are the necessary 'playthings' that the toddler, child, teenager, adult and elderly must appreciate. The environmental conditions of reading whether it be at the home, school or community must exist to supplement an important habit such as reading. I would like to touch on the school and community library design strategies in order to encourage a nation and her people to better themselves through reading books.

Before deliberating on the design strategies of school libraries, I have a bone or in fact several bones to pick with the school curriculum and pedagogy and also with its administration. If these bones were not picked, no amount of 'architecturalising' of the library space will change anything. The first bone is the curriculum and pedagogy. Where is the act of encouraging reading as a pleasurable activity? What is the time actually allocated for immersing oneself

in a story book, a pictorial encyclopaedia, a Popular Science Magazine or a comic book in a library? There is hardly any time during recess. The library is closed after school and on weekends and long holidays. Next comes the bones of the administration. Firstly, where is the proper librarian? No, no, I do not accept the teacher who had been drafted to be the librarian as a proper librarian. The teacher is to teach and libraries need the proper person who has a degree in library science. Next bone is where are the books? What I have seen are libraries that barely has 30% of capacity in schools that are more than 10 years old. Of these 30% capacity, 80% are PMR and SPM books. Dear Malaysians, we can build and finance the two tallest buildings in the world and yet we can't seem to find money for a librarian (even with a Diploma), the proper books to excite our young minds and the proper time to read and borrow books. What's that you say? Malaysian children are too lazy to read? Well please come to my house on Sundays and see all the Low Cost Housing children flock to my 2,000 book house-library eagerly rushing to borrow Batman Comic books, Archie Digest, abridged Classics, children encyclopaedias and even my Health Encylopaedias.

Once we have those bones picked and problems dealt with seriously, we can now look at the simple abc of library design for schools. Firstly, do not site the library on the fourth floor or next to the head teacher's office. No one is going to go up to the fourth floor or walk by the head teacher's office! It should be near the canteen where it is visible to the children. It could also be on the ground floor opposite the bus lay bys and pick up points so that while waiting, the children can browse through the books and even do some homework. Next, put in display windows like the bookshops to attract the young users. For the furniture, there should be varied sitting such as settees, thick carpets with cushions and study carrels. Not too much of these canteen table types of chairs and desks please. For the shelving, firstly, do not point the books towards the sunlight as the writings and ink will eventually fade. The library should have different coloured shelves placed in rows or boxed in or L-shaped to create pockets of different spaces. If possible, divide the library into a 'noisy' section and a quite one. You're surprised? How many Year 1, 2 and 3 children who can be kept quite when they see beautiful and exciting images in books? So let them exclaim! Let them show the book excitedly to their friends. Let the UPSR kids in the silent section if they feel so incline to study.

Let us now consider the design of the community Libraries. First question: where the heck are the Community Libraries? If the modern community settlement in Malaysia is defined as the Housing estates with 500 or more families then I would certainly expect a library for each estate. Ok.. I'll settle for one for every three estates. But still, there are none. Libraries must be sited where the children, teenagers and adults can access easily and not spend 40 minutes in a traffic jam to get to one. When I was in the UK, there were libraries everywhere and where there are none, the library truck would service it five days a week. Now that is real civilizing efforts. If, as a country with the jewel city of Putrajaya, we say we cannot afford it, why not attach a few library rooms to the Dewan Serbaguna or Community Hall? Or we could hire two clerks and let them run a shop lot library. In my experience, our children loves reading and looking at books. Its just that they never had an opportunity before. We could also upgrade school libraries into community ones if we can site them at the school boundary and the housing streets.

Next strategy is to get rid of any kind of fencing and just open up the library to the community. Who do we want to keep out with the fences? The community? I would then place a large verandah space with seatings and a small cafeteria or warung at the library where people can come to read newspapers, magazines or comics while enjoying the tarik. I would place a huge glass partition that gives visual access from the verandah into the library book stacking area so as to psychologically invite the users in to read. I would also attach a small playground right next to the children'noisy book section with parental seatings in the form of a tv lounge area. As before, I will keep the quite reading and reference section on the second floor for the UPSR, PMR and SPM readers. Seating areas should be varied and pockets of spaces as nooks and crannies designed with colourful materials. Take much lessons from Borders or Kinikuniya Bookstores.

We are what we read. First we must make the time for reading, then get the librarians for our schools and community libraries and then the different kinds of books. Finally the architecture is simply to house all of them in an inviting warung-styled typology with bookstore interiors. That, dear Malaysians is the way to a thinking generation.

37

Campus Design in Malaysia: Of Motorcycles and Mediocrity

Introduction

If anyone were to ask me what I would remember most about Malaysian universities, I would unabashedly claim that it would be the dangerous presence of motorcycles and the common existence of intellectual mediocrity of the students, academics and administrators. Now how do those two items have relevance to campus design, you might ask, I would simply answer... everything!

This short essay is a critic of campus design in Malaysia in which I will highlight that architects have failed to understand two fundamental things; specifically an appreciation of student culture and the interpretation of the idea of knowledge acquisition. The responsibility of understanding the student culture represents the most basic of understanding in architecture and it is almost as utilitarian as designing a kitchen. Expressing the idea of knowledge and the act of acquiring it should have been the architect's *tour de force* as this is the their poetic license in architectural interpretation. Both of these aspects add up to the architect's professional 4 to 6 percent fee (or, as I was told, its getting smaller?). My assessment of recent government sponsored campuses or IPTA (Institut Pengajian Tinggi Awam) shows extreme failure in both aspects of design.

The Architectural Message

Let us take a look first at how the architects fare at expressing the 'holy grail' of campus design which is the interpretation of the idea of knowledge and its position in society. As architects cannot stand long-haired philosophical musings on the idea of knowledge, I will simplify the discussion by referring to Thomas Jefferson and Frank Lloyd Wright. In one of his writings, Jefferson proclaimed that in order to safeguard the idea of sanctity in the new constitution of the US of America against self interested leaders who would treat the country like their back pockets or the military like their own private toys, it was important and crucial to educate the whole society about the basic rights of the citizens. In other words knowledge was to ensure the appropriate values of living truly as human beings and not like someone else's slave. Wright supported this view when he lamented in a speech about education on how universities were mere trade schools which did not impart knowledge for enlightenment but for specific conditioning. In other words students were conditioned to be so many screws, nuts and bolts that would fit the machine metaphor of 'industry'. (You can get a hint of this concern when you attend management meetings at the university level concerning student development in which the officials kindly refer to students as 'products'. I have always maintained privately that universities in this country seems more like a glorified shoe factory then it is Moses' mountain of enlightenment). I would, thus, sum up that knowledge is important not only for our spiritual development but also for our social growth. Now, before some of you shout... what about technology and ICT...well I'll yell back...so what about it? To me if a small ant can learn to be a worker ant or a soldier ant in a short period of time, what is the big deal about learning all the techno stuff and computer mumbo-jumbo. The real knowledge, if anyone actually reads the nation's education charter, is when you start having an attitude or a personal opinion about things around you. Swami Rama, in his book <u>Himalayan Masters</u>, recount of his conversation with a university graduate who had a problem about his social life. When asked to recount what he has learnt from his university days, Swami Rama pointed out that the man had not learnt anything at all but have merely 'imitated' knowledge. Wright said almost the same thing when he said that true knowledge is the ability to see 'in' and not merely looking 'at'.

There are so many university graduates who are able to see 'at' but very few have the ability to see the 'in' of things and events.

There is, therefore, a lot that can be said or implied from the above-mentioned discussion about the position of knowledge and its interpretation in campus design. I am forced to look at only one issue at this limited discourse concerning this matter. For this next piece of discussion I want all of us who have ever set foot in overseas universities in the West to take a good hard look at the photographs of our campus life and compare that to the graduation photographs of our sons, daughters or friends who graduated from the local IPTA. Can you spot the differences in the photographs? You can't? Well, take a clue...which buildings form the backdrop of the photographs? You might find that three structures form the backdrop of the local IPTA pictures; the mosque, the chancellery and the gateway. I don't know about you guys out there but I have a lot of photographs with the library and the student union as the backdrop when I was in the US and Scotland. Now...the ten Ringgit question is...what does this mean?

Well, to me, it simply means that in Malaysia, knowledge is not for enlightenment but for pure conditioning whether in the economic or political sense. The design language in our new campuses like UTM, UUM or IIUM is simply as follows, "Welcome student. Know that you are damned lucky to be here. Don't forget that! Now come inside and register and..oh..don't forget to wipe your feet first and speak only when you're spoken to, understand?" It is most interesting to note the presence of what I term as the 'architecture of knowledge feudalism' in these campuses. Well, how else am I supposed to interpret it? You come in through the main triumphal arch and (don't forget to take a 'pass I-D' before you do and listen to a short speech by the Pak Guard) before you know it, you're engulfed or squeezed between the huge Administration Building (where the 'King of the Campus' reside, 'his majesty', the Vice Chancellor) and the immense Middle Eastern or Central Asian mosque (which is supposed to say that there is this thing called Tauhidic unity of knowledge and life, and never-mind-that-it-is-too-far-from-the-student-dorm message). When I was in the US and Scotland, you'd have to ask three times before you'd find where the chancellery building is, let alone the office the VC was in. I also distinctly remember of no triumphal arches or Pak Guards in the mostly urban campuses or even in the campus laid out on a relaxing meadow. I can immediately tell where the library and the student unions are and of course

you can see the student dorm rising sedately in between the campus buildings. I may be wrong but I do believe that the campus in the West explains what I term as the democratization of knowledge for enlightenment and I always felt free and relaxed to think my own thoughts. I certainly cannot share that feeling in the local IPTA here. I am most happy visiting private colleges like PJCC (Petaling Jaya Community College, LICT (Lim Kok Wing Institute of Creative Technology) and Universitas Trisakti, Jakarta as they are all urban based and housed in a single building or on a floor of a building or in several office-like structures. No Triumphal Arches, no monumental mosques and more importantly, no overly ornate chancellery would greet me. I do not see the sense of wasting much of the country's resources to locate a university in an isolated site with all these monumental statements of grandeur. When universities are isolated as such it brings the idea of elitism in knowledge acquisition which is divorced somewhat from the hustle and bustle of real life. Once I was admitted to meet one of the Board of Advisers at PJCC and we met in his simple 12 ft. by 12 ft office which was no larger than my own! Thus, what I had termed as mediocrity is related to the culture of knowledge in local universities that revolves not only around regulations about hairs, political meetings and *akujanji*, there is also the architectural element that nurtures the sad phenomena. I sincerely hope that architects would at least attempt to argue a bit about the idea of democratization of knowledge rather than the idea of conditioning knowledge with regards to the architectural setting and building design.

A Serious Safety Issue

Let us now switch to the issue of motorcycles on campuses. Once at a local U, I was told that there was a move by the university official to ban those noisy motorcycles but it was dropped. The university officials seem to have looked at the problem from aspects of noise pollution more than anything else. The fact of the matter is simpler than that. The motorcycle to the local university student is like beer to the students in US or UK. Now the funny thing is I think that there are a great deal less motorcycles among students in private colleges like PJCC and LICT than in the local IPTA. I don't think you'd need three guesses why. The isolated sites and the want of facilities for the social life of the students are apparent problems in the local IPTAs. Simple.

No big philosophical debate here. I'm not sure if anyone notices but university students are adults. They left their *asrama* days a few years back. But the unfortunate thing is that the local IPTAs seem to be big *asrama* or boarding schools. I have had the privilege to be in two types of universities in the US; one in a sub-urban site in Green Bay and the other in the heart of the City of Milwaukee. I do not find transportation to be a problem in both situations since the local bus service is prompt, courteous and dependable. Furthermore, I only go to the town center once a week since much of the social facilities are present on campus. At the UWM, we've got bowling alleys, snooker tables, video arcades and I always look forward to the third off price at the student Union Cinemas. I fail to see how these elements might degrade the sanctity of knowledge acquisition or even destroy a religious value system in a society. It surprises me that even the mere suggestion of a McDonalds on campuses have irked some quarters in relation to some twisted moral issues.

The previous discussion have centered around the problem of isolated sites and the lack of certain facilities for students that have encouraged students to use motorcycles as their vehicle *par excellence*. I wish to concentrate now on the problem of dormitory locations and student circulation in the campuses. In my theory and design classes I've always asked the students whether universities in Malaysia are designed for students or lecturers and administrators. The student would naively answer the former. I said that if the universities were designed for the 30,000 strong student against the 3,000 academic and administrative staff, why are the dorms located far away from the lecture halls? Furthermore, where is the pedestrianized circulation pathway for the 80% student population who do not own private vehicles? One trip in a local IPTA will have anyone convinced that it is designed for the car and I have yet to find a university where students are better off than lecturers in relation to vehicle ownership. If a university were truly designed for students, I would expect dormitory towers to be located within a five minute sheltered walkway from their classes and that the pedestrianize walkway would always have the right-of-way over any murderous vehicles.. At certain campuses you would be totally drenched in sweat if you tried cycling or walking from the dormitories to class. At the university of Wisconsin Milwaukee, the dorms are in the form of two towers located almost a spitting distance from the library, student union and a few of the faculty buildings. I have always thought that the former International Islamic University Campus in Petaling Jaya was quiet an ideal design since

it has a few towers smack in the middle of the campus with the mosque, library, faculties and other support facilities a mere 5-10 minutes of sheltered walk away. There seem to be a feeling that the presence of tower blocks in the middle of the campus would destroy any aesthetic intention of the design and significantly drown the monumental grandeur of chancelleries and mosques. Is this the price which students have to pay? If it were mere convenience and time wastage, I would probably never write this paper. But the problem of motorcycles and other vehicles are more serious than that. Students have died and been maimed in accidents. I don't have the statistics but my students have been involved in numerous accidents just rushing to submit their design. A few of my students have actually passed away. You might want to still cry out for statistics which I don't have but try this for size: at the writing of the final sentences of this article, I was told that one of my fourth year students had just hours ago been involved in a motorcycle accident. My heart went in my stomach at the news but I was relieved to know that the student was lucky, just a broken bone and about thirty stitches.

Final Words

I can live with the insensitive designs of lecture halls, studios and regimented landscaping on campuses. Heck, I can even live with all the mediocrity surrounding campus life for I can always inspire individuals to climb out of their mediocre shells. As a Muslim, my conscience draw the line with such serious incidents as death and being maimed on something which I am also part and parcel of; an architectural academic who understands that the design decisions were partly to be blamed for these 'accidents'. In the interest of our children, I implore architects of IPTAs to seriously evaluate their design priorities and convince their clients on the simple fact that universities should be designed for students and not specifically tailored for the whims of Vice Chancellors or Ministers. The former actually live on campus whilst the other practically has a permanent suite in air planes. Now for those architects who simply love impressing their VCs and Ministers concerning campus design to the extent that it posses serious implications on students lives, all I can say is… may God have mercy on your souls.

38

Of Christian Values, Democracy and Islamic Fundamentalism: Thoughts and Readings behind a Book

My latest book is called 'Rethinking Islamic Architecture'. Thanks to a dedicated editor, Dayaneetha DeSilva, and the people at the Strategic Information and Research Development Centre, this important book have come into being that culminates most of my thoughts of 25 years about what I think the idea of Islamic Architecture should be. How is this book unique and different than other numerous books on Islamic Architecture? Well, it is the first serious attempt at criticizing Islamic Architecture and reconstructing its idea from the use of the values of the Sunnah or the Prophet's tradition. It is also controversially using the framework of thinking of the late 19th century Western Modernist in interpreting the Sunnah and the hadiths. Does this make sense? Probably not. Let me explain. Do you remember seeing those mosques with expensive domes, minarets, ornaments and there was also one made of crystals? Well the book says these mosques are anti-thesis to what Islam is all about. That's right, in my book (literally) these mosques are 'un-Islamic'. What about the non-mosque buildings like the Prime Minister's Office in Putrajaya? Same thing, they are also un-Islamic. Well, you might say that all those domed skyscrapers by the PAS led government in Kelantan are very Islamic. In my book, they fall under the same sad state of affairs. Well, what then is Islamic Architectur? Not to use a cliché but ...you have to read the book! Anyway, if you've been following my column for the past three years, you should get a

pretty good idea where I'm coming from. What I thought I would write today was what were the influencing factors of my ideas about Islamic Architecture? Why is this essay important? Because it shows that in order to discover 'the truth of things' one must traverse beyond one's own religio-cultural context and seek other perspectives before coming back to earth in order to make sense of it all. My intellectual journey crosses the seemingly 'conflicting' ideas of Islam and the West. What I found at the end of the journey was that what we consider the 'West' and what we consider 'Islam' are actually complementing one another if we but choose to open our hearts. Not only in architecture will we see this as true but in politics, education and I think literally everything under the sun. What has driven us farther and farther apart are simply out own arrogance and some very evil politicians who makes use of our fears to their limited and twisted economic ends. The recent burning of the churches also has something to do with why I am writing this column. I am being overly simplistic of course but then again the bigger the problem, usually the simpler the answer is staring at you in the face.

My romance with the Western culture began early in my primary and secondary school years. My father wanted me to go to an English medium school and I started my schooling at St'Marks Primary school in Butterworth. After a short one year stint in Prai during Standard One, my family moved to the Police Barracks in Butterworth which I had written about a few years back. I started in 1969, you know... the 13th May incident. All I knew then was that for about a week my father, who was a policeman, came home every night with a Sten machine gun. My reading years blossomed at the Police Barrack from Standard 2 to the middle of Form Two. I don't remember how I got the first copies of The Beano, Dandy, Beezer, Topper and Whizzer but there I was in standard Three, Four and Five voraciously reading and buying these comics. I was also introduced to the Disney comics from the school library. I read many Bedtime story books which were in the form of Fairy Tales as well as stories from the Bible. My contact with Christianity was very strong with the content of these comics and books centering around Christmas, Thanksgiving Easter and many other celebrations. The clothes and food with different cakes, puddings, macaroons (whatever they are) scone served at tea time, breakfast, dinner and supper were second nature to me mind. Standard Six was a turning point in my life. I was introduced to the books by Enid Blyton! As a present for doing well in class my mother allowed me to buy

two story books and I stumbled upon two translation of Enid Blyton. One was called Misteri Desa Bunyi Loceng (The Ring O'Bells Mystery) and the other was Sungai Pengembaraan (The River of Adventure). After those two wonderful books I spent every cent I had buying second hand books by Enid Blyton and read hundreds of the Famous Five series, the Mystery Series, The Five Find Outer series, the Adventure series, the Malory Tower series, the St' Clare series, the Farm series and many-many more. The whole British world with its Christian values were laid bare to me and I enjoyed every word that she wrote. May Allah bless this 'wonderful' soul for bringing such treasure. My family was not too strict with Islamic rituals of prayers and others. As my father seldom performed them, I never really went to the mosque because he never took me there. My father thankfully became more religious when he retired and started walking a kilometer to the mosque everyday for the next 6 years before he suffered a heart attack at 63.

In secondary school, I added Alfred Hitchcock series to my list as well as Hardy Boys and Nancy Drew. These books were just one-time-read only, unlike Enid Blyton books which I read an average of four times for each book (I read at every meal). I can recount all the characters, scenes, jokes, painful moments of all the series from Enid Blyton that I read until now. You can quiz me on all the names of characters, pets, places, foods, plots and whatever and I will surely be able to answer you though I always forget where my spectacles are or where my hand phone is! My teenager years of Form 3, 4 and 5 were filled with Archie comics and Jughead Digests that filled a void left by Enid Blyton. I think I own about 500 copies of these Digest and I still buy them even now for my children. Then there was also 2 years of collecting 'Action' comics and 'Battle'. From the Hua Lian National Secondary school in Taiping, I found all the classics of King Solomon Mines, Black Beauty, Ivanhoe and many, many others. What was the point of all these recountings? That the West was a wonderful world to me and that Christianity offered the values that I never understood or came across in Islam during my childhood and teen years. Imagine that. Professor Dr. Mohamad Tajuddin, the expert on Islamic Architecture and the Malay academic owes his early teachings of values to… Western Chritiandom. Why did I not find any Islamic novels or comics that can excite and nurture my life then as a child and as a teenager? Muslims must answer this predicament before pointing fingers at Christians for trying to 'convert' Muslims. I thank Allah for all the books that have made me who I

am and ask a special 'doa' for the authors of these works. The ulamak can call me blasphemous but my readings in the Prophet's sunnah tells me differently. There were, of course all the English television shows that I watch such as Scooby Doo, Johnny Quest, Star Trek, Voyage to the bottom of the Sea and all that. I watch very few Malay programs and now, after the 1998 Reformasi Movement, I don't even watch the local television stations... period.

I discovered the wonders of Islam only when I set foot in the United States of America, in Green Bay Wisconsin and later on in Milwaukee Wisconsin. My first two years in the USA was in Green Bay before transferring to a full Architecture School in Milwaukee. In Green Bay, I began reading about UFO's, Supernatural Phenomena, Christianity, Buddhism and Hinduism to answer my gnawing question of 'What comes after death?' as well as 'Does the cosmos have an end?" Pretty heavy stuff for a first and second year undergrad! My other friends at the university who were trained well in Islamic teachings spend their time traveling, going to night clubs with exotic dancers (I went once!) and performing the religious rituals whilst I spend most of my time brooding, thinking and reading. What a Nerd! But the nerdy years paid off in bundles later on. In my second year, a 'sister' meaning a Malay senior student who wears the tudung gave me a book entitled 'Towards Understanding Islam' by Abul A'la Maududi. Wow! That was an eye opener! After reading Maududi's 'Fundamentals of Islam', Islamic Law and Constitution, Syed Qutb's Milestone and Dr. Ali Shariati's 'Man and Islam', my path towards what I term as 'political Islam' was set for the next 20 years. With the discovery of the collection of Hadiths of Sahih al-Bukhari that opened my eyes to the world of Prophet Muhammad, I began to affirm and 'accept' Islam as my way of life way back in 1984. I pledged then not to miss a single solat or prayers and learn the akhlak or morals as well as political organization that was Islam. It was then that I began in earnest to participate in political activism holding the post of Vice President for the Malaysian and the Muslim student societies. I mixed with the students who ran the MISG or the Malaysian Islamic Study Group who were instrumental in building a framework for educating Muslim students the true meaning of Islamic teachings. If left to the government of Malaysia and their Malaysian Students Affairs Department, I dare say that all the Malay students who went overseas would have strayed very far away from their religion and culture. The most influential political character that I discovered in my Graduate Years was Abdul Hadi Awang. I bought hundreds

of his Tafsir Cassettes and while drawing architecture assignments listened to them over and over again trying to understand the meaning of the Qur'an through his Terengganu accent!. I owe this man a special doa and prayers. Finally, I discovered the Tabligh Group who were Islamic missionaries that came from all walks of life from garbage truck drivers to specialist surgeons all bent on spreading Islam and crying softly to Allah in the silence of the night. Thus, my Islamic education was complete then. (I did not know then that I had a lot more to learn after my other turning point at the age of 45).

Hey, what about the Architecture part? Well, that did not take much reading but read I did. In my third year of architecture school, I read 'Master Builders' by Peter Blake. It was a biographical writing of three of the most important architects ever, Le Corbusier, Mies van der Rohe and Mr. Frank Lloyd Wright. After that I sought out books by Wright and found his 'In the Cause of Architecture' and the 'Testament'. Along with Le Corbusier's fiery 'Towards a New Architecture', I began to make sense that architecture came from the values of the architect and not from simple historical precedence. Precedence of historical typology was frowned upon by the modernists. You must understand what you want and then design accordingly. That's it. No rules of 'propriety' or 'good taste' as noted by such historians as John Fergusson or Niklaus Pevsner. I also read the difficult book 'Kindergarten Chats' by the 'Prophet' of the modern skyscraper, Mr. Louis Henry Sullivan' and also his 'Autobiography of an Idea'. I read a book on 'The Architecture of Henry Hobson Richardson' by the famed architectural historian, Henry Russel Hitchcock. I then registered for an independent study class and proposed the reading of the 600 page Modern Architecture since 1900 by William J. R. Curtis. I discovered the light readings of Professor Eugene Ruskin with his 'Architecturally Speaking' and Architecture and People'. The modernists taught me not to look for any historical precedents. I also saw that political views mattered much in Wrights rendition of democracy and Sullivan's long tirade of nation construction. Psychologists like Gary T. Moore and Professor Dr. Eugene Raskin taught me that architectural vocabulary should be made up of the sum total of our experience with the physical world. Again, no magic formula, mystical principles and esoteric ideas. The architectural principles to me was as clear as day. When the time came for me to complete my design thesis for my Masters course, I chose the design of the mosque for the Milawaukee Muslim community. During this time, I was actively running the

MISG Training Camp programs as well as the Tabligh activities most of which requires a lot of sleeping in the mosque which then was a former elementary school building. In my thesis design, I chose a wholly rational approach using the hadith that I learned to provide a totally different interpretation of Islamic architecture based on the values of the sunnah and the modernist as well as behaviorist interpretation of these values. I graduated my Masters in 1986 and ten years later, I completed my Ph.D thesis in the University of Edinburgh with fine tuning the ideas of the mosque as a community development center.

In 2006, I wrote my best paper entitled 'Reconstructing the Idea of Islamic Architecture from the Perspective of the Sunnah and Early Modernist Framework'. What sparked this paper was Anwar Ibrahim's Reformasi Declaration in Permatang Pauh in 1998. Mahathir's arrogant an un-islamic way of eliminating his political opponent destroyed all my faith in the idea of Malaysia. Twelve years after that fateful day, I can still hear that declaration and my conviction that this country is being run by people who should never be there is totally and unequivocally confirmed. The burnings of the churches proved to me that an irresponsible leadership has in many ways led to this frightening turn of events. When I saw the buildings of Putrajaya rising up from the ground, I fed my anger and frustration by mercilessly criticising these architecture products as my 'sindiran' of attacking the racist and arrogant policies of the ruling party. You might say that I am a bias academician. Well, read E.H. Carr's 'What is History' and you will find out that all historians are bias and in understanding any writing one must always understand the author and the political contexts of his or her times. I am the product of that Reformasi age and my writing is a critic of the country's politics hidden behind an architectural discourse. Yes, I have a political agenda. If we are upstanding, responsible citizens of this country we must all have a political agenda to make this country safe, strong and prosperous for our children. Writing architecture for architects and students do not appeal to me and above all, it made no sense. Architecture is the stage for human activities contained within a set of cultural and religious value system. If one talks about architecture in a way an art connoisseur talks about painting or sculpture then that person has no sense of what architecture means.

Thus this book, 'Rethinking Islamic Architecture', is the sum total at this point of my life about what I think the real Islamic Architecture should be. I am a product of Christian values, democratic ideas, Islamic political

'fundamentalism' and the Reformasi Movement. To be a good architect, to understand architecture there must be 90% readings of life and 10% of architecture. All of us Malaysians must rediscover who we are by looking deep into our own cultural and religious history but we must also transcend that context into another culture's view of the world. We should not just 'tolerate' our cultural, religious and philosophical differences but, like in my case, our differences of view have helped me understand who I am as a Muslim, a Malaysian and an architect.

39

Taylors University College Lakeside Campus: A Malaysian Campus par excellence

Taylors University College has a new residence. Their own Lakeside Campus near the Sunway Pyramids. I recall being at the ground breaking ceremony about three years ago. Now the Campus is almost complete and partially occupied. Although I have been for many years an advisor to MASSA or the Center for Modern Architecture Studies in Southeast Asia, a center I helped to start at the School of Architecture and Quantity Survey, I only laid eyes on the design of the new campus only three months ago. I took my son who had recently got his SPM result and was shopping for a course when I decided to ask the councilors about Taylor's Hotel Management Program. It was then that I saw their video promo. Well…it took my breath away! Simple modernist forms, universalist architecture, some tropical hints, non-hierarchical planning, completely accessible and full of commercial, educational activities. This was a campus that Malaysia can learn from. Far from the kingdom like qualities of public institutions with their ethno-centric language, grand mosque-Chancellory gestures and far peasant-student accommodation making commuting a wasteful endeavor, here was the answer to most of all this dilemma. Of course, I quickly noticed some weakness and I will dwell on that.

The first item on my campus design checklist would be where are the student accommodation in relation to their classes. Lo and behold Taylors has placed them in a multi-story block barely a hundred meters away from

the three blocks of faculties and departments. Excellent! The thousand over strong student community will have a safe, cheap and easy commuting to the classes. Just a hop and a scotch away. No more motorcycles that can kill or maim our children. No more bus drivers with an attitude of 'I will drive when I am damn good and ready and not to some silly schedule!" What's the downside? RM600.00. I cannot imagine paying for a single person a whole family terrace house in the Kajang area. Why so expensive? Air-cond. lah! The designers have not considered any sun shading device or planning system with a variety of timber and masonry construction like the JKR Police Barrack that I wrote about. I do not think that sleeping for 4 years in an air cond place is healthy. This solution of non-tropical consideration at the hostel is a very weak one. Fans and the JKR Police Barrack are there to show the way. Even the high ceiling colonial buildings also has solutions. Dr. Ken Yeang can also show the stuff. Pity.

The next thing on the list is …where is the Vice chancellor Office? I have been to the campus three times and I still do not know where it is. Verdict… Excellent! Let the office disappear! Perhaps never to be found. The university is not about the VC. He or she is just a 'janitor' of sorts. Now I am not belittling his or her role but architecturally, it need never be expressed. Let the student and faculty blocks be obvious and conspicuous. It means democratic architecture. Enough with the Putrajaya Effect of kingdom architecture. Hurray with Miesian socialist architecture of 'Worker Architecture'. No downside to this item.

Next is the item of where can the student 'lepak' while waiting or in between classes? Ada tak? The answer…bayaaaak! I saw the student 'playground' next to the Student Services (where the parents pay the fees0. It is excellent! It reminds me of my days at Uni. Of Wisconsin Green Bay and UW Milwaukee with their pool tables (no, no you don't swim in it. …it's billiard or snooker-like lah!), Foozball (not sure how to spell it), video arcades ping pong tables and bowling alleys. Except in Taylors there are no bowling alleys…yet?? Students have no problem waiting for classes in this plush recreation rooms filled with cheerful stress relieving colours and expensive looking designer settees and sofas. Wow! Now that is spending on students? At public U? Well…tak nampak sangat-lah. Money goes to …er elsewhere like high maintenance landscaping. At Taylors, the landscaping is simple. They have a lake in the middle with a touch of plants and pottery here and there. Very Spartan but good. I also notice the clever and

strategically designed café's that are next to the lecture theaters. Excellent! Teh tarik before class! Tell that to Bloom's education taxonomy guys! So again no downside on 'lepak spaces'.

Next item is there strong statements of 'security' with imposing guardhouses and gateways. Nope. Nothing of the sort. But there is the weakness of entering the campus with a security guard stopping you and checking if you have weapons of mass destruction. I mean Malaysians are so insecure that there are security everywhere with smart card access and what nots. Come on guys… when was the last great terrorist explosion in this wonderful country? This is a downer to me. I was hopping that the campus was true to its free form and free flow expression without the Bangladeshi guards. What can you steal from a campus. Only knowledge. So …let people steal lah!! Big downer. Not the architect's fault I think.

There iare generous retail spaces that caters to all the different ethnic food groups and that is a big plus. Although there is some allocation of spaces for student political bodies, it confirms the idea that Malaysia will probably be governed by the same political party perhaps for the next generation. There are not many spaces for that although there is a student executive meeting space. Don't hope for any grass root movement in Taylors I suppose. Taylors Uni College I classify as a big and exciting shopping mall cum educational institution. Better than the public ones by far but still short on the political agenda….oops sorry, MY political agenda. I wish Allah would grant me a time where I would see a more promising student political movement that would give me great comfort that our children or those belonging to bus drivers, doctors, teachers and others can learn to govern themselves amicably and also be the beacon of hope for this country. If not political nepotism rules in our backyard.

Finally, on the good side, there is an excellent hotel facility that is next to the student dorm for visiting parents and professors gracing the corridors of Taylors U. I would also like to acknowledge the presence of two generously spacious surau for Muslims. I think it is good for the administration to equip the facility. I did not come across any other spaces for worship like an ecumenical center or a chapel. I believe the presence of several religious facilities would help tremendously the spiritual message that is badly in need to fuel the young with the proper moral idealism. Political leadership with no moral idealism is disastrous.

So what is the downer side of all? Parking. What else? Malaysia is a car country with cities and communities with a must-drive-car motto. I wish we were not a car country or city but there it is. Mixing politics and selling cars will always do this guys. Until we vote politicians with car companies and AP tagged to their names, all architecture complex must have a…multi-storey parking structure! Yes, yes, there are so of ugly but I could not find parking in order to deliver an invited lecture! What more of the students attending classes from their moderately priced apartments 3 kilometers away. This design flaw, to me, is inexcusable.

So there's my two cents worth of architectural criticism of Campus Design Part 3 (I've written 2 pieces before). Taylors University College now ranks number ONE on my list of good Malaysian Campus despite some of its weakness and parking flaw. Now I have a place to inspire my architectural students and encourage them to do a much better one for Malaysia's public universities. My message to the Malaysian public? Tell the leadership to learn from this democratic, reasonably sustainable and exciting experience for students campus architecture. My hat off to the designers and administrators. Way to go guys!

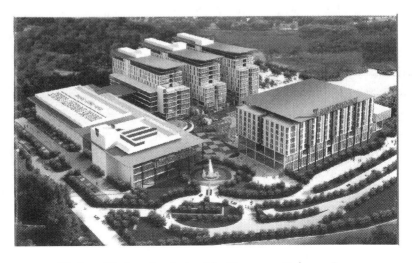

Taylors University Lakeside Campus, Subang Jaya

40

An Alternative Discourse on Islamic Architecture: The Compatibility of Wright's Organic Architecture with Sunnah

Introduction

The main purpose of this paper is to provide a new framework for a discourse on the idea of 'Islamic Architecture'. We wish to propose that the idea of Islamic architecture was only considered in the later half of the twentieth century and that its discourse has been limited to either a Sufistic framework of art or simply as a by-product of the modern-postmodern discourses of architecture. We wish to propose that the hadiths or the traditions of the Prophet Muhammad become one of the important basis for developing the new framework. Lest many would think that this might be a regressive or a 'fanatical' or 'fundamental' approach to Islamic architecture, we hope that critics might suspend their judgement until the arguments for the framework be allowed to be put forth.

There are two parts to this paper. The first part deals with a summary of the various approaches of Islamic architecture that is practiced presently with a critic of their strengths and 'weaknesses'. By 'weaknesses' we are in no way implying that these approaches are invalid in any way but that they present certain questions as regards the context of the Sunnah or way of the Prophet Muhammad. The second part of the paper deals with an argument how the hadith fits in the architectural value system as proposed by one of the strongest architectural visionary, Frank

Lloyd Wright. The choice of Wright is by no means an exhaustive one and it is also by no means an attempt to 'compromise' the bigger question of Islam and the West in favour of any intellectual or political agenda. Although it can be argued that the adoption of Wright has the authors trapped by their own criticism of Islamic Architecture framed as a by-product of a Western intellectual discourse, it is intended here to illustrate what Islamic architecture could be apart from its various historic revivalism presently rampant in today's context.

It is hoped that such a discourse present here will perhaps set the better course of Islamic architecture in a path that would have been deemed more desirable in the sense that the clash of values between the idea of technology, economic revolution, political thoughts and cultural upheavals would begin anew rather than the discourse being framed within the context of an intellectual by-product. We pray that the path of future Islamic Architecture does not lie dormant in the restricted idea of simplistic typological interpretation.

Approaches of Islamic Architecture: Contexts and Weaknesses

When the Western world was embroiled in an architectural discourse framed within a clash of values between the so called 'enlightened' secular values against that of the 'regressive and dogmatic religious values and also the idea of scientific revolution as the ultimate savior of mankind, the idea of Islamic architecture was relegated only to the few historical and descriptive surveys found in such works as by Caetani, Fergusson and Fletcher. Whilst the West was questioning the very fabric of revivalism and historical eclecticism for a more 'progressive' architecture to fit the coming global society, Islamic architecture was undergoing the first phase of intellectualization; that of typological classification. The mid-twentieth century saw the introduction of textual sources of the Qur'an and the Sufistic teachings of Muslims from various sects as tools for comprehending the idea of Islamic architecture. Up until the present time the hadith or traditions of the Prophet was never taken up as a serious foundation to set the intellectual discourse of Islamic architecture.

The approaches to design of mosques around the world can be used as the base data to form some summarized ideas of Islamic architecture[13]. The

13 For an excellent review of contemporary styles in mosque design, we recommend
 Renata Holod and Hasan-Uddin Khan's <u>The Mosque and the Modern World</u>

most common approach of Islamic architecture is Revivalism. Inherent in this approach is the idea that Islam had reached some kind of zenith in the past Turkish, Egyptian or Persian architecture and all one has to do is simply to imitate these typologies within contemporary economic and constructional contexts. The Shah Alam Mosque, the Putra Mosque and the Wilayah Mosque are blatant examples of this approach. Although the strength of this approach might be linked to a kind of 'universality' of Islamic architecture which finds friendly adherents in the United States of America, Great Britain, Europe and many others, there are two apparent weakness. The rebuttal against revivalism can be seen from the writings that are now over a century old in the words of Louis Henry Sullivan, Frank Lloyd Wright and Le Corbusier. Revivalism gives the impression that Islam has no capacity to progress forward other than a nostalgic look to the past. Secondly, there is no evidence in the teachings of the Qur'an that puts forth a particular race or geographical location as the preferred Islamic society or place. Indeed Islam extols that the best Muslims are those who emulate the values of the Prophet and the teachings of the Qur'an.

The second approach is Regionalism. In one sense both Regionalism and Revivalism share the same parent. The Revivalism approach is actually a recent phenomena brought about by the idea of a Post-Modern rebuttal against modernism. There was also the nationalistic aspiration of many nations which found political and economic independence in the mid twentieth century. Post-Modern criticism had unleashed the modernistic taboo of historicism and saw architects diving wholeheartedly into the historical baggage of past architecture. Criticism of modernism from the perspective of economy of construction and cultural response brought about the idea of an architecture of the region as the savior. The Niono Mosque and the ASPA mosque are attempts at adapting past regionalistic models built by traditional materials using local craftsmen. Regionalism has the strength of answering the problem of scale in a traditional culture as well as the economic factor of not having to import labour and materials. Furthermore the buildings weather well in their specific climate. With respect to Islamic architecture, since Islam does not subscribe to any idea of a pan Islam imagery, but does subscribe to the idea of useful and culturally sensitive responses, this approach serves a much better prospect than Revivalism. The only setback seems to be that these vernacular regional models

(Thames and Hudson Ltd., London: 1997).

are harder to adapt for an urbanized community. Mud construction and timber works do not pose much potential for high rise development. The National Mosque in Malaysia presents a better potential in its modernistic Regionalist approach with its use of air wells, light courts, generous *serambi* or verandah space, wide interior volumes with proper fenestration areas and ventilation grillwork. It is sad to see Malaysian architects ignoring many lessons from this mosque and preferring, instead, to choose the foreign revivalist typology.

The modernistic idealism in Europe left several legacies for the approach in Islamic Architecture. The most common one it seems is the exploration of modern structural solutions in adapting historical ideas and metaphorical messages.[14] The Negeri Sembilan State Mosque uses a structuralist solution in the reinforced concrete connoidal shell roof system meant to express the traditional Minangkabau architectural vocabulary. There are also pure structuralist solutions of 'Bedouin tents' echoing the successful Haj Terminal in Jeddah. Finally, there is the geometricist approach as found in Gulzar Haidar's solution to the ISNA mosque. The idea of Islamic Architecture as a set of geometric forms found a highly questionable solution in the Kuala Lumpur City Center twin towers of Cessar Pelli. The various twisted squares and octagons find much favour in architects who perhaps wishes to engage in non-controversial and quick solutions to their approach. Although the strength of the modernist approach lies in the idea of 'progress' in religion and not in revivalism, there is also ambiguity in this approach since the idea of Islam and architecture seems to be framed in a universal modernistic ideaology fit for any building and culture.

Other discussions on Islamic architecture falls in the realm of Sufistic mysticism as expounded by such scholars as Titus Burckhardt, Syed Hussein Nasr and Nader Ardalan.[15] The basic premise held by these scholars seems to be that since only the Sufis were rational enough to make sense of religion through their inner understanding of Islam and they had actually put form to their rituals and beliefs, thus they were the better source of Islamic art and architecture.

[14] M.Tajuddin Rasdi, <u>Mosques in Malaysia: Styles and Socio-Political Influences</u>, (Utusan Publications and Distributors, Kuala Lumpur: 2002)

[15] M.Tajuddin Rasdi, <u>The Mosque as a Community Development Center: Programme and Architectural Design</u>, (Penerbit UTM, Johor:1998). See Chapter Two entitled 'An Appraisal of the Method and Approach of Architectural History concerning the Idea of the Mosque' pg.34-72

Although this approach finds strength in the fact that those who practice it are Muslims and that the precedents has the form-language framework, there is a question of relevance from the perspective of the values and framework of the Prophet Muhammad's *sunnah* or way of life. Much of the sufi's mysticism are innovation deemed suspect by the guardians of the traditions of Islam.

The work of Besim Selim Al-Hakim comes closest to what we try to impart to architects in our approach towards Islamic Architecture from the Sunnah. Al-Hakim was instrumental in his pioneering work about deriving a set of criteria for Urban Design and city Planning by using the cultural tool of Islamic traditions. He had compiled a significant list of hadiths and juristic rulings on various aspects of urban design for Muslims. Our work falls into this approach but our emphasis will be on architecture and building design.

Deriving a New Framework for Islamic Architecture

In the previous section, it can be seen that Islam has become a mere 'attachment' to the various discourses on architecture of post-modern revivalism, neo-vernacularism, regionalism, modernistic structuralism, abstractionism, geometricism in architecture. The Sufistic based iconographical allusions in traditional Islamic architecture raises questions of validity from the perspective of the *sunnah* as adhered to by the majority of Muslims in this world. Thus, only the work of Al-Hakim presents possibilities of reinterpreting the values of Islam as propagated by the Prophet into meaningful built forms.

We propose a new framework for generating the discourse of architecture by creating firstly a foundation of values inherent in the hadiths of the Prophet Muhammad. We must reiterate here that this framework in no way recommends direct or literal interpretation of the hadiths into built form. As we have indicated earlier, this framework is mooted because of the knowledge that the discourse of values against technology and a new pattern of life had not occurred seriously in Islamic architecture. Since the discourse on modernism had occurred during a time of political upheaval and societal restructuring, questionable dogmas of religious beliefs, the advancement of technology and materials and a wholly new economic formula for nationalistic relationship, we felt that it is important for a similar discourse be nurtured. For this purpose, we have compiled over a thousand hadiths from a reading of about 20,000 traditions of the Prophet Muhammad. The present paper presents only a miniscule possibility of starting

the discourse by comparing Wright's work with the values of the sunnah. We hope many more comparisons can occur so as to generate a vocabulary of thought pattern that would ultimately result in more original findings, ideas and meanings phrased directly from the value system left by the Prophet.

Among the three traditions of modernism of Le Corbusier, Mies van der Rohe and Frank Lloyd Wright, we have chosen Wright because he was questioning the fundamental values of his society and actively involved in the idea of nation building. Islam is not just a private religion but claims to possess a blueprint for a dynamic society rooted in an eternal value system stemming from the best of all religions.

The Idea of Humility in Islamic Architecture

Humility is a significant value in Islam and this quality is required to enable man to have an impeccable life that comprehends every living aspect in the temporal world. When a man realizes the greatness of God through his creation, he will feel humble and his everyday desires, behavior, obligations and duties will always leave space for the remembrance of God. He will then learn to appreciate God's creation and understand the true meaning of humility.

This moralistic value is also one of the Prophet's principles and he always reprimanded men not to possess the negative traits such as arrogance and pride as it will only bring destruction to the soul. The messenger of Allah said:

> 'He who has in his heart the weight of a grain of mustard seed of pride shall not enter Paradise. A person (amongst his hearers) said: Verily a person loves that his dress should be fine, and his shoes should be fine. He (The Holy Prophet) remarked: Verily, Allah is Graceful and he loves grace. Pride is disdaining the truth (out of self-conceitedness) and contempt for the people.'[16]

[16] <u>Sahih Muslim</u> (translated by Abdul Hamid Siddiqui) Lahore, Pakistan: Sh Muhammad Ashraf, 1976 Vol.I, p.53

'He who lets his garment trail during prayer out of pride, Allah the Almighty, has nothing to do with pardoning him and protecting him from hell.'[17]

This value of humility as stated in the Sunnah has a strong reflection in architecture. Architecture and these virtuous values are to be embodied together to build a form that has inner soul.[18] This will enable man to deeply know his existence and learns to appreciate God's creation. This modest manner is also implemented in Frank Lloyd Wright's architectural work.

Wright yield this organic form or '*down to earth*' architectural style by adapting conspicuous horizontal lines from different materials, color and texture at its internal and external façade. This horizontal line continues across the whole inner and outer façade to form a strong band emphasizing the plain façade brick wall. By using this method, he deliberately breaks the height of the external façade and lowers the building scale to harmoniously suit the existing exterior landscape. Whatever form he selected to express the nature of a building, he used the ordinary human scale to represent his simplistic and basic form. This created a harmonious planning layout and kept the proportion of the building, in elevation and details. The human scale proportion that he used, always have the connection to the spirit of the space. This kind of approach generates equipoise between natural surroundings and its building form composition.

Wright richly expressed the value of humility by portraying his building referring to human scale and proportion. He believed that by expressing architecture in this manner one will much more realize the existence of natural elements and this will bring one closer in knowing and appreciate God's creation. He stated:

[17] Sunan Abu Dawud (translated by Ahmad Hassan) New Delhi, India: Al-Medina Publication, 1985 Vol. I, p. 167

[18] There are many more examples of hadith in our upcoming books entitled 'Hadith and Islamic Architecture: Vol.1-3 (Utusan Publications and Distributors, Kuala Lumpur: 2002). The Prophet forbid his companions to stand up when he comes to a gathering, forbids the act of identifying a specific place for any person and the absence of a 'throne-like' place in his house and mosque.

'That's why I think we made a great mistake when we took the capital 'n' off nature and put it only on God. (Putting it) on God is all right-leave it there because God is the great mysterious motivator of what we call nature- and it has been said often by philosophers that nature is the will of God. In addition, I prefer to say that nature is the only body of God we shall ever see. If we wish to know the truth concerning anything, we will find it in the nature of that thing.

The Kingdom of God is within you! That we cling to it now, and that's where you'll find it, and it's in the nature of what you are that this thing is going to come that we call appropriate architecture that we call the nature of building beautifully man's life according to time, to place and to man.'[19]

Wright's well-known masterpiece is the Falling Water located at Bear Run, Pennsylvania. This house combines two sorts of romanticism; the romanticism about nature and the romanticism about scientific feats of construction. It is cantilevered over a waterfall using long horizontal slabs and parapets that seem to float in space. Although his design is based on rectangle organic layout using a simple modular composition but the architectural building form is perfectly balanced and contrasted with the natural setting. The whole composition refers to ordinary human scale and proportion to portray a moderate and humble expression.

The Idea of the 'Eternal' in Islamic Architecture

Central to the teaching of Islam is the reminder that Allah is present and eternal. Muslims are recommended to contemplate His existence through the creations in the natural surrounding. Modern machine architecture with steel and concrete framed within a devastated landscape fails to bring home this message

19 Meehan, J. Patrick(1987) Truth Against The World: Frank Lloyd Wright Speaks About Organic Architecture,Wiley Interscience p.29

'Verily the sun and the moon are two signs of Allah. They are two created things from among his creation. Allah creates in his creation whatever he likes. Allah warns his bonds through them and makes the bonds to get a lesson from them, then he sees who from among them repents.'[20]

'Behold! In the creation of the heavens and the earth and the alternation of the day and night. They are indeed signs for men to understand. Men who celebrate the praises of god standing, sitting, and lying down on their sides, and contemplate the wonders of creation. (Surah 3: Verse 190-191)

Wright's architectural works also characterize the value of gratitude and the need to appreciate the existing universe. He acquired most of the natural materials such as stone, brick, and wood from the surrounding site to assimilate it in his design. The combinations of these natural materials form an expressive style with different texture and colors. Wright dislikes using any plastering, staining or coating but prefer adapting the work naturally. These natural characteristics will blend in with the building form to make it appear harmoniously with its surroundings. The materials that he adapted for the entire building structure also integrates with the site landscape. He stated:

'These materials are human riches. They are nature gifts to the sensibilities that are again, gifts of nature. By means of these gifts, the story and the song of man will be wrought as once upon the papyrus, and now on paper it is written. Each material have its own message and to the creative artist, its own song.'[21]

Wright was very particular about detailing and ornamentations but he prefers to adapt it with the existing structure. The basic motifs that he uses create rhythm and are compatible with the design of the windows, doors, walls, fixtures, and furniture. His ability to unify all these elements through the

[20] Abu Daud Hadayi U'mal. <u>Muslim with Nawawi, Vol II, p122, 123</u>. Bukhari p.353

[21] Wright, Frank Lloyd (April 1928) <u>In The Cause of Architecture (iii) The Meaning of Materials</u> Architecture Record Books. New York, p. 51

detailing gives his building a strong interrelationship of structure, surface, and openings which therefore born a distinctive character. A closer examination at his buildings will show that Wright inevitably focuses on details that were complex but never complicated. He intricately sculptured the detailing from variations of living things such as flowers, trees, shells etc. The range of colors, shapes, and texture that naturally exist in these natural elements inspired him. He says:

> 'This (nature) is the model you should use in developing your buildings. Nature will show you the way to build. Ornament is the abstraction of nature'.[22]

One of Wright's buildings that exemplify the usage of natural elements is the Barnsdall residence. The whole building is made of textile concrete block to accentuate the natural texture. The hard concrete surface uses no plastering or fabricated coating. Wright also implements the abstract geometric rendering from the hollyhock flower that surrounds the site. The flower motif is made of concrete and he used it as integral ornamentation throughout the interior and exterior space. Corbelled walls devoid of openings constrict this *hollyhock house* walled path and at the end of this dark passage is a pair of cast concrete doors that head toward several living spaces. Natural materials from the combination of wood and concrete block adorned the exterior and interior spaces. He believes that by using these natural materials in our design scheme, we will consciously be aware of God's creation. As Wright says:

> 'Nature is gradually apprehended as the principle of life-to-life –giving principle in making things with the mind, reacting in turn upon the makers. Earth –dwellers that we are, we are become now sentient to the truth that living on Earth is a materialization of Spirit instead of trying to make our dwelling here a spiritualization of matter. Simplicity of sense now honorably takes the lead. To be good Gods on earth here is all the significance we have here. A God is a God on earth

22 Dunham, Edith (1994) <u>Details of Frank Lloyd Wright: The California Work (1909-1974)</u>, Thames & Hudson, London, p. 9

as in heaven. And there will never be too many Gods. Just as great master knows no masterpiece, and there are no 'favorite' trees, nor color, nor flowers: no 'greatest' master: so gods are gods, and all are GOD.'[23]

The above text shows the compatibility between the traditions of the Prophet with Wright's organic architecture. Wright was able to bring out these natural elements to form a building that has inner soul and moralistic values. These values are the eternal reminders in bringing one closer to understanding God's creation. We feel that the Unitarian Church brings forth this aspect of Islam more than and expensively detailed revivalistic mosques such as those of Putra Jaya or the Wilayah Mosque in Malaysia

The Idea of Integration and Wastefulness in Islamic Architecture

The Prophet Muhammad forbids man from being wasteful concerning every duty and obligations he performs, as this negative trait will destroy man's faith in God. Hence, if man's soul concealed with this lavish attitude, he will disregard God's existence and in turn be impious.

'I swear by Allah that it is not poverty I fear for you, but I fear the worldly goods may be given to you lavishly as they were to your predecessors, that you may vie with one another in desiring them as they did, and that they may destroy you as they destroyed them.'[24]

'When my followers will adore only the worldly goods, their hearts will be deprived of the love of Islam: and when they stop enjoining right conduct and forbidding indecency, they will

[23] Wright, Frank Lloyd (October 1927) In The Cause of Architecture (iv) Fabrication and Imagination: Architecture Record Books. New York, p. 51

[24] Excerpt from Bukhari and Muslim. See p. 31 book entitled : The Orations of Muhammad : The Prophet of Islam by M.Muhammad Ubaidul Kadir, Kitab Bhavan,New Delhi, India

be deprived of the blessings of revelation: and they will abuse each other and will drop in the estimation.'[25]

The Islamic concept of 'worship' or *Ibadat* encourages Muslims to integrate all useful and beneficial aspects of life as a form of worship. Hence a person may attain rewards for working at an office or taking care of the family if he or she is fully conscious that these acts are performed not for any other reasons but to please Allah and ensure the future advancement of Islam in this world.[26]

Wright was also against wastefulness in his architectural works and he signified this by minimizing the usage of unnecessary detailing. He relates most of the ornamentations with structural elements. Although, their relationship to the structural system did not appear direct they still have the connection with the exterior and interior space. The detailing articulates the space and gives his building strong relationship with the openings and wall surfaces:

'The matter of ornament is primarily a spiritual matter, a proof of culture, an expression of the quality of the soul in us, easily read and enjoyed by the enlightened when it is the real expression of ourselves. The greater the riches it seems the less poetry and less healthful significance.'[27]

Besides that, he also integrates the main core services such as lighting, heating, and ventilation with the main structural system to create spacious living spaces that are functional. This method is effective for small and compact planning layout to reduce building costs. Wright also assimilates all the appliances and fixtures as part of the building scheme. It does not

[25] Excerpt from Tirmidhi. See p. 79 book entitled : The Orations of Muhammad : The Prophet of Islam by M.Muhammad Ubaidul Kadir, Kitab Bhavan,New Delhi, India

[26] For a discussion of this topic and its relation to architecture, see Chapter 5 entitled 'The Idea of the mosque in relation to the Meaning of *Ibadat*', pg. 146-207 and Chapter 6 entitled 'The Idea of the Mosque in Relation to the Muslim's Individual and Collective Responsibilities and Obligations', pg.208-218 in our book The Mosque as a community Development Center.

[27] Meehan, J. Patrick (1987) Truth Against The World: Frank Lloyd Wright Speaks About Organic Architecture, Wiley Interscience, p. 71

only add character but also help to define and give sense of scale. He puts no premium upon an enclosed plan. Most of his designs have large glass area, numerous ventilation holes and open flow rooms for natural lighting and ventilation without any sacrifice of comfort or economy. He expresses his design effects using juxtaposition of spaces, variations of height and width, contrast of open and closed surfaces, the drama of pitched or flat roof slabs and superb craftsmanship through natural materials. These materials are specially adapted from the existing site and devoid any artificial treatment as its natural characteristic will blend in with the local context.

'This conventional representation must always be worked out in harmony with the nature of the materials used, to develop, if possible, some beauty peculiar to this material. Hence one must know materials and apprehend their nature before one can judge them. Fitness to use and form adapted to function are part of the rule.'[28]

Wright abhors elaborate and meaningless building elements. Each structural element that he proposed and spaces that he creates has own functional values. He approves uncomplicated but simplistic planning layout using basic shapes such as squares and rectangle to enable living spaces to integrate with each other freely:

'We are living today encrusted with dead things forms from which the soul is gone, and we are devoted to them, trying to get joy out of them, trying to believe them still potent. It behooves us, as partially civilized beings, to find out what it means, and the first wholesome effects of this attitude of inquiry is to make us do away with most of it, to make us feel safer and more comfortable with plain things. Simple things are not necessarily plain, but plain things are all that most of us are really entitled to, in any spiritual reckoning, at present.'[29]

28 Wright, Frank Lloyd (April 1928) In The Cause of Architecture (iii) The Meaning of Materials Architecture Record Books. New York, p. 88
29 Meehan, J. Patrick (1987) Truth Against The World: Frank Lloyd Wright Speaks About Organic Architecture, Wiley Interscience, p. 73

Most of Wright's work implements the idea of simplicity, functional and against frugality. Such example is the Unitarian Church at Shorewood Hills where it represents an ideal model of a religious architecture. The whole interior space spans about sixty feet long and covered by angled wooden roof, which is supported by a series of transverse wooden trusses that reach from wall to wall. The entire building structure is made of natural materials from brick and timber decorated with minimal ornamentations. Every structural elements and detailing in this church has its own function and values.

The Idea of 'Democracy' in Islamic Architecture

The idea of 'democracy' in islam is about accountability of both the ruled and the rulers to Allah with respect to justice within the framework of the Qur'an and the Sunnah. New laws are made by Muslims whilst taking account of the original spirit of Islam inherent in the Prophet's tradition endows Islam with a dynamic character rooted or anchored by a fundamental idea of justice. Thus, there is a sense of awkwardness in the idea of monumental architecture that is built with questionable accountability by patrons of buildings in Islam and the restricted idea of assesibility between the rulers and the ruled. The Prophet Muhammad condemns humankind who is fully obsessed in building colossal monuments for personal grandeur and egotistical reasons.

> 'I was not commanded to build high mosques. One of the portents of the Day of Judgment is that you will vie with one another in building mosques.'[30]

> 'I shall be there as your predecessor on the cistern before you and it is as wide as the distance between Aila and Juhfa. I am not afraid that you would associate anything with Allah after me but I am afraid that you may be allured by the world and vie with one another in possessing material wealth and

[30] Excerpt from Sahih Muslim See p. 98 book entitled : The Orations of Muhammad : The Prophet of Islam by M.Muhammad Ubaidul Kadir, Kitab Bhavan,New Delhi, India

begin killing one another, and you would be destroyed as were destroyed those who had gone before you.'[31]

The Apostle of Allah also discourages mankind from following their passions and desires blindly, as he said that the worldly wealth and lavish luxuries only will rusts a person's soul and take him away from his spiritual goal.

Wright suggests the idea of architectural democracy in his design. His building scheme represents an organic style where the ground plan grows from a germ idea like a plant growing from seed. The seed is the basic floor plan that will determine the entire building form. This seed will then grow or can be multiplied vertically and horizontally to form different spaces and details. The juxtaposition of different spaces will produce an unsymmetrical and non –formal planning layout. He is against the idea of colossal building form as it opposed the major and minor centerlines of true architecture:

> 'Not satisfied, look at Moscow. The case is much the same. A new civilization, unable to find a way of building that is its own, slavishly reproduces the buildings of the culture it overthrew. It overthrew the great high ceilings, high chandeliers, pornographic statues playing on grand terraces. Only now they want the ceilings higher, five chandeliers where there was one before, and they want it all everywhere, even in subway. Not liking Moscow, see London! The greatest habitation on earth sunk in its own traditions, unable to see daylight anywhere-part of its charm, of course. If you see within at all, you will see the same degradation in all. You will find them poisoned for democracy, all militaristic, their columns marshaled like soldiers menacing the human spirit –the true crucifixion. A democratic building is at ease: it stands relaxed. A democratic building again is far and belongs to the people. It is of human scale for men and women to live in and feel at home.'[32]

[31] Sahih Muslim Vol.IV, p.1237

[32] Meehan, J. Patrick (1987) Truth Against The World: Frank Lloyd Wright Speaks About Organic Architecture, Wiley Interscience, p. 302-303

The Madison Civic Center exemplifies the idea of non-symmetry and a massing which does not dominate the natural surrounding as found usually in castles and many palaces all around the world. Compare this to the design of the capital of the 'Islamic State' of Malaysia in the new imperial city of Putrajaya with its King Louis style of axis and monumental grandeur.

Conclusion

The main purpose of this paper has been to provoke a new approach in generating a more meaningful discourse of Islamic architecture from the spirit and idea of Islam interpreted by the Prophet Muhammad himself. Although there are many approaches to designing what is claimed to be 'Islamic Architecture', there seems to be a question of strength and validity in them as they are either by-products of existing modernistic discourse or that they are based on values and practices deemed questionable from the Sunnah of the Prophet himself. The approach which we have presented here brings back the rejected body of knowledge known as the 'hadiths' which simply means the traditions of the Prophet Muhammad to the fore front of the discourse. Since the discourse on the fundamental life values of Islam had never seriously taken shape as the discourse on modernism in the late 19th century Europe and America, we hope that this paper paves the way for it to happen. The idea of using Wright' architecture as a comparative basis in comprehending the value system of Islam is simply a tool for provoking the question of Islamic Architecture. There are certainly many other ways to establish this discourse in future studies.

THOUGHTS FOR AN ARCHITECTURAL LEGACY

As a conclusion to this book, I thought it would be appropriate to end with my final column in The Star published in December 2010. The following is the unedited version of the published piece:

This will be my last column entry. No, I was not given any marching orders by The Star people. And No… I was not issued a 'show cause letter' by the UTM leadership concerning my criticism of national monuments and so called Islamic edifices. Whatever weaknesses UTM may have in the eyes of the Malaysian public, I can completely assure you 'academic freedom' is not one of them. Yes I have heard some rumblings of discontent among the higher ups about criticizing what is deemed national architectural masterpieces. But to their credit, the UTM leadership has respected my intellectual right and responsibility to present knowledge that I saw fit to be the vehicle of 'nation building'. Thus, in today's column, I will explain why I am voluntarily ending the column, I will reiterate or summarize my main message, thank those who were responsible for allowing me this 4 year stint in the world of newspaper column writing and perhaps some of my activities after this or I should say 'life after the column'!

Okay ..so first the why. Well, if not anything…it's been four years! That's 48 months and 47 articles ago. I have run out of main things to say. Well, there are many more interesting projects on the drawing board by my UTM students for me to talk about. There's the Friendly Prison, the Elderly Day Care Center, the ShopHouse Comeback and small town living, there's the multi-functional Mosque that can change internally to provide 300% prayer capacity and many

others. But I am afraid if I do that, then I would diminish the main message of the column. The second reason for stopping was that I am too excited to complete my book called 'Architecture and Nation Building: Of Community, Politics, Religion and Education'. This book shall contain all the writings from the column in the star in its ORIGINAL unedited and spicy version. Not to say that the editors in the Star have de-spiced my writing but there was some small censorship going on during the 4 years of writing. Very small censorship-lah. *Biasalah…nak hidup*! I'd say a mere 2%. *Tak apalah*. It had probably save my behind from some nasty actions by my employers.

Okay …so now the thanking part. First of all I would like to thank my editor Malini whose last name I do not even know. I even tried to find her facebook but since I myself am NOT an ardent Facebook-ian, I do not even know what she looks like. She will probably remain a voice in my phone and words in cyberspace e-mails until I find the time to climb the Star's building and give her the first copy of my latest book. Thank you for passionately editing my writing to be within a more acceptable style but still unmistakably mine (for better or for worse!). Hey if I had my way she deserves a big fat promotion. Thank you also to June who I remember her smiling face when she offered me the column but latter on her business-like replies to my questions left me feeling thankful for the very limited phone conversations that we had (merely 2 in 4 years!) …but a big thank you for believing in me. I suppose I should thank those who own the newspapers because my friend, a former high ranking Malay Editor of a Malaysian daily, remarked "Hey Din, I am surprised that the Star lets you write the way you write…I guess the Star is ok!" Well, let's just say I know enough politics in this country to know what he meant. If you do not know what he means then forget you ever read this line. I would also like to go on record to thank three individuals; my late Dean of Faculty of Built Environment Professor Dr. Supian Ahmad who passed away this year of cancer, the previous Vice Chancellor Professor Dato' Dr. Zulkifli and the present one Prof. Dato' Dr. Zaini Ujang. Why am I thanking them? No.. none of them had ever encouraged my writing in the press. I am thanking them simply because they kept virtually silent throughout my stint with the Star. After 24 years in the Civil Service, I have come to understand that 'silence' can be construed as the biggest accolade in the business of architectural criticism that I am in. I have heard rumblings from the top via my Dean but when I asked him whether I should stop, the Dean merely signaled something like

'some may not like what you do but they know that it was your right as an academic and as a citizen of Malaysia to say things responsibly.' I think that was the signal in not so many words. The most difficult thing for me in my writing the things that I write is that I may have caused certain pressure placed on my colleagues the Dean and the VCs. Sorry guys but thank you for sticking up by not saying anything. It means a great deal to me because I consider the 4 year stint in the Star as the pinnacle of my academic career. Not for the glamour nor the notoriety. Certainly not for the university KPI points (there is barely any). It is simply discharging what the Prophet Muhammad (peace be upon him) has said to 'encourage good and forbid evil with your hand, with your pen or with your heart'. I also did this in the hope that my children will live in a better Malaysia with the ideas put forth in these writings. Changing this country for the good is not difficult. You simply choose to change and follow your conscience. Contrary to many opinions, Malaysia is NOT a dictatorship. The people can change this country to what they think to be the best for their children. It's just that we put up invisible barriers between ourselves and do not look deep enough into our hearts about what really matters. Allah gave us a mind and a heart. We should stop thinking with our skin and money bags.

Okay boys and girls, what was the message of the column all throughout the 4 years? Simple *saja-lah*. Architecture must be governed by our values. Our values are our life construct of universal concerns (such as crime and children safety), of cultural-religious requirements (such as privacy and burning joss sticks),of the dictates of modern life (such as jogging and picking up children from school) and of the ideals of responsible democracy (such as non-ethnic biased language in administration buildings and multi-religious centers in universities). Itu saja. Architecture IS NOT about bringing back the dome, minarets, Minangkabau roofs and monumental kingdoms but a simple and honest expression of how we live and how we would like to live. For architecture students, stick with that theme and you'll score A's all along your college life. For architects, stick with that and you might regain the lost respect of the Malaysian people. For academics, stick with this approach and your conscience will be clearer than if you choose to fulfill the universities dubious KPI's. To the people of Malaysia, you do not need an architecture degree to criticize your architect if he or she strays away from that main theme. For the leadership... ah well I think I'll reserve my advice after the upcoming election! Anyway in my book the people ARE the leaders of this country.

Finally, what's next for me? Well apart from my usual work of maintaining two research centers and training new academics to take over this job of educating the public in architecture, I thought I would dabble with non-architectural writings. I would like to write my thoughts on our 'disastrous' education system from the primary, secondary and especially tertiary levels. We are waaaaay out, guys! Then I thought of writing about Islam and it's TRUE relationship with non-Muslim to counter certain overzealous remarks by overeager politicians… just to keep this country safe for our children. There are other things but this column is getting to lengthy and teary eyed for me. So thanks for reading and commenting my column all this while. This is Prof. Taj…signing off!

Printed in the United States
By Bookmasters